POST-IMPRESSIONISM

Author: Nathalia Brodskaïa

Layout:
BASELINE CO LTD
33 Ter – 33 Bis Mac Dinh Chi St.,
Star Building; 6th floor
District 1, Ho Chi Minh City
Vietnam

ISBN: 978-1-84484-746-4

Printed in India

Nathalia Brodskaïa

POST-IMPRESSIONISM

PARKSTONE
INTERNATIONAL

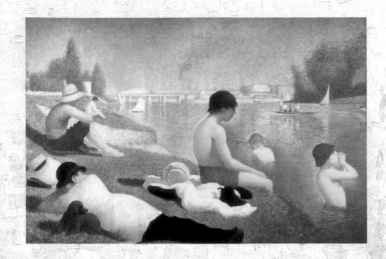

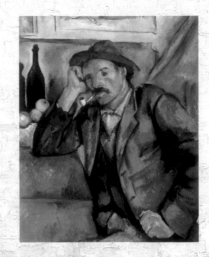

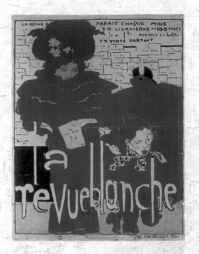

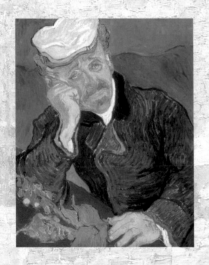

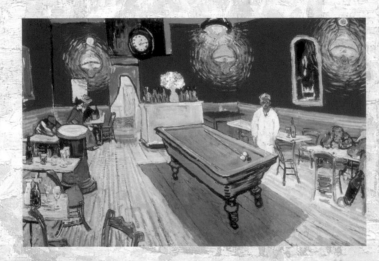

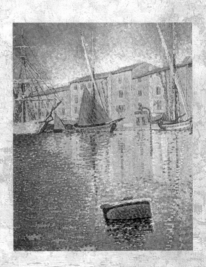

CONTENTS

INTRODUCTION

The term 'Post-Impressionism' has only one meaning: 'after Impressionism'. Post-Impressionism is not an art movement, nor an art style; it is a brief period at the end of the nineteenth century. Impressionism being a phenomenon unique to French painting, the idea of Post-Impressionism is also closely linked to French art. Generally, the beginning of the Post-Impressionist era dates from 1886, from the moment of the eighth and final joint Impressionist Art exhibition. The era ends after 1900, running only into the first decade of the twentieth century. Although 'Post-Impressionism' and its chronological limits are well-defined, it seems that several Post-Impressionist works exist outside this period. Despite this period's extreme brevity, it is often described as an 'era' of Post-Impressionism. In fact, this twenty-year period saw the emergence of such striking artistic phenomena, such varying styles of pictorial art and such remarkable creative personalities, that these years at the turn of the century can without a doubt be characterised as an 'era'.

The Technical and Scientific Revolution

The period of Post-Impressionism began at a time of unbelievable changes in the world. Technology was generating true wonders. The development of science, which formerly had general titles – physics, chemistry, biology, medicine – took many different, narrower channels. At the same time this encouraged very different areas of science to combine their efforts, giving birth to discoveries that had been unthinkable just two to three decades earlier. They dramatically changed the perception of the world and humanity. For example, the work of Charles Darwin *The Descent of Man, and Selection in Relation to Sex* was published as early as 1871. Each new discovery or expedition brought something new. Inventions in transport and communications took men into previously inaccessible corners of the Earth. Ambitious new projects were designed to ease the communication between different parts of the world. In 1882 in Greece, the construction of the canal through the Isthmus of Corinth began; in 1891 Russia commenced the construction of the great Trans-Siberian railway which was finished by 1902; in America work started on the construction of the Panama Canal. Knowledge of new territories could not go unnoticed in the development of art.

At the same time there were great developments in telecommunications and transport. In 1876 Bell invented the telephone and, in the last quarter of the nineteenth century people began talking to each other in spite of the distance. Thanks to the invention of the telegraph, in 1895 Marconi developed the network of Hertzien waves, and four years later, the first radio program was broadcast. The speed of travelling across the Earth was increasing incredibly. In 1884 the first steam-car appeared on the streets of France; in 1886 Daimler and Benz were already producing cars in Germany, and the first car exhibition took place in Paris in 1898. In 1892 the first tramway was running in the streets of Paris, and in 1900 the Paris underground railway was opened. Man was taking to the air and exploring the depths of the earth. In 1890 Ader was the first to take off in an airplane; in 1897 he flew with a passenger, and in 1909 Blériot flew across the Channel. As early as 1887 Zédé had designed an electrically-fired submarine. It seemed like all the science-fiction projects of Jules Verne had become reality.

1. **Paul Cézanne**, *Peaches and Pears*, 1888-1890. Oil on canvas, 61 x 90 cm. The Pushkin State Museum of Fine Arts, Moscow.

2. **Vincent van Gogh**, *Self-Portrait with Bandaged Ear and Pipe*, 1889. Oil on canvas, 51 x 45 cm. Private collection, Chicago.

3. **Paul Cézanne**, *Self-Portrait with a Cap*, 1872. Oil on canvas, 53 x 39.7 cm. The State Hermitage Museum, St. Petersburg.

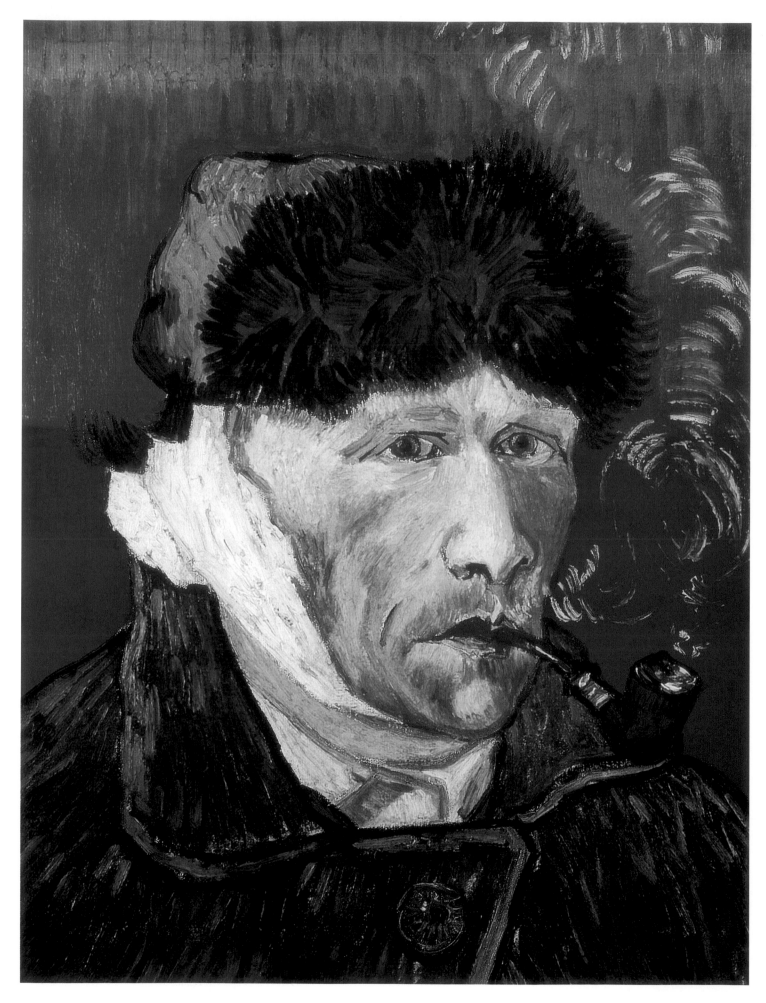

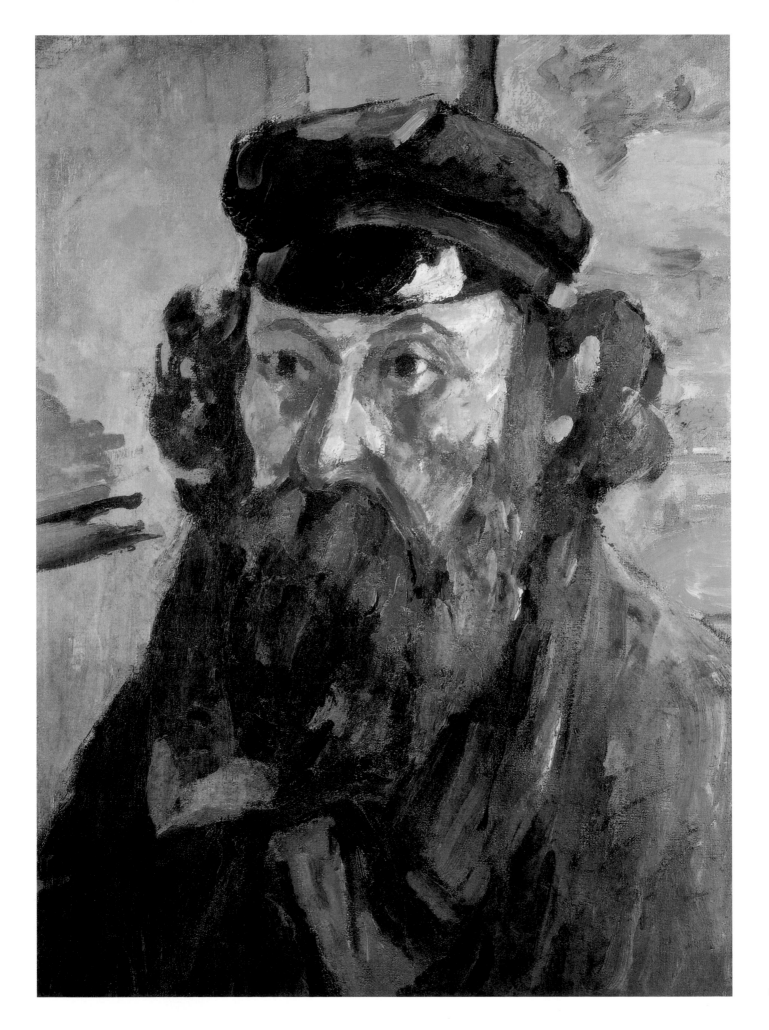

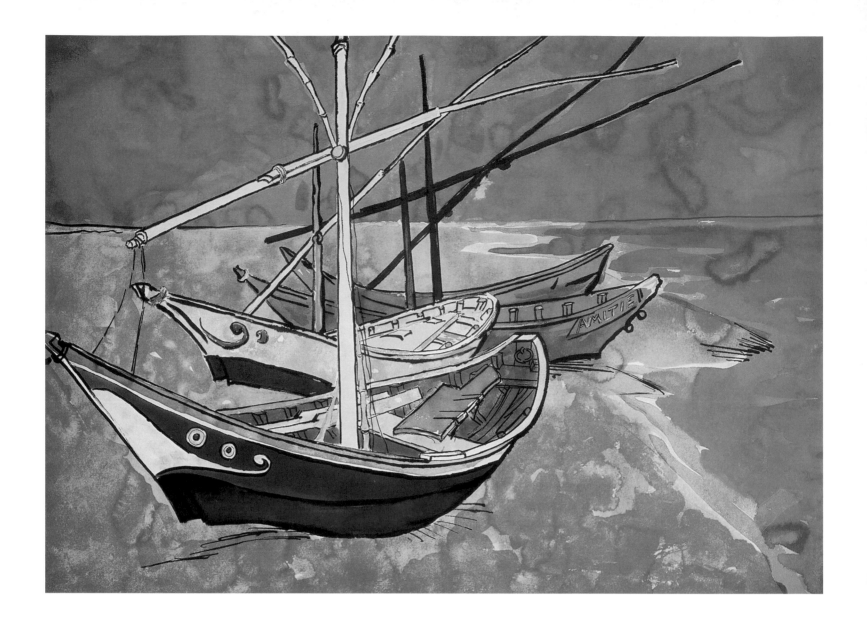

4. **Vincent van Gogh**, *Boats on the Beach of Saintes-Maries*, 1888.
Pencil, pen and Indian ink, watercolour on paper, 39 x 54 cm.
The State Hermitage Museum, St. Petersburg.

5. **Paul Signac**, *Boat in the St Tropez Harbour – Tartanes pavoisées, Saint-Tropez*, 1893.
Oil on canvas, 56 x 46.5 cm.
Von der Heydt-Museum, Wuppertal.

At the same period, scientific discoveries, barely noticed, but nevertheless significant for humanity, were taking place. In 1875 Flemming discovered chromosomes; in 1879 Pasteur found it was possible to vaccinate against diseases; in 1887 August Weismann published the Theory of Heredity. Lawrence discovered electrons; Röntgen did the same for X-rays and Pierre and Marie Curie discovered radioactivity. These discoveries in the field of science and engineering might seem distant from the Fine Arts, but nevertheless, they had a major influence on them. Technology gave birth to a new kind of art: in 1894 Edison recorded the first moving pictures, and in 1895 the Lumière brothers screened their first film.

European explorers became more and more adventurous, and brought back to Europe new and remarkable materials. In 1874 Stanley crossed Africa. In 1891 Dubois discovered the remains of a 'pithecanthropus erectus' on the island of Java. Previously during the 1860s, archaeologists E. Lartet and H. Christy found a drawing of a woolly mammoth engraved on a tusk in the Madeleine caves. It was hard to believe in the existence of Palaeolithic art, but further archaeological research provided evidence of its aesthetic value. In 1902 archaeologist Émile Cartailhac published a book in Paris called 'Confession of a Sceptic' which put an end to the long-lasting scorn of cave art. The amazing Altamira cave paintings, which had been

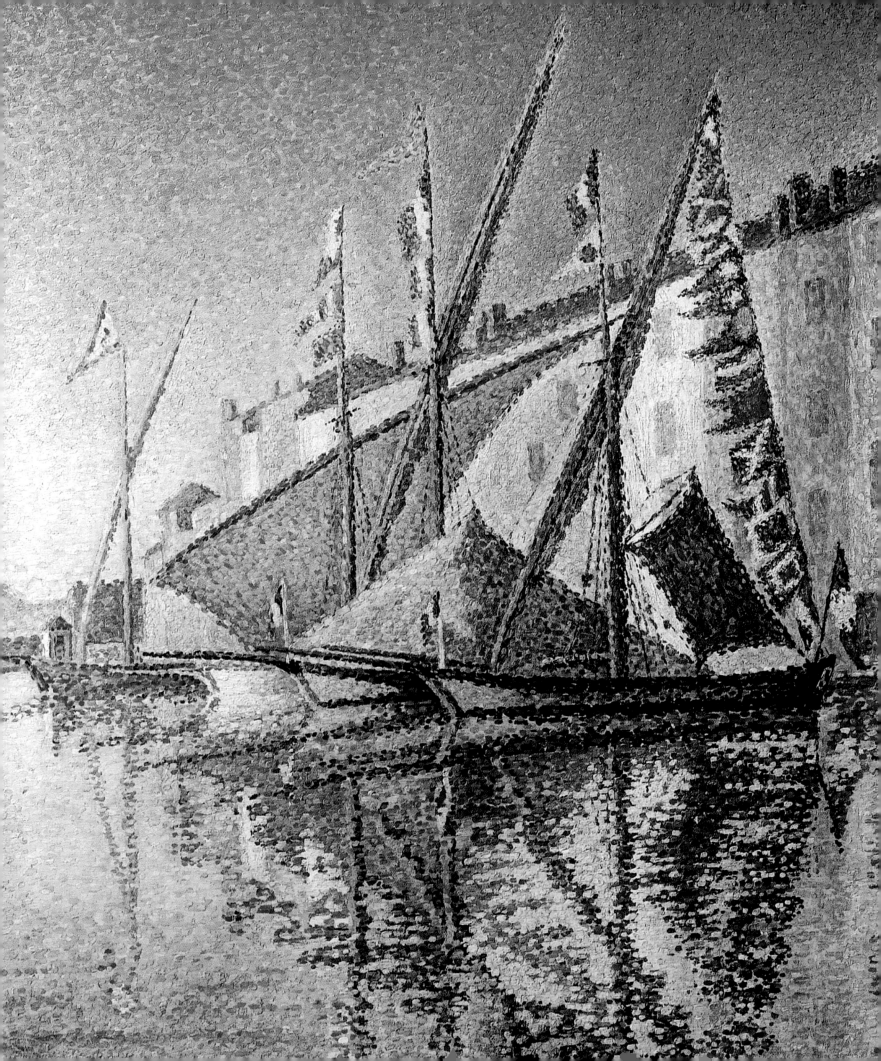

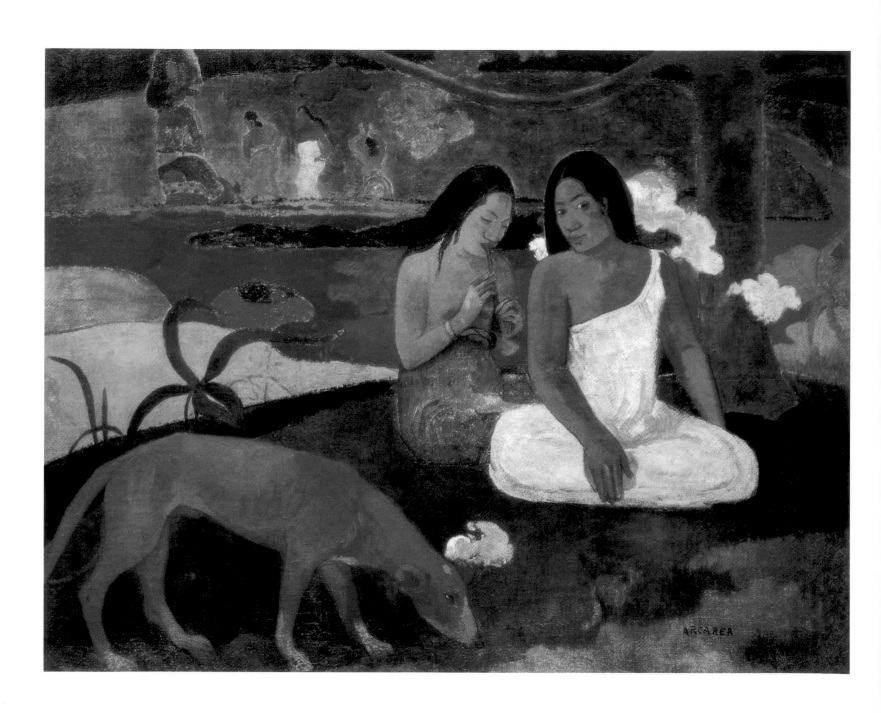

6. **Paul Gauguin**, *Arearea (Happiness)*,
 1892.
 Oil on canvas, 75 x 94 cm.
 Musée d'Orsay, Paris.

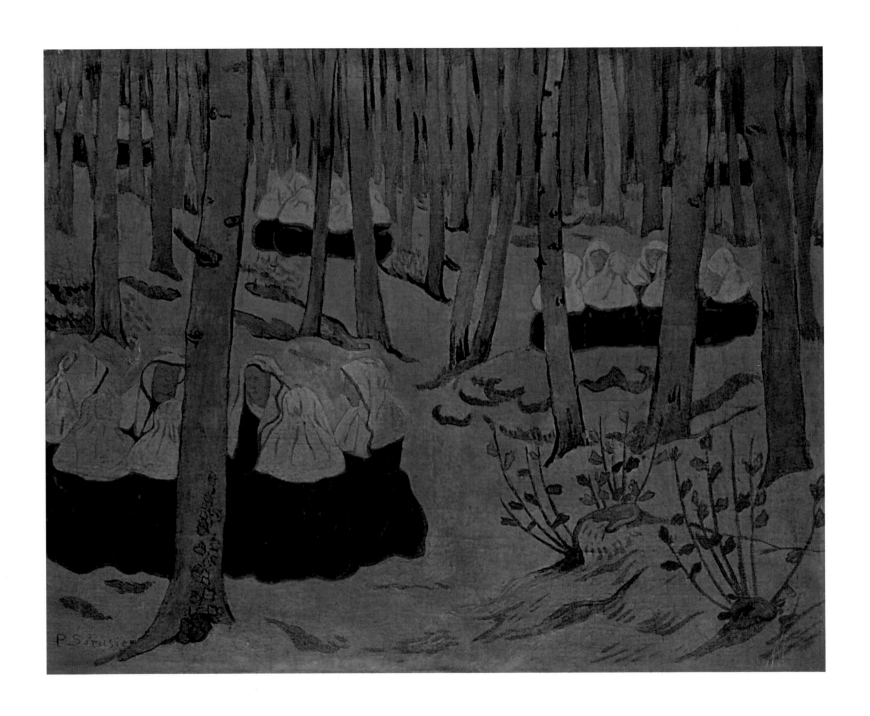

7. **Paul Sérusier**, *Breton Women,
the Meeting in the Sacred Wood*,
c. 1891-1893.
Oil on canvas, 72 x 92 cm.
Private collection.

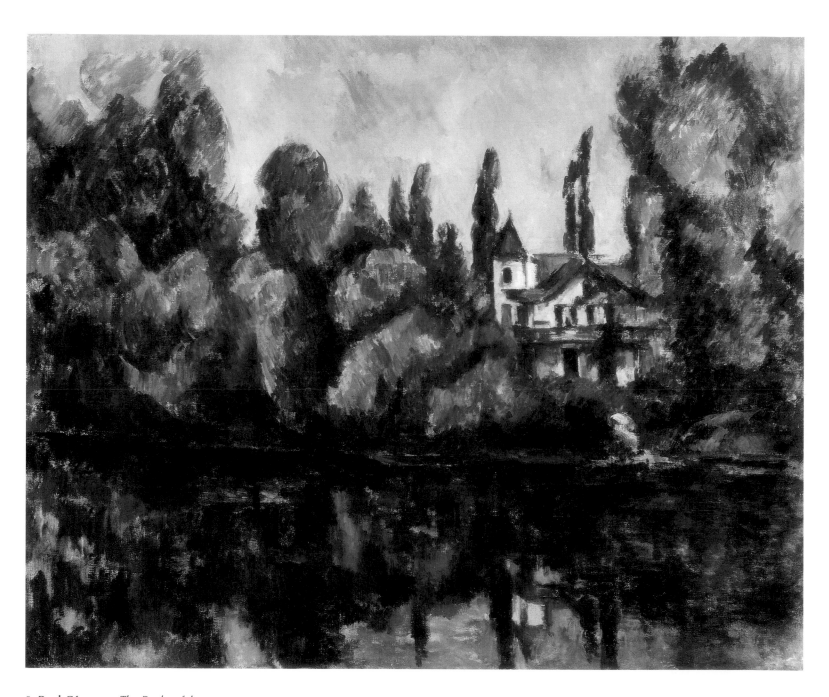

8. **Paul Cézanne**, *The Banks of the
Marne (Villa on the Bank of a River)*,
1888.
Oil on canvas, 65.5 x 81.3 cm.
The State Hermitage Museum,
St. Petersburg.

subject to doubt for a long time, were finally proclaimed authentic. An intensive search for examples of prehistoric art began, which at the turn of the century turned into 'cave fever'.

The end of the nineteenth century also saw the birth of a new science: ethnography. In 1882 the ethnographical museum was opened in Paris and in 1893 an exhibition of Central America took place in Madrid. In 1898 during a punitive expedition to the British African colonies, the English rediscovered Benin and its strange art long after the Portuguese discovery in the fifteenth century. The art works in gold of the indigenous Peruvian and Mexican populations, which had flooded Europe in the sixteenth century after the discovery of America and had scarcely been noticed by the art world; it was nothing more than precious metal to be melted down. The expansion of European boundaries at the end of the nineteenth century opened incredible aesthetic horizons to painters. Classic antiquity ceased to be the only source of inspiration for figurative art. What O. Spengler later called the 'decline of Europe', which implied the end of pan-Europeanism in the widest sense of the word, had immediate effects on art.

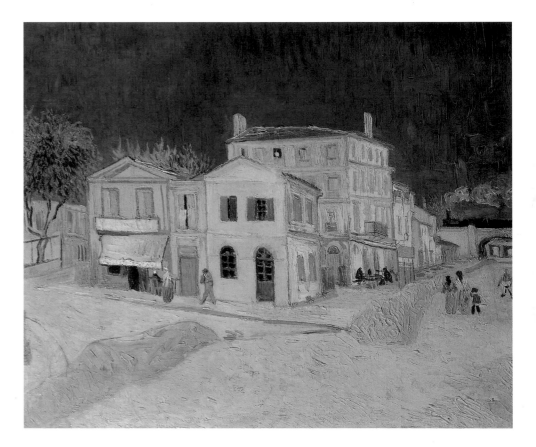

The year 1886 marked the beginning of fundamental changes in the appearance of Paris. A competition was organised for the construction of a monument to commemorate the centenary of the French Revolution (1789) which coincided with the World's Fair. It was the project of the engineer Gustave Eiffel to build a tower which was accepted. The idea of building a 300 metre tall metal tower in the very centre of Paris alarmed Parisians. On February 14, 1887, the newspaper *Le Temps* published an open letter signed by Francois Coppée, Alexandre Dumas, Guy de Maupassant, Sully Prudhomme, and Charles Garnier, architect of the Paris Opera building which was finished in 1875. They wrote: "We the writers, painters, sculptors, achitects, passionate lovers of the as yet intact beauty of Paris express our indignation and vigourously protest, in the name of French taste, in the name of threatened French art and history, against the erection of the useless and monstrous Eiffel Tower right in the centre of our capital. Is the city of Paris to be associated any longer with oddities and with the mercantile imagination of a machine builder, to irreparably disfigure and dishonour it? (…) Imagine for a moment this vertiginously ridiculous tower dominating Paris like a gigantic black smokestack, overpowering with its bulk Notre-Dame, the Sainte-Chapelle, the Saint-Jacques Tower, the Louvre, and the dome of Les Invalides, shaming all our monuments, dwarfing all our architecture, which will disappear in this nightmare (…) And, for twenty years, we shall see, spreading out like a blot of ink, the hateful shadow of this abominable column of bolted metal."[1]

9. **Vincent van Gogh**, *The Yellow House (Vincent's House at Arles)*, 1888.
Oil on canvas, 72 x 91.5 cm.
Van Gogh Museum, Amsterdam.

10. **Vincent van Gogh**, *The Starry Night* (detail), 1888.
Oil on canvas, 72.5 x 92 cm.
Musée d'Orsay, Paris.

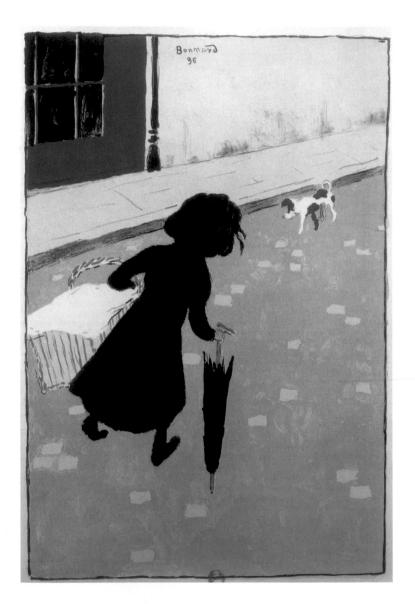

Nevertheless, the World's Fair of 1889 surprised Paris with the fine beauty of Eiffel's architecture. During the exhibition 12,000 people a day visited the tower, and later it was used for telegraphic transmissions. But more importantly it finally became one of the dominant architectural features against which it had been opposed. The city was moving towards the twentieth century, and nothing could stop its development. Given the metal market pavilions of Baltard and the railway stations, the Paris of Haussmann had no trouble adopting the Eiffel Tower. Amongst the Post-Impressionist artists of the period, some immediately welcomed the new architectural aesthetic. For Paul Gauguin the World's Fair was the discovery of the exotic world of the East, with its Hindu temples and its Javanese dances. But the functional purity of the pavilion construction also impressed him. Gauguin wrote a text entitled "Notes sur l'art à l'Exposition universelle," ("Notes on Art at the World's Fair") which was published in *Le Moderniste illustré* on July 4, 1889. "A new decorative art has been invented by engineer-architects, such as ornamental bolts, iron corners extending beyond the main line, a kind of gothic iron lacework," he wrote. "We find this to some extent in the Eiffel Tower." Gauguin liked the heavy and simple decoration of the tower, and its purely industrial material. He was categorically opposed to eclecticism and a mixture of styles. The new era produced a new aesthetic: "So why paint the iron the colour of butter, why gild it like the Opera? No, that's not good taste. Iron, iron and more iron!"[2] The Post-Impressionist era was to dramatically change tastes and artistic passions. In 1912 Guillaume Apollinaire already designated the Eiffel tower as the new symbol of the city, becoming in his poems a shepherd guarding the bridges of Paris.

The year 1900 brought Paris new architectural landmarks: palaces appeared on the banks of the Seine, where pavilions for World's Fair were traditionally built. Eugène Hénard drew up a plan for the right bank of which the principal feature was a wide avenue in the axis of the esplanade of Les Invalides and the Alexandre III Bridge. Along both sides of the avenue two pavilions were erected for the World's Fair of 1900 – the Grand Palais and the Petit Palais – miracles of modern construction engineering. The principle of these constructions is that of a metallic structure surrounded by a façade of stone. The use of metal structures allowed decorating palaces with heavy stone and bronze sculptures in combination with painting and mosaic. These structures allowed roofs to be built over the huge spaces of the Grand Palais and to place spectacular halls for different kinds of temporary exhibitions, even industrial ones, inside. Many famous sculptors and painters of the end of nineteenth century took part in the decoration of the palace, so that it became the monument to the new style, born in the era of Post-Impressionism.

11. **Pierre Bonnard**, *The Little Laundry Girl*, 1896.
Lithograph in 5 colours, 30 x 19 cm.
Bibliothèque nationale de France, Paris.

12. **Henri de Toulouse-Lautrec**, *Divan Japonais*, c. 1892-1893.
Lithograph in colours, poster, 80.8 x 60.8 cm. Private collection.

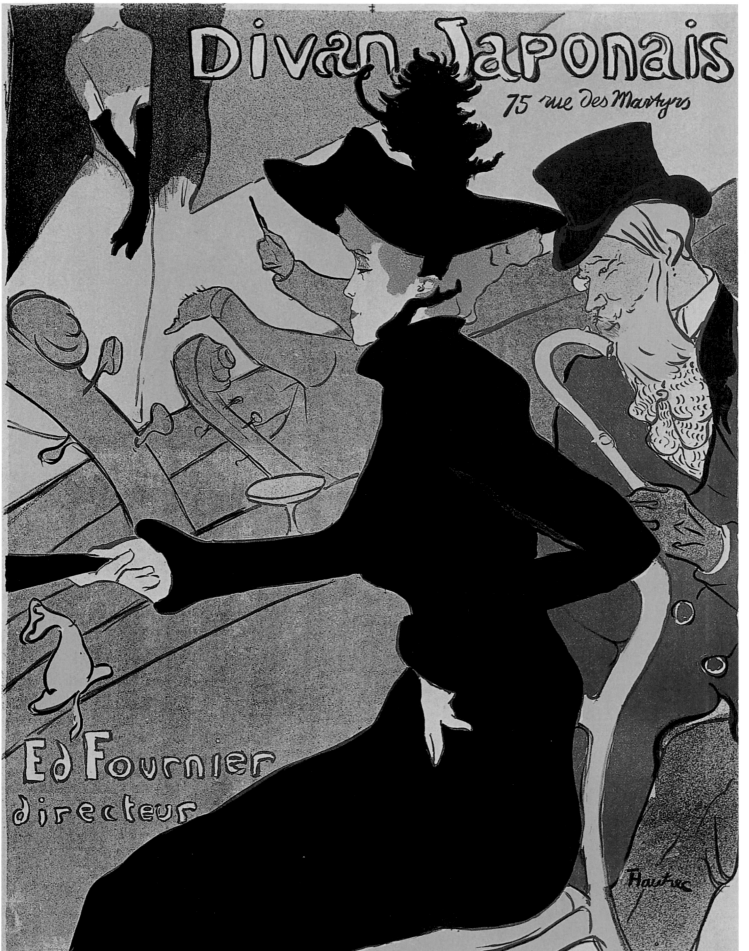

Divan Japonais

75 rue des Martyrs

Ed Fournier

directeur

19

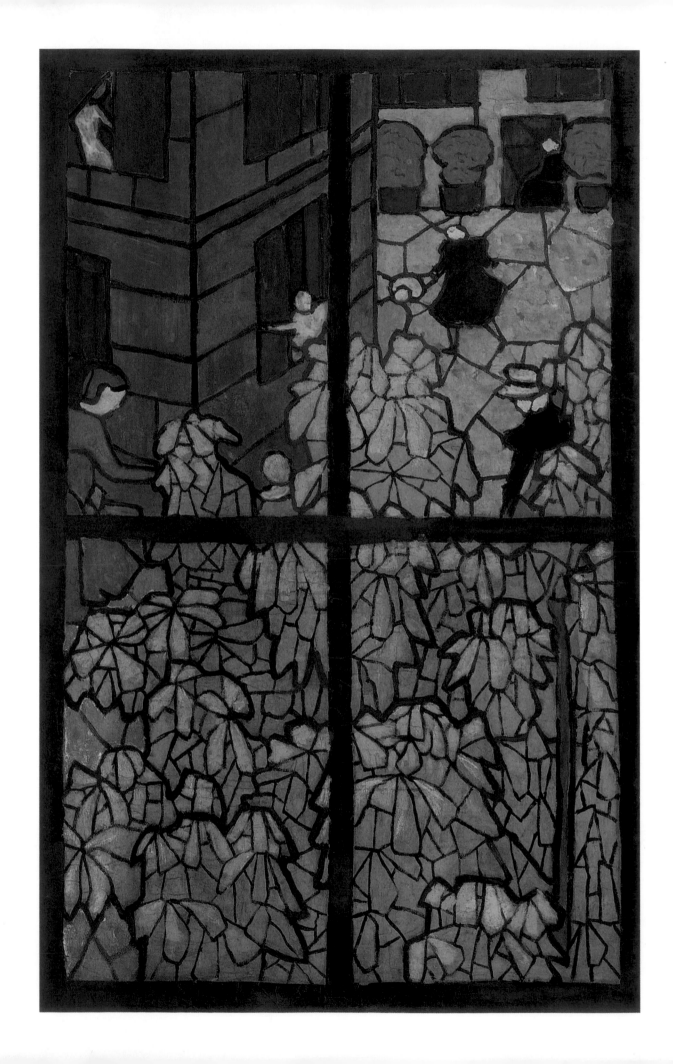

At the same time, on the left bank of the Seine stood another palace. Well, it was not a palace as such, but the Gare d'Orsay and a hotel, built with the drawings of architect Victor Laloux. Trains were supposed to deliver visitors of the World's Fair of 1900 directly in the centre of Paris. Contemporaries compared the station to the Petit Palais. "The station is superb, and looks like a Palais des Beaux-Arts. Just like the Palais des Beaux-Arts resembles a train station, I proposed to Laloux that he make the switch if there is still time," wrote one of the artists after the opening of the World's Fair. These new palaces completed Impressionist and Post-Impressionist Paris.

Post-Impressionism and its Contributions

The era of Post-Impressionism was the time of lone painters; only a very small number of them got together, and then only rarely. The great specialist of Impressionism, John Rewald, used the ingenious phrase of Émile Verhaeren: "There is no longer a unique school, he wrote in 1891, there are a few groups, but even they break up constantly. All these movements remind me of moving geometrical pieces in a kaleidoscope, which separate suddenly only to better come together again. They move apart then get together, but, nevertheless, stay in the same circle – the circle of the new art."[3]

They didn't share the same opinion about art, nature or painting style. The only thing the painters had in common was the impression that Impressionism left on them: none of them could have worked in this manner, working as if Impressionism had not existed. All these artists faced the same sad fate – not one of them had a hope of ever entering the Salon and showing his work to the public. Impressionists had shown them a possible way: they created their own exhibitions, excluding from it those who were not with them. They were all very different: some did not have the necessary level of professionalism according to the jury's rules; some shocked the public by being too bold in their style, too negligent or using colours which were too intense. A new exhibition opened in 1884 in Paris: Le Salon des artistes indépendants. The new Salon was a solution for everyone, because there was no jury and nobody was selecting works for the exhibition. Each painter could show whatever he wanted. The only condition was the number of works being shown, that number changed year after year. Georges Seurat, a Neo-Impressionist, whose unusual position made him undesirable for official exhibitions, took a very active part in organising the Salon des Indépendants. The Independents proclaimed what became the significant achievement of the Post-Impressionism era. According to the 'Sunday' painter Henri Rousseau, "Freedom to create must be given to initiators".[4] Only two years after the last Impressionists exhibition, each painter had the possibility of showing his work to a wide audience.

Although it was often hard to discover a great talent among hundreds of pieces shown there, it was that Salon that gave the opportunity to such uneducated artists as Henri Rousseau to discover the art scene. School education ceased to be an essential quality for painters; Vincent van Gogh and Paul Gauguin were also persistent, self-taught painters. Paul Cézanne – 'the Impressionist' –, who was not satisfied with Impressionists' style, also chose his own special path; Henri de Toulouse-Lautrec, even though he had received classical education, decided to choose a disapproved path. The work of all these painters was conceived in the era of Post-Impressionism and their lives, surprisingly, ended with the end of the century: Van Gogh died in 1890, Seurat – in 1891, Lautrec – in 1901, Gauguin – in 1903, Cézanne – in 1910, the Douanier Rousseau – in 1910.

13. **Édouard Vuillard**, *Chestnut Trees*. Distemper on cardboard mounted on canvas, 110 x 70 cm. Private collection.

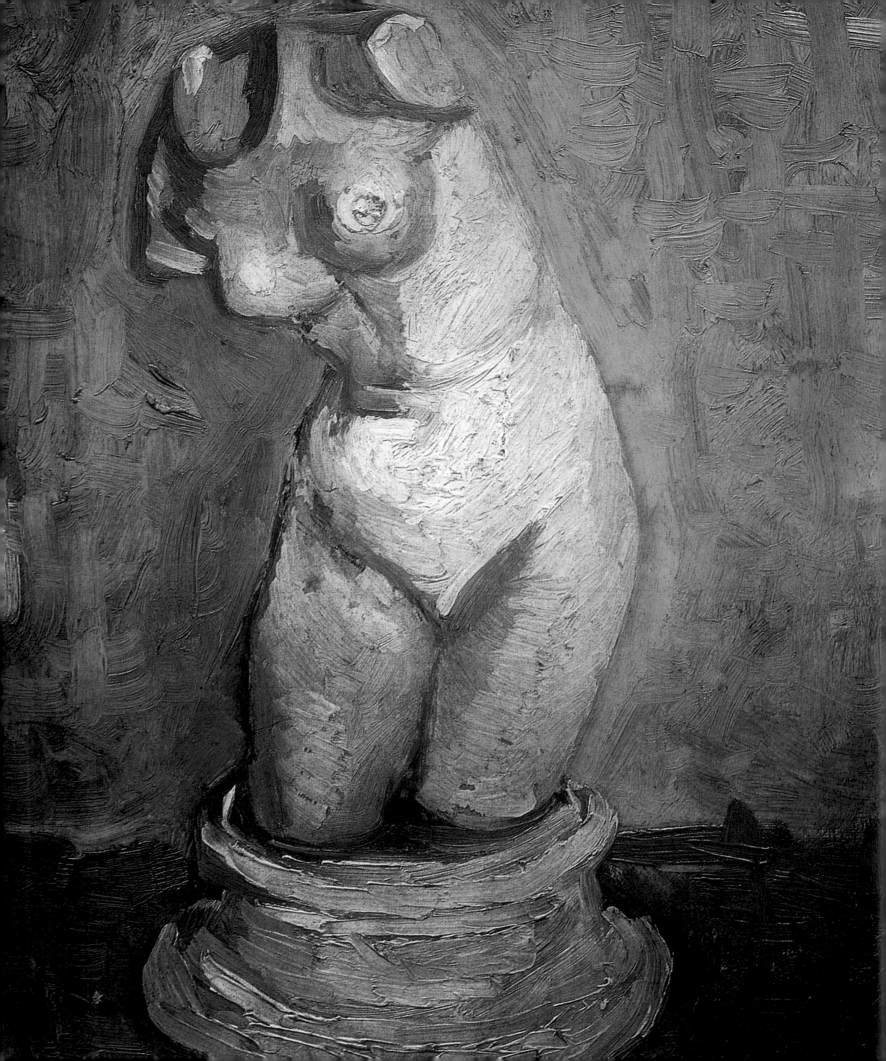

MAJOR ARTISTS

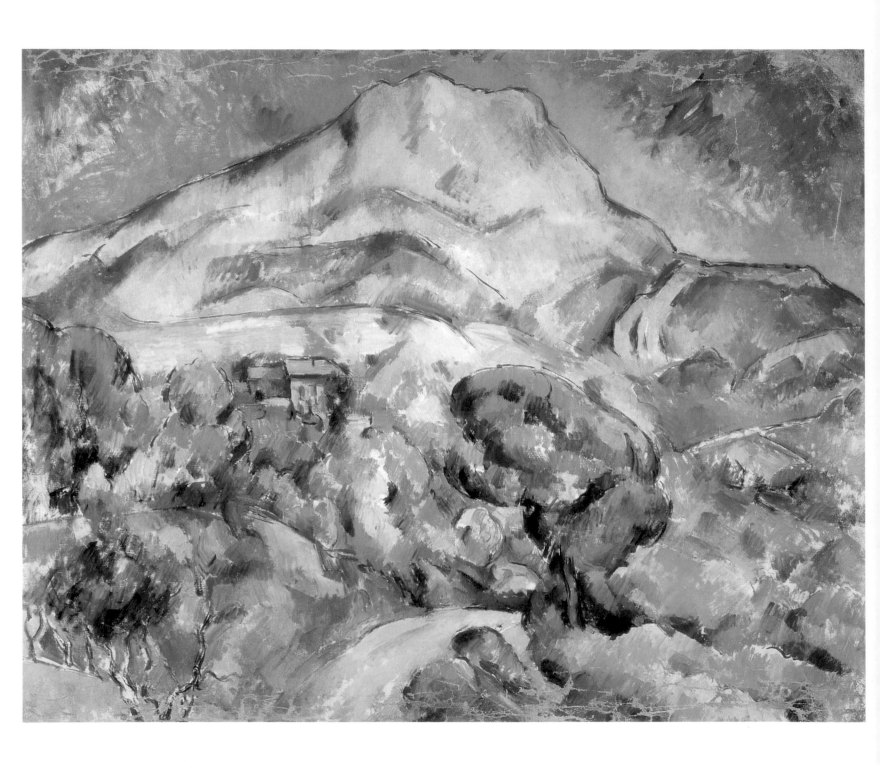

PAUL CÉZANNE (1839-1906)

*P*aul Cézanne is considered an artist of the Post-Impressionism era, although he was a contemporary and friend of the Impressionists. Those contemporaries rightfully counted him among the Impressionists – Cézanne had exhibited with the Impressionists at the first 1874 exhibition, consequently, even the critic Leroy branded him, as he did the others, with this label. While working alongside Monet, Renoir and Pissarro, who were his friends all his life, Cézanne appraised their painting critically and followed his own, independent path. The Impressionists' aspiration to copy nature objectively did not satisfy him. "One must think", he said, 'the eye is not enough, thinking is also necessary".[5] Cézanne's own system of painting was born in a dispute with Impressionism.

Paul Cézanne was born on January 19, 1839, in the city of Aix-en-Provence, where his father had founded a bank. At the Age of thirteen, his father sent him to boarding school at Bourbon College, where Paul studied for six years.

These years would have been rather unhappy had he not made friends at the College. A boy from a poor family, Émile Zola, the dynamic excellent student Jean-Baptiste Baille and the shy Paul Cézanne became an inseparable trio.

In Aix there was also a free drawing school, where Cézanne began to busy himself in the evenings from 1858 on. But, his father had linked his son's future with the bank; however, Paul rebelled against it from the very beginning.

In 1859, Cézanne's father bought an estate near Aix. Jas de Bouffan, which in the Provencal dialect means, "Home of the Winds" was situated on a small rise and had vineyards. At the time of Louis XIV, it had been the palace of the Provence governor. The living rooms of the ancient house were repaired and Paul installed a studio upstairs. He came to love this place and often painted the deserted park, the lane of old nut trees and the pool with the stone dolphins. In his letters, Zola persistently demonstrated his faith in his friend's talent as an artist and invited his friend to Paris: "You must satisfy your father by studying law as assiduously as possible. But you must also work seriously on drawing."[6] Paul's father was obstinate, but, finally, he gave in, not having lost hope that his son would change his mind. Paul was able to abandon law and leave for Paris to take up painting. Finally, in 1861, Paul's father himself took the future artist to Paris and promised to send him 250 francs every month.

In the novel *L'Œuvre*, Zola endows his hero with the young Cézanne's appearance such as it was when he showed up in Paris: "A skinny boy, with knobbly joints, a stubborn spirit and a bearded face…"[7] This is how Cézanne also appears in the self-portraits of his Parisian youth: a beard, which covered the lower part of his face, forcefully sculpted cheekbones, and a serious, sharp stare.

Paris life did not spoil Cézanne. The joy of meeting with Zola, their first excursions together to the museums, and walks around the city and its suburbs gave way to the harsh regimen of work. Most of all, Cézanne went to the Swiss Academy on the Ile de la Cité.

14. **Vincent van Gogh**, *Torso of a Woman (Plaster Statue)*, 1886. Oil on canvas, 41 x 32.5 cm. Van Gogh Museum, Amsterdam.

15. **Paul Cézanne**, *Mont Sainte-Victoire*, 1896-1898. Oil on canvas, 78 x 99 cm. The State Hermitage Museum, St. Petersburg.

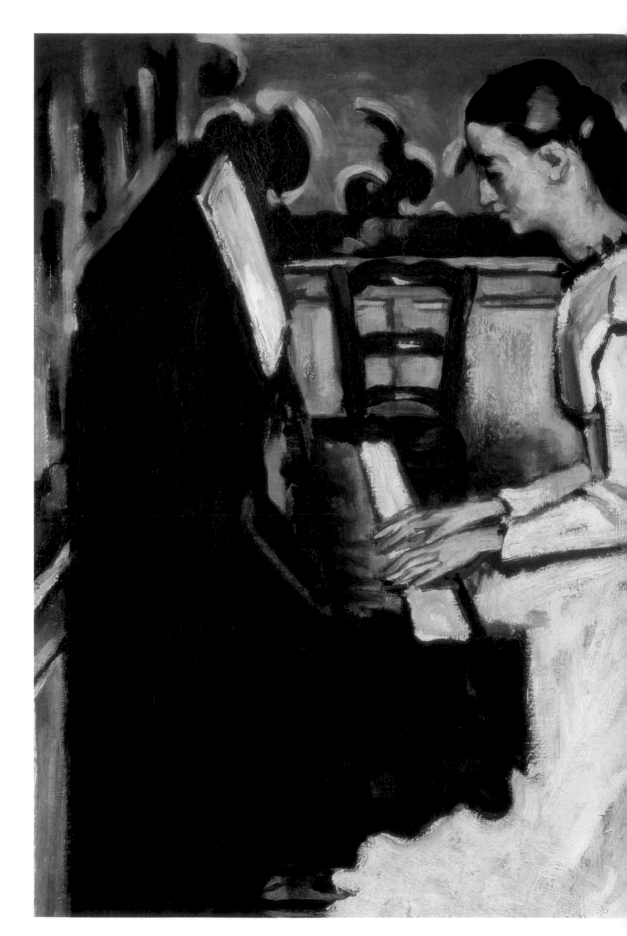

16. **Paul Cézanne**, *Girl at the Piano
 (The Ouverture to Tannhäuser)*,
 1868.
 Oil on canvas, 57.8 x 92.5 cm.
 The State Hermitage Museum,
 St. Petersburg.

17. **Paul Cézanne**, *Achille Emperaire*,
 c. 1868-1870.
 Oil on canvas, 200 x 120 cm.
 Musée d'Orsay, Paris.

18. **Paul Cézanne**, *Portrait of Louis
 Auguste Cézanne, the Artist's Father*,
 1866.
 Oil on canvas, 198.5 x 119.3 cm.
 National Gallery of Art,
 Washington, D. C.

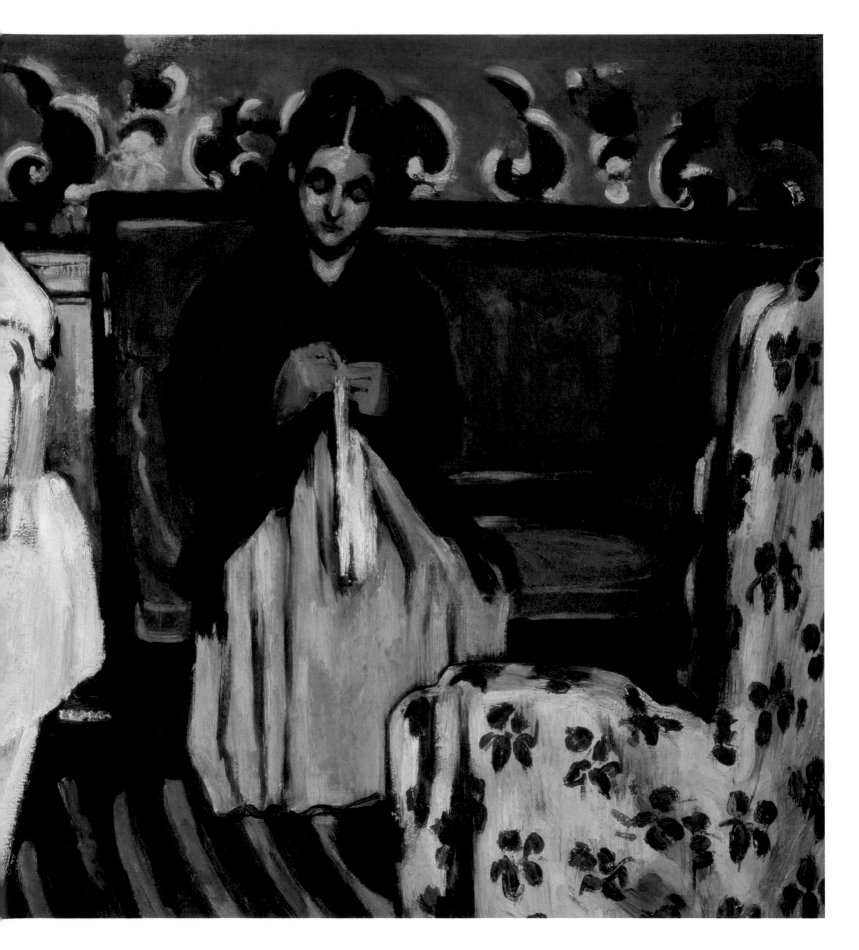

But he missed Aix, its valleys and the Mont Sainte-Victoire, and the friends he left behind. Paris disappointed him. But chiefly, he was constantly dissatisfied with himself.

Cézanne found many friends at the Swiss Academy and friends they remained.

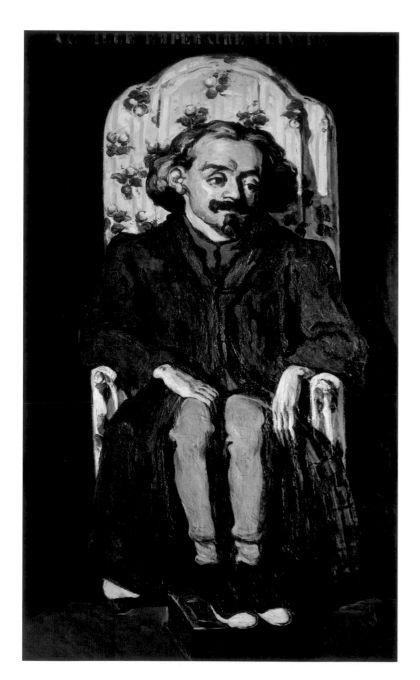

Pissarro immediately appreciated Cézanne's boldness and ingenuity. Very likely, Armand Guillaumin, who later exhibited with the Impressionists, introduced them. Then Pissarro brought Cézanne to his friends – Monet, Renoir, Sisley and Bazille. In that same 1866, Cézanne became acquainted with Édouard Manet – through the mediation of mutual acquaintances, he obtained permission to visit Manet's studio. After his visit, the master himself arrived at Guillaumin's studio to see Paul's still lives that were there. Cézanne always sensed the distance that separated him, a provincial painter just starting out, from the elegant, worldly Parisian, Manet. However, by virtue of his stubborn, cocky nature, he flaunted his own coarse provincialism.

Cézanne, like all artists, wanted to show his paintings, and this meant exhibiting at the Salon. He carried his canvases on a hand truck and impatiently awaited the jury's decision, although he understood that his painting could not be accepted.

Cézanne only succeeded in showing his canvases to the public for the first time at the first exhibition of Impressionists in 1874.

Cézanne's painting constantly surprised not only the jury, but also those artists who regarded him kindly. Once, when he was working 'en plein air', the landscape painter, Charles-François D'Aubigny, who lived in Auvers, saw him. However, it was not within his power to win over the jury.

When Cézanne was painting with his friends – the Impressionists – the difference between their works was striking. The motifs of his landscapes are those same banks of the Seine which Claude Monet, Sisley and Pissarro painted. Monet fragmented the colours of the trees and their reflections in the water into a multitude of minute flecks of pure colour, achieving impressions of movement and his colours radiated the sunlight. Cézanne, on the contrary, selected a single, conventional, sufficiently dark greenish blue with which he painted both the water and the bank of the Marne. He needed colour only to extrapolate volume. The effect proved to be directly the opposite of the impressionistic: the smooth river was absolutely still and not a single leaf fluttered on the trees, which stood out on the canvas like dense rounded masses.

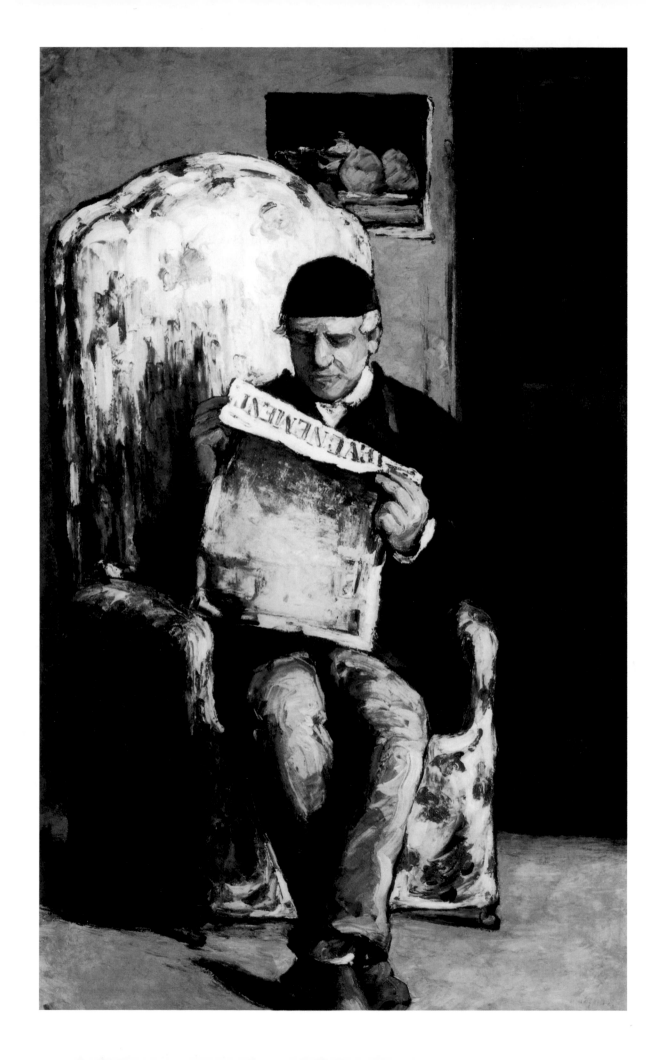

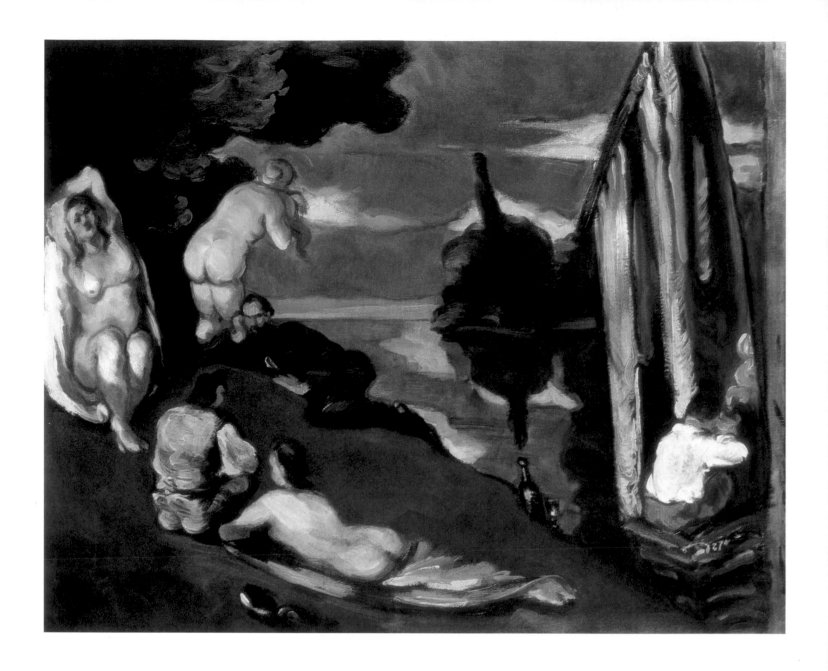

19. **Paul Cézanne**, *Pastoral (Idyll)*,
 1870.
 Oil on canvas, 65 x 81 cm.
 Musée d'Orsay, Paris.

However, it was impossible to reproach Cézanne for negligence with 'plein air' – he had been working and shaping his art along with the Impressionists. The same as they, he even imparted huge significance to the observation of nature.

Cézanne thought that one of the most difficult tasks for an artist was to know how to see in nature what an ordinary, unsophisticated observer was in no condition to see, not only the object itself, but the environment almost imperceptible by the human eye.

Indeed, in Cézanne's opinion, the painter is supposed to catch in the life around him not a momentary transient impression; its theme is nature eternal and unchanging, such as it was created by God.

This constitutes Cézanne's second thesis. The rough nature of the Impressionists' pictures was unsuitable for the resolution of this task. Their composition did not seem to have been thought out earlier, and they bore in themselves the reflection of that very same chance of impression to which they aspired.

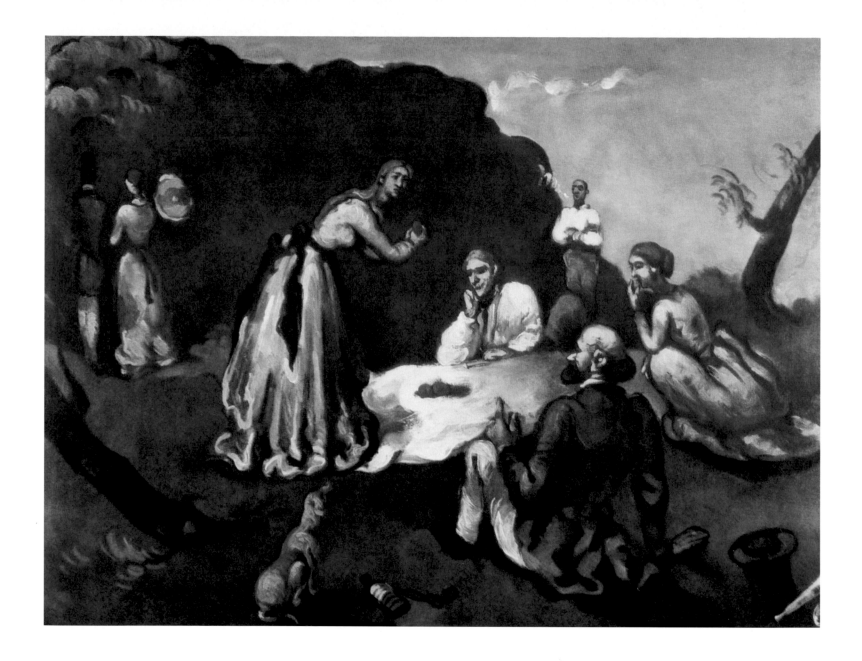

Cézanne constructed all of his own canvases, whether a landscape, a still life or a figurative picture, according to the rules of classical composition. Any fragment of nature was for Cézanne the embodiment of the world's eternity, the most intimate motif became a cause for the creation of a monumental painting.

His *Great Pine near Aix* (p. 53), the favourite pine tree of his happy childhood, shows an impressionistic joy of life. The floating, blurred splotches of colour in the background create a sensation of heated air. However, the picture was constructed according to a strict geometric scheme: the trunk of the pine became the core of the composition, the spreading branches made up its frame. The green of the crown combined with the blue of the sky and the gold of the sunlight embody the colour basis of the world's beauty. Each of Cézanne's landscapes approaches his ideal, according to his own words, "We must become classic again through nature." However, observation of nature, for Cézanne, was only a part of the process for creating a painting. "Imagine Poussin completely reconstructed from nature, that's what I mean by classic," he said.[8]

20. **Paul Cézanne**, *Luncheon on the Grass*, c. 1870-1871. Private collection, Paris.

21. **Paul Cézanne**, *The House of
the Hanged Man*, 1873.
Oil on canvas, 55 x 66 cm.
Musée d'Orsay, Paris.

22. **Paul Cézanne**, *Quartier Four,
Auvers-sur-Oise (Landscape, Auvers)*,
c. 1873.
Oil on canvas, 46.3 x 55.2 cm.
Philadelphia Museum of Art,
Philadelphia.

23. **Paul Cézanne**, *A Modern Olympia*,
c. 1873.
Oil on canvas, 46 x 55.5 cm.
Musée d'Orsay, Paris.

Cézanne often painted outdoors in Provence. Sometimes artist friends called on him, and they worked together. Simultaneously, he worked on sketches in his studio in Jas de Bouffan, not one of which has been preserved. It is possible that Cézanne, who as before had been dissatisfied with himself, destroyed them. His father still hoped that Paul would give up painting, and he threw every obstacle in his way, and Paul was reduced to despair. "I am here with my family," Nonetheless, his father continued to support Paul with money. Paul's mother and sisters, judging by his letters from Aix, modelled for him more than once. In the 1860s, Paul created in Jas de Bouffan one of his best paintings, which was dedicated to Wagner – *Girl at the Piano. (The Ouverture to Tannhäuser)* (p. 26-27).

Cézanne portrayed one of his sisters playing the piano, and his mother, or another sister, sitting on a divan with needlework in her hands. In essence, it would have been possible to ascribe this painting to genre painting; however, there is no development of the subject in it;

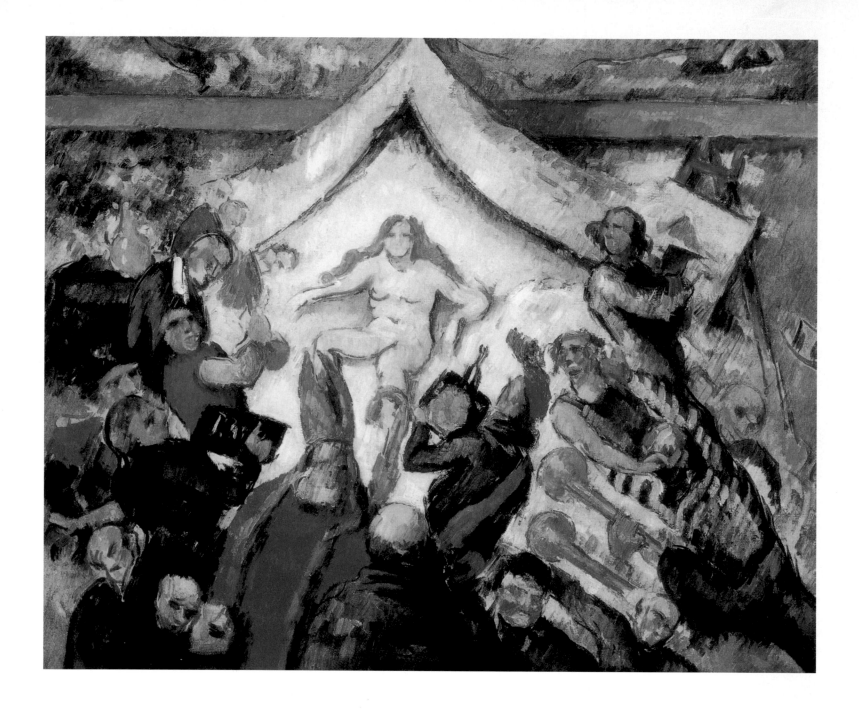

as Édouard Manet, and as all his impressionist friends, Cézanne was against literature in his painting. Cézanne had created a monumental picture based on an everyday motif. The composition had been constructed according to the best classical standards. A specific area of the room was confined from two sides as side scenes: the piano and an armchair in the shape of the letter 'L'. The limit of the divan's back forms a vertical axis in the centre. The figures of the women are at an equal distance from the axis. Movement is completely absent in the picture, the characters are frozen, like mannequins. In the painting of the impressionist Renoir, white clothing vibrated with a multitude of blue, green and rose hues. Cézanne paints his sister's dress with huge strokes of pure whites; colour is completely absent in the grey shadows.

The extrapolation in Cézanne's painting gradually became bolder, the strokes, coarser. Changes of colour were of no interest to him; he was communicating those qualities of the subject that are permanent: volume and form.

24. **Paul Cézanne**, *The Eternal Woman*,
c. 1877.
Oil on canvas, 43 x 53 cm.
Private collection, New York.

25. **Paul Cézanne**, *The Estaque*,
 c. 1878-1879.
 Oil on canvas, 59.5 x 73 cm.
 Musée d'Orsay, Paris.

26. **Paul Cézanne**, *Trees in a Park
(The Jas de Bouffan)*, 1885-1887.
Oil on canvas, 72 x 91 cm.
The Pushkin State Museum of
Fine Arts, Moscow.

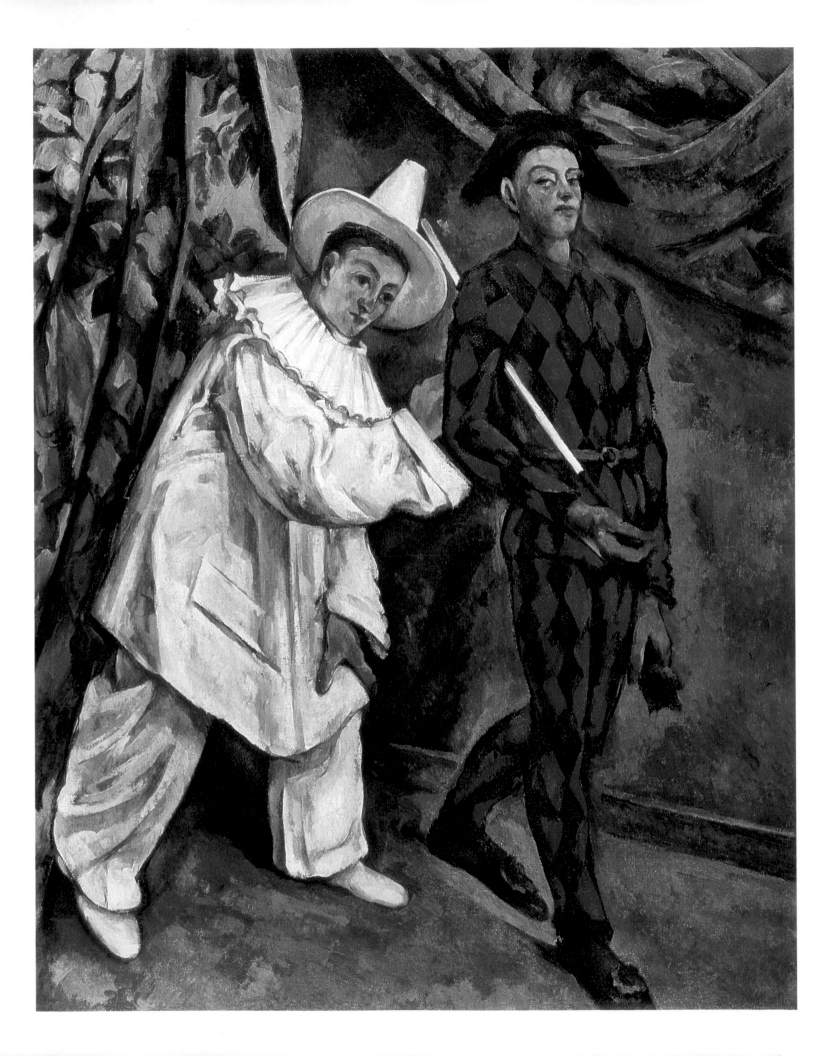

In the middle of the 1860s, Cézanne did a great deal of portraits in Aix. He attempted to paint outdoors the friends of his youth, Antoine Marion and Antonin Valabrègue – who later became an art critic. Dominic, his grandfather sat for Cézanne many times. Playing on his name, Paul portrayed Dominic as a Dominican monk, in a white monk's habit. He painted forcefully, often applying colour with a palette knife, dividing colours with a black outline, exploring different means of expression.

At the same time, the portrait of Louis-Auguste Cézanne, the artist's father, was painted reading the newspaper *L'Évènement*. The figure of his father possesses those characteristic features which make him meaningful. However, reproducing the volume, which mattered to him very much, was provided by a style of painting he had discovered (p. 29).

The portrait of *Achille Emperaire* (p. 28) was also painted in the 1860s. This strange character was also one of Cézanne's close friends. Emperaire was fascinated with art and loved painting. In Paris he and Cézanne walked around the Louvre, admiring Rubens and the Venetians. Cézanne painted Achille's portrait in Aix. He depicted his model in a dressing gown and sat him in the same armchair in which he had painted his father.

At the end of the 1860s, Cézanne was in a state of agonising quests. On the one hand, he was full of respect for the masters of the past, for the classics. At the same time, he was convinced that their way was not suitable for him; outdoors, and only the outdoors, is exactly what an artist of his time needs. His conversation with Pissarro convinced him to a great extent. He states in a letter to Zola, "But, you see! All indoors, studio painting will never match those done outdoors".[9] He painted views of the Aix vicinity, the valley with the aqueduct and Mont Sainte-Victoire, usually from a height, from which they had viewed the landscape during their childhood outings. He once more offered his landscapes, portraits and nudes for the Salon jury's verdict, and once more they did not accept them.

The events of the Paris Commune and the Franco-Prussian War did not find any appreciable reflection in Cézanne's works and life.

Many meaningful events occurred for him during these years of his life. He had very likely met Marie-Hortense Fiquet as early as 1869. The beautiful brunette with a classical face had shown up at Cézanne's studio as a model.

Life with Hortense brought Paul new difficulties; he had to conceal her existence from his father because he was able to deprive Paul of his cash allowance.

Simultaneously, he painted a picture with bathers, *Pastoral (Idyll)* (p. 30), and a harsh, violent composition under the name of *The Murder*. *Magdalene* or *Grief*, suffering,

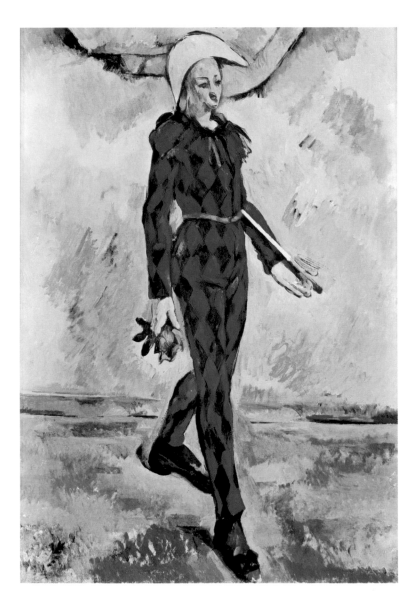

27. **Paul Cézanne**, *Pierrot and Arlequin (Shrove Tuesday)*, 1888-1890.
Oil on canvas, 102 x 81 cm.
The Pushkin State Museum of Fine Arts, Moscow.

28. **Paul Cézanne**, *Harlequin*, c. 1888-1889.
Oil on canvas, 92 x 65 cm.
Rothschild Collection, Cambridge.

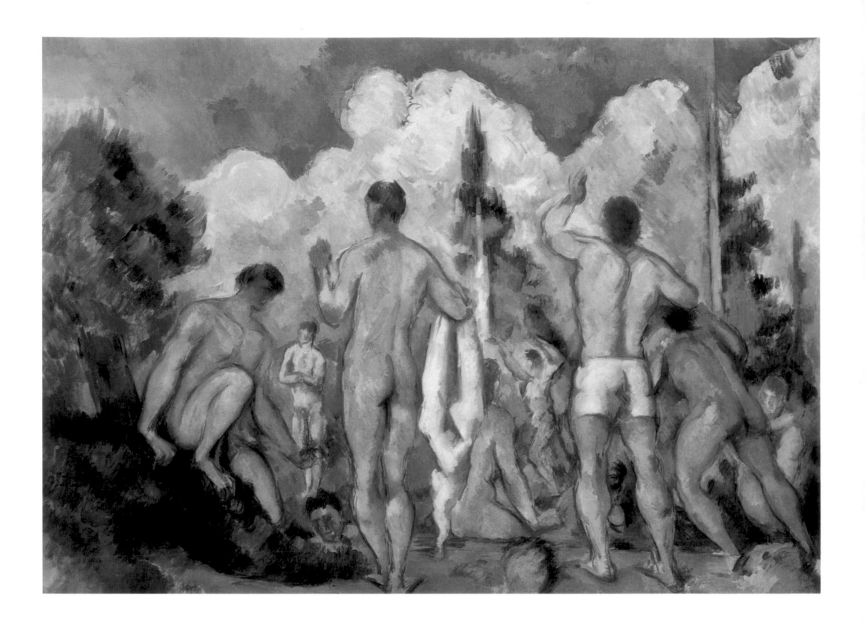

29. **Paul Cézanne**, *Bathers*,
c. 1890-1892.
Oil on canvas, 60 x 82 cm.
Musée d'Orsay, Paris.

30. **Paul Cézanne**, *The Bather*,
c. 1885.
Oil on canvas, 127 x 96.8 cm.
The Museum of Modern Art,
New York.

full of passion and painted in a sharp expressive stroke, belongs to this same series of pictures. These pictures can be called narrative only in relation to the others. They were most likely his reflection on life, an outlet for his own passions and in a way a tribute to Symbolism. *A Modern Olympia* (p. 34) was the conclusion of this cycle.

It is well known that, while discussing Manet's *Olympia*, with a friend of the Impressionists, Doctor Gachet, Cézanne declared, "I can also do something similar to *Olympia*." Gachet replied: "Well, do it." So his canvas could be perceived as a kind of parody of Manet's painting; there are many common components: the black-skinned servant as well as the flowers. It is, however, a protest aimed at the respected master; yet another of Cézanne's arguments in his constant battle against Impressionism and against Manet. In comparison to Manet's cold, elegant, model Victorine Meurent, Cézanne's Olympia, curled into a ball in a ray of dazzling light, embodies a bundle of passions and, very likely, his personal drama. And the artist himself, enveloped in the smoke of a water pipe, contemplates her, like a spectator would the actress on the stage. Nevertheless, it was through the scandal caused by *A Modern Olympia* during the first exhibition of the Impressionists that Cézanne first became famous.

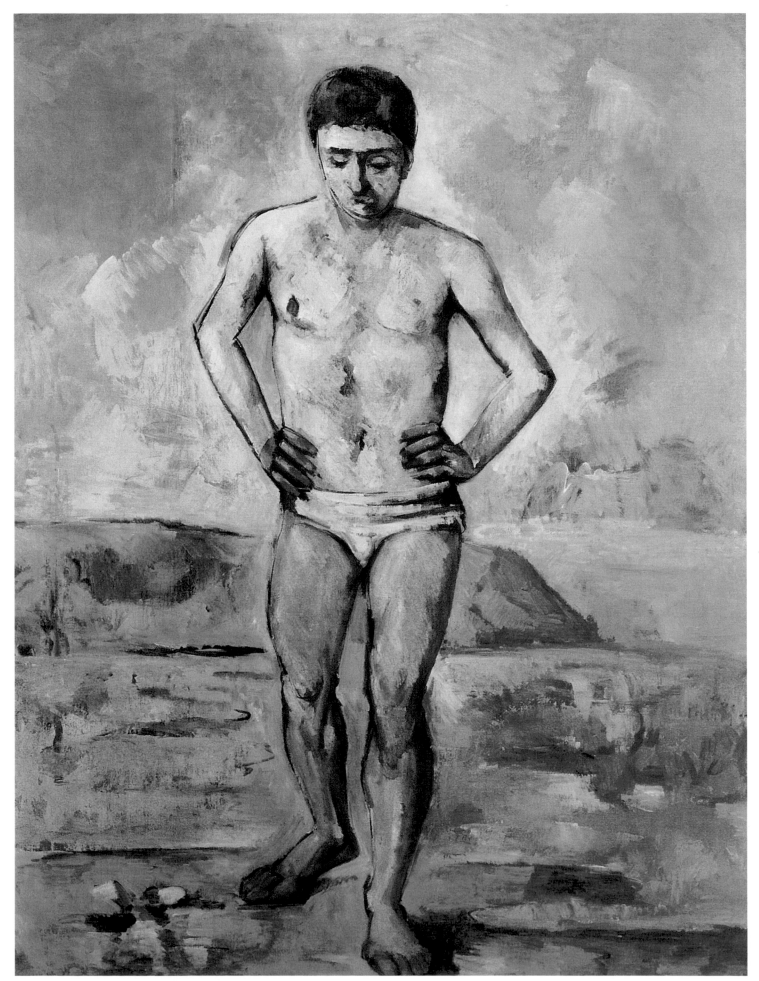

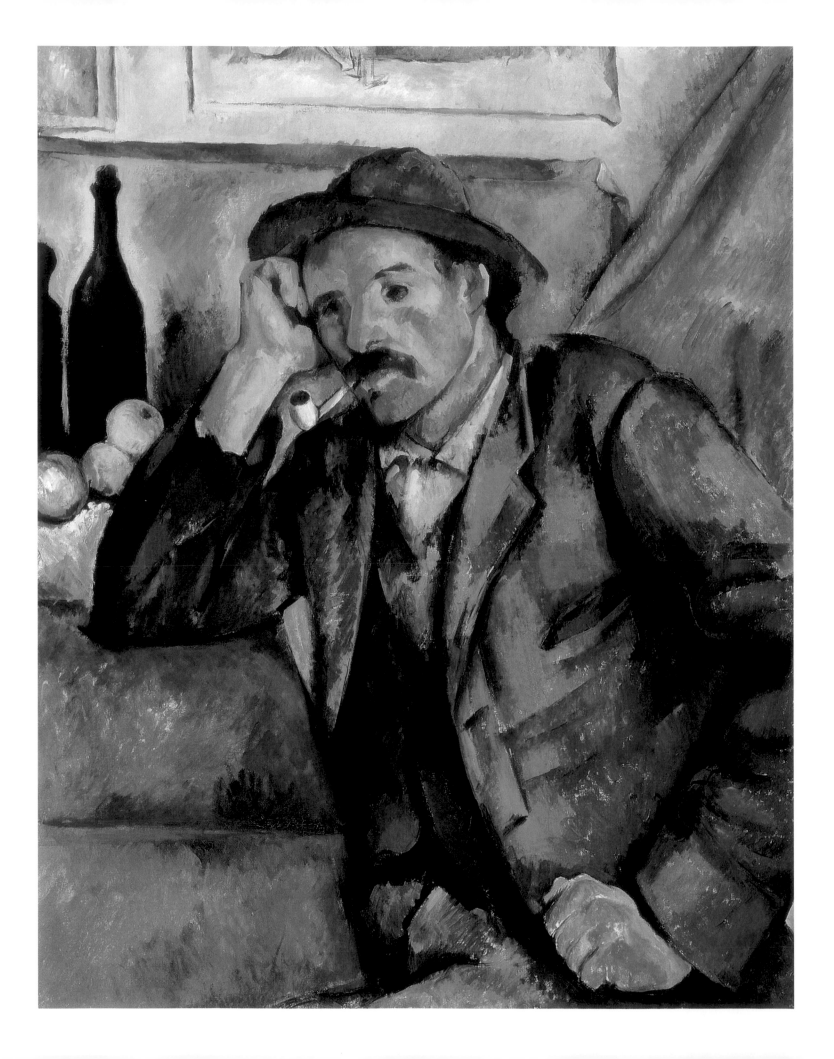

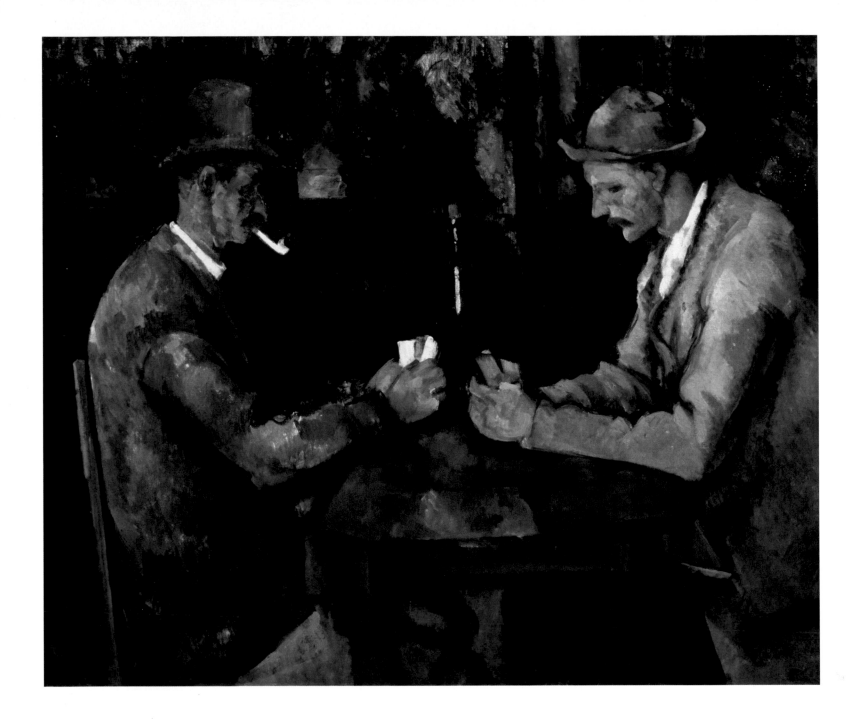

He displayed there a number of canvases, but one of the most important critics of that time wrote that it was impossible to imagine a jury that would agree to accept Cézanne's works. A comparatively liberal female journalist, hiding behind the pseudonym Marc de Montifaud, called *A Modern Olympia* the work of a mad man suffering from delirium tremens; a picture in which "a nightmare is represented as a sensual vision." The opinions on Cézanne's painting did not seem so awful against the overall background of criticism. The exhibition brought gratification, too; the collector Count Doria bought a landscape entitled *The House of the Hanged Man* (p. 32), which was called an "appalling daub" in Leroy's celebrated article.

However, after all these insults and derision, Cézanne retreated to Aix leaving Hortense and her son, the young Paul, who was born in 1872, in Paris.

31. **Paul Cézanne**, *The Smoker*,
1890-1892.
Oil on canvas, 92.5 x 73.5 cm.
The State Hermitage Museum,
St. Petersburg.

32. **Paul Cézanne**, *The Card Players*,
c. 1890-1895.
Oil on canvas, 47.5 x 57 cm.
Musée d'Orsay, Paris.

During the third exhibition of the Impressionists in 1877, Cézanne was honoured with special attention of the *Charivari* critic Louis Leroy, who singled him out as the target of his most subtle insults. Paul exhibited canvases typical of the genres he preferred at that time: landscapes, portraits, some still lifes and bathers. Toward the end of the 1870s, bathers became the symbol of his figurative compositions. Cézanne's work featured less and less narrative pictures, preferring more and more objects and motifs.

At the end of the 1870s and the beginning of the 1880s, Cézanne lived much of the time in Paris and worked in the area, in Melun or Médan-sur-Seine, at Zola's. Thus he sometimes painted the banks of the Oise, the Auvers or the Pontoise where Pissarro lived. He could be sometimes seen in Normandy. Needless to say Cézanne regularly returned to his native Provence, as he was too attached to his roots. His principal difficulty at this time was his relationship with his family and the need to hide from his father the existence of his son and Hortense whom he could not resolve to marry. Despite all his contrivances, his father eventually found out about the grandchild's existence.

The year 1886 was an extraordinary one in Cézanne's life. The publication of Zola's *L'Œuvre* was a shock to all the artists of the Impressionists' circle.

The publication of *L'Œuvre* meant for Cézanne the end of a lifelong friendship with Zola. The character of Claude Lantier in *L'Œuvre* a failure who did not succeed in realising his ambitions, deeply annoyed him. On April 4, 1886, Cézanne wrote to Zola to thank him for the book, which he had not yet had the time to read. This was the last letter they sent each other. Zola's novel was one of the reasons for Cézanne's fleeing Paris. He was afraid that all his acquaintances would see in him the hero of *L'Œuvre*.

On the other hand, the problems of Cézanne's family life solved themselves one after the other that year. In the spring of 1886, on the advice of his mother and sister Marie, Cézanne officially married Hortense at the Aix town hall. His son, Paul, was fourteen years old, and the matrimonial relations between him and Hortense were, in fact, dead. In October, at the age of eighty-eight, Louis-Auguste Cézanne died, and Paul inherited from him nearly 400,000 francs. The artist was thus able to settle all his debts and no longer needed to worry about his livelihood. Painting remained the only thing in his life.

Cézanne henceforth worked most of his time in Aix, rarely going to Paris. He refused to be exhibited, even with the Independents, where there was no jury. Gradually his circle of contacts became extremely narrow, the Paris of the arts almost forgot the strange Provençal.

In 1895, the art dealer Ambroise Vollard, recently established in Paris, decided on a risky experiment: he resolved to organise an exhibition of Cézanne's works in his gallery at 39, rue Lafitte. Cézanne agreed to the exhibition and sent Vollard nearly 150 rolled pictures from Aix. They were paintings from all the periods of his work. The large number of works was an expression of his appreciation for the recognition that he no longer expected from his contemporaries. Cézanne was right to trust Vollard although the task was difficult for the latter. For the first time the Vollard exhibition allowed Cézanne to demonstrate the path along which he had travelled and the results he had achieved. The Impressionists rejoiced. Camille Pissarro wrote to his son Lucien: "My admiration is nothing compared to Renoir's

33. **Paul Cézanne**, *Woman with a Coffee Pot*, c. 1890-1895.
Oil on canvas, 130.5 x 96.5 cm.
Musée d'Orsay, Paris.

34. **Paul Cézanne**, *Portrait of Ambroise Vollard*, 1899.
Oil on canvas, 100 x 81 cm.
Petit Palais – Musée des Beaux-Arts de la Ville de Paris, Paris.

35. **Paul Cézanne**, *Woman in Blue*, 1898-1899.
Oil on canvas, 88.5 x 72 cm.
The State Hermitage Museum, St. Petersburg.

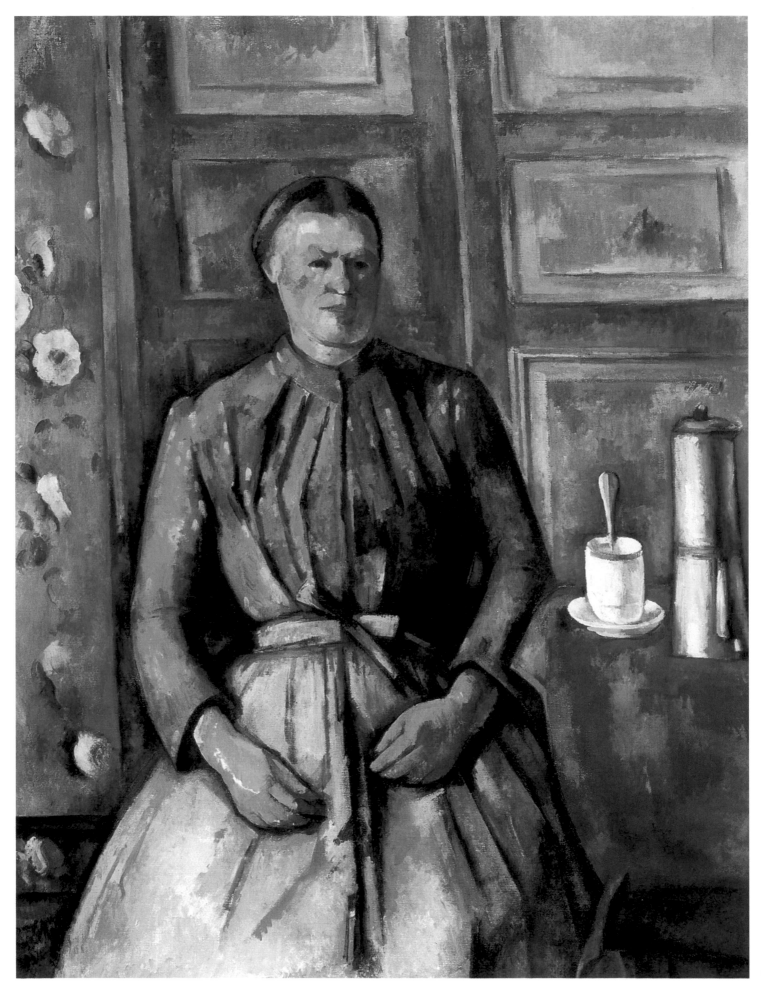

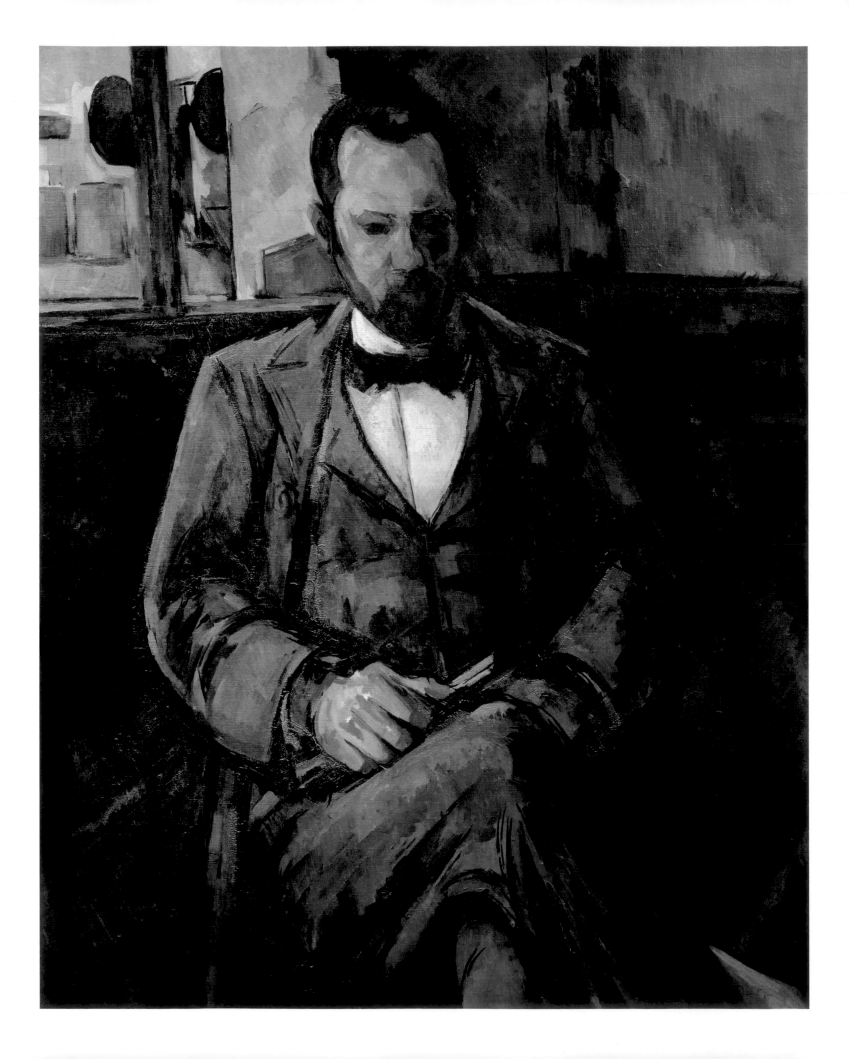

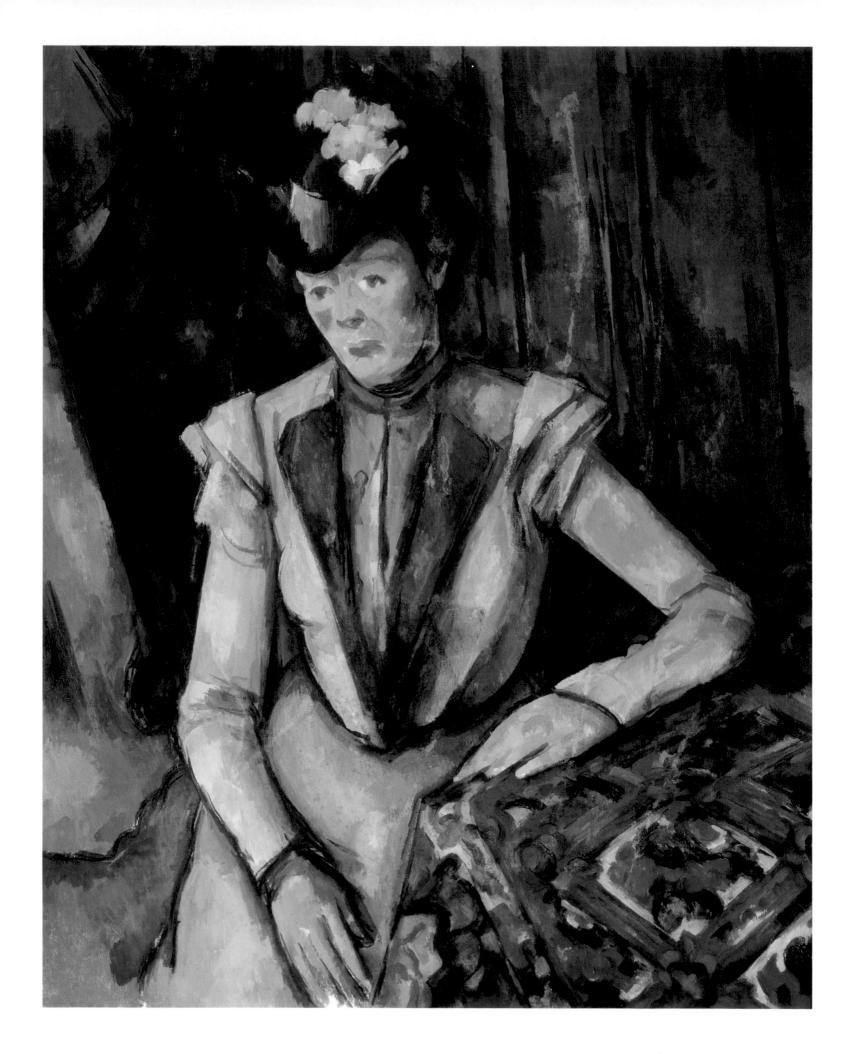

36. **Paul Cézanne**, *Apples and Oranges*,
 c. 1895-1900.
 Oil on canvas, 74 x 93 cm.
 Musée d'Orsay, Paris.

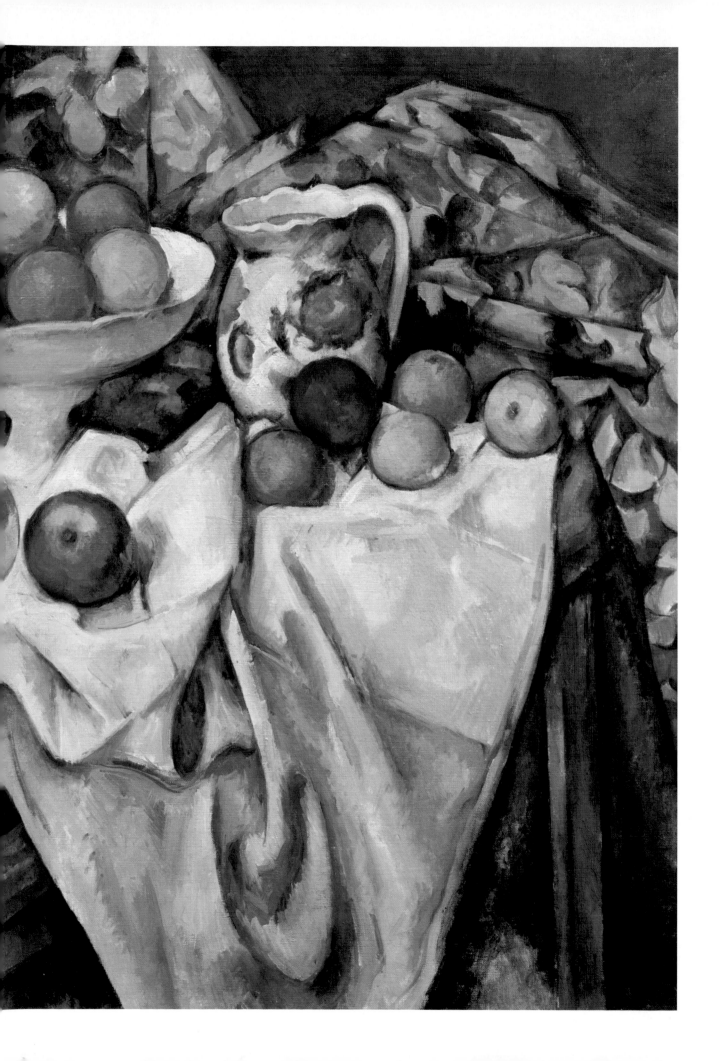

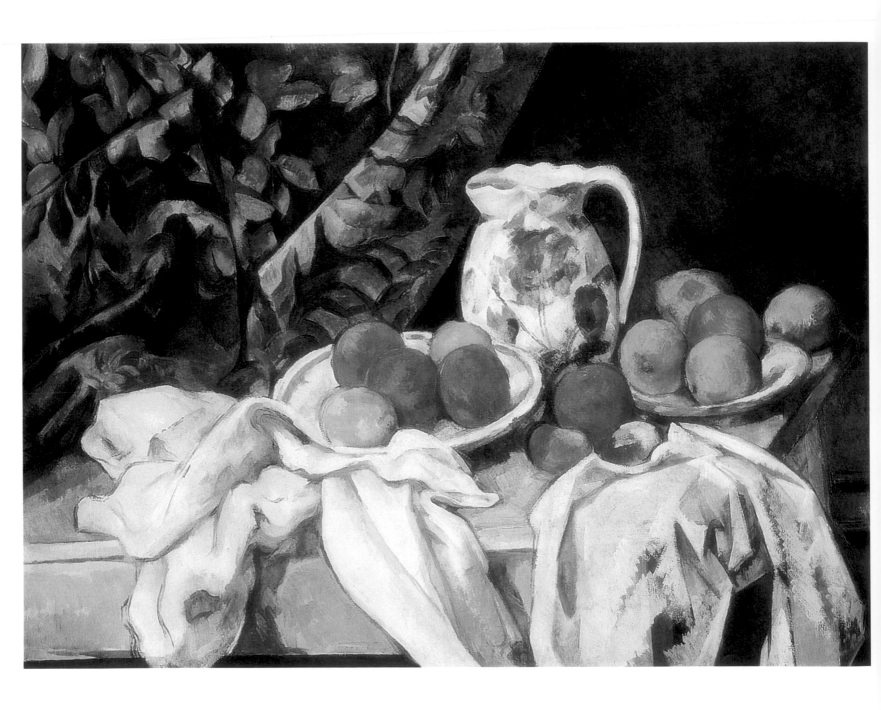

delight. Even Degas fell under the spell of this refined barbarian. Monet too, and all of us… really, could we have been mistaken? I don't think so."[10] The critics, on the whole, were horrified. However, the editor of the magazine *Revue blanche*, Thadée Nathanson, wrote that Cézanne was an original and obstinate creator. The critic appreciated the fact that Cézanne concentrated on one single aim and that he knowingly pursued it. He said, shortly before his death: "I wanted to make of Impressionism something solid and lasting like the art found in museums."[11]

Cézanne demonstrated the conversion of Impressionism into "something solid and lasting" most of all in his landscapes. It seemed that he was not able to admire nature directly and could not experience the full vibration of colours. He had to organise it and construct his own landscape. He felt like an architect of nature. His affection for nature was completely natural and immutable. When he lived in Provence, he used the motif every day, like an obligation.

When he lived near the Mediterranean, he created yet another type of landscape. While working on a landscape at the seashore, in L'Estaque, he wrote Pissarro: "It is like a playing card. Red roofs on a blue sea… There are motifs which would require three or four months of work, could one find it, for there the vegetation never changes. There are olive trees and pines which never lose their leaves."[12] The result is a canvas made up of several touches of well defined colours which represent the quintessence of the south: the blue sea, red roofs and the green trees.

He also often painted his favourite mountain, Mont Sainte-Victoire, from a high viewpoint. The valley spreads out at his feet, sprinkled with squares and circles representing houses and trees. The mountain's cone encloses the picture. He removed everything unnecessary from the landscape, using only clear geometric forms to compose it. Nevertheless nature does not lose its poetic aspect that Cézanne had already felt in his childhood.

Cézanne had progressed all his life toward this geometric simplicity, but he expressed it in words for the first time only two years before his death. During his visit to Aix in 1904, Émile Bernard recalled that Cézanne complained of the modern school of painting, declaring: "One should first study the geometric forms: the cone, the cube, the cylinder, and the sphere."[13]

Cézanne never painted spheres, cones and cylinders; he preferred oranges, apples, peaches or onions. Still life was for him the ideal genre: fruit and objects were patient, and they did not change. It was possible to paint them for a long time, for days, weeks and even months.

In Cézanne's portraits expression gave way more often than not to normalised forms, subject to the laws of geometry. Brush strokes emphasised the roundness of his own head in his self-portraits or in the classical face of his wife. Those close to Cézanne said that Hortense was the perfect Cézanne model – very patient, she endured a multitude of sittings. And Cézanne painted her many times, never trying to find a new interesting angle, but improving his ability to build a form with the help of pure colour. In the last years of his life, Cézanne often painted one of his neighbours – a farmer or his gardener. It is difficult to call their pictures portraits. Cézanne had his model sit in a comfortable, steady pose and set

37. **Paul Cézanne**, *Still Life with Curtain*, 1895.
Oil on canvas, 55 x 74.5 cm.
The State Hermitage Museum,
St. Petersburg.

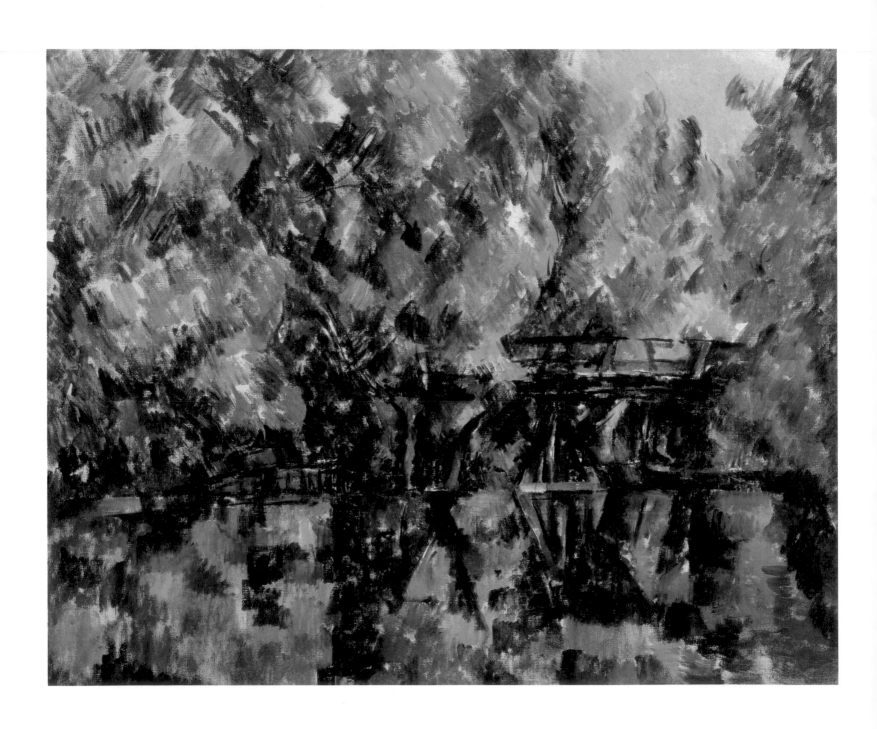

38. **Paul Cézanne**, *The Bridge*,
1888-1890.
Oil on canvas.
The Pushkin State Museum of
Fine Arts, Moscow.

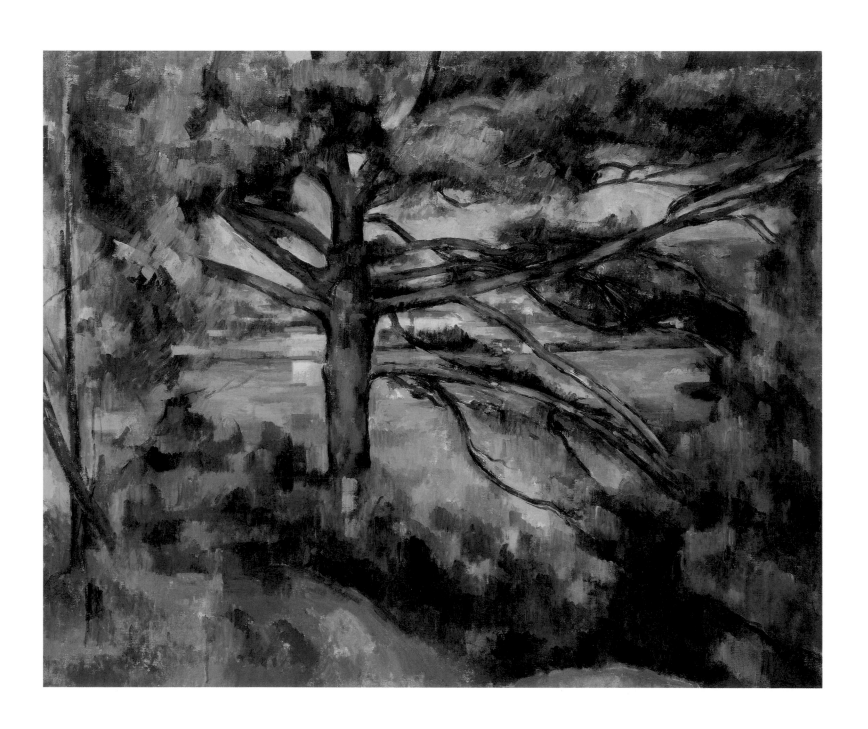

39. **Paul Cézanne**, *Great Pine near Aix*,
1895-1897.
Oil on canvas, 72 x 91 cm.
The State Hermitage Museum,
St. Petersburg.

40. **Paul Cézanne**, *Lac d'Annecy*,
 1896.
 Oil on canvas, 65 x 81 cm.
 Samuel Courtauld Trust, Courtauld
 Institute of Art Gallery, London.

about arranging colours to form the torso, hands and head. Human figure became a sort of still life; they were motionless, like objects.

After the expressive compositions of 1869, pictures appeared which were devoid of both subject and emotion. In *Pierrot and Harlequin (Shrove Tuesday)* (p. 38) he depicted the characters of the Commedia dell'Arte, reminiscent of eighteenth century dandies and the paintings of Watteau. Contemporaries said that Paul Cézanne the younger had posed for Harlequin, and one of his friends for Pierrot.

After his experience of Impressionism, Cézanne was unable to work without colour. Colour is the basis of everything in his compositions, both the construction of the picture and the shape of the subject. Numerous canvases with bathers allowed Cézanne to experiment with the classical composition of naked models. *The Card Players* (p.43) represents an ideally balanced, almost symmetrical composition in which the human figures become objects like the bottle standing on the table. The precise and well-organized system upon which Cézanne based his paintings shocked people after the seemingly disorganised Impressionism. And it was just this system which allowed the next generation of artists to learn a good deal from Cézanne's paintings which they discovered during the exhibition of 1906.

Among all the people Cézanne met at the beginning of the twentieth century were two Nabis artists: the theoretician of this group, Maurice Denis, and his friend, Ker Xavier Roussel. During a trip to Provence they visited Cézanne in Aix. Another young artist, Charles Camoin, also called on Cézanne. It was with these young artists of the future that Cézanne became aware of the role he played in painting and he tried to understand the animosity of his contemporaries.

He wrote to one of his young friends: "I am perhaps before my time. I was the painter of your generation, more than of mine."[14] There was not much time left to demonstrate the truth of this. During the 1906 Spring Salon, in the part where nobody in principle was part of the official exhibition, an exhibition of the recluse from Aix was already being prepared.

Cézanne, meanwhile, had been continuing to work with his former perseverance. The letters of his last autumn reflect the drama of the artist's life. He wrote to Bernard on September 21, 1906. "…I am old and sick, and I have sworn to die painting rather than sink into shameful decrepitude, which threatens the old who let themselves be dominated by soul-destroying passions."[15]

Cézanne wrote on October 15, 1906: "Dear Paul, it rained Saturday and Sunday, there were storms and the weather has cooled. It is no longer hot at all… It is still difficult to work, but at last, there is some relief."[16] On that day, Cézanne, as always, got up early to go and paint his favourite motif – Mont Sainte-Victoire. He refused to take a coach and carried all his equipment himself. When a thunderstorm struck, he continued to paint, hoping that the weather would improve. Soaked and tired, he collapsed on the way home. A coachman picked up Cézanne and took him from a laundry to his home. Over the next few days he tried to work, although his health was deteriorating. Cézanne died on October 22, 1906, from pneumonia, failing to live long enough to see the opening of his triumphal exhibition at the Salon d'Automne. Some of Cézanne's biographers said that it was his favourite mountain that killed him.

41. **Paul Cézanne**, *The Château noir*, 1903-1904.
Oil on canvas, 73.6 x 93.2 cm.
The Museum of Modern Art, New York.

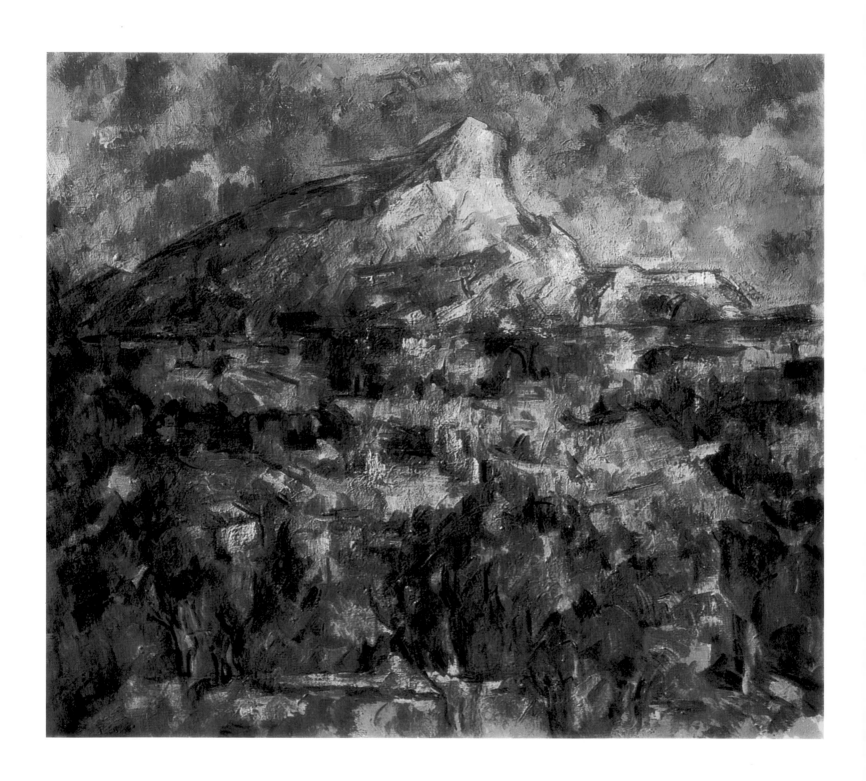

42. **Paul Cézanne**, *Landscape at Aix
(Mont Sainte-Victoire)*, 1905.
Oil on canvas.
The Pushkin State Museum of
Fine Arts, Moscow.

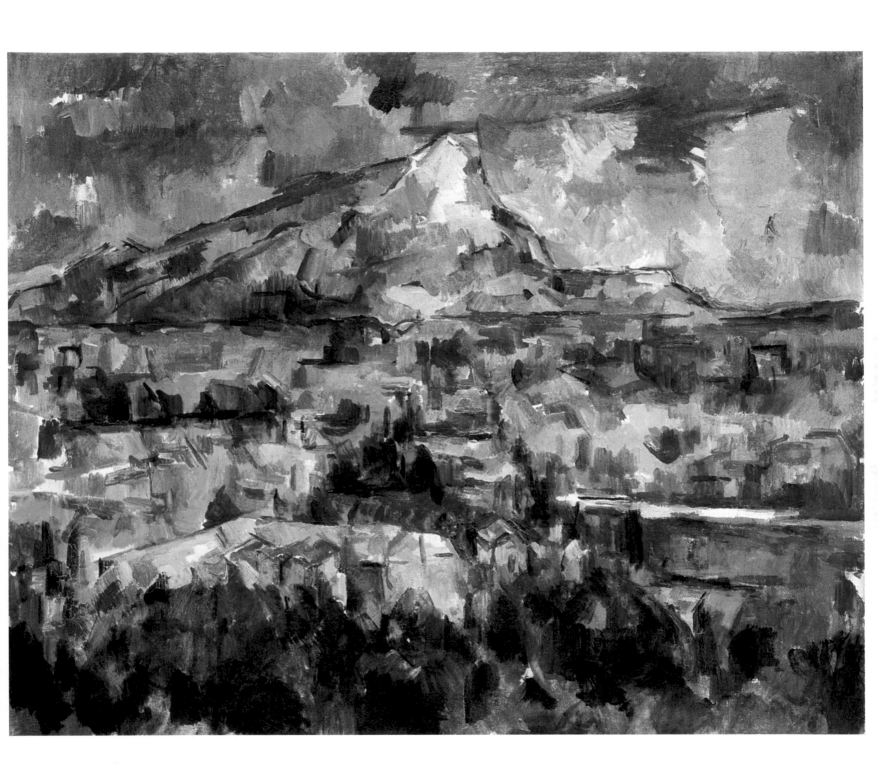

43. **Paul Cézanne**, *Mont Sainte-Victoire*,
1902-1904.
Oil on canvas, 73 x 91.9 cm.
Philadelphia Museum of Art,
Philadelphia.

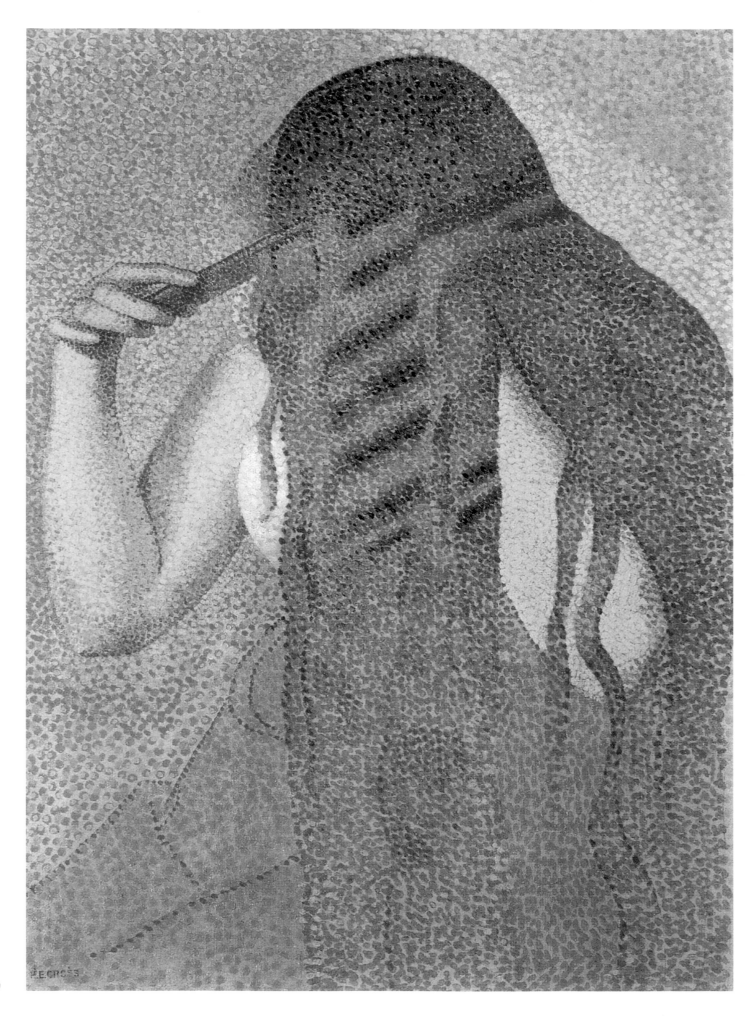

NEO-IMPRESSIONISM

A strange painting appeared at the last Impressionist exhibition in 1886. Its motif was purely impressionistic: Parisians spending a leisurely Sunday on the island La Grande Jatte. The similarity with Impressionism, however, ended there. Contrary to the small size of Impressionist canvases, the painting was huge; it took the whole wall in the last show room. At a time when Renoir's compositions were filled with motion and gayety, forty personages of *A Sunday on La Grande Jatte* (p. 64–65) looked like mannequins. Life appeared to come to a standstill with a wave of a wand. But the strangest thing about the painting was the manner in which it had been painted. Instead of dynamic spontaneous impressionistic strokes laid in different directions, these painting contained clear strokes of the same shape and size, which had been laid next to each other. On canvas they made a sort of decorative mosaic. The author of the painting was Georges Seurat.

The *Grande Jatte* puzzled fans of classic art as well those who had managed to get used to the style of Impressionists. Seurat was criticised like the Impressionists when they first exhibited. One critic called him a cold-blooded mystifier; another implied that he was passing himself off as an impressionist. Seurat presented his painting at the exhibition of Impressionists, though it obviously had nothing in common with Impressionism, even contradicting it. Spontaneity and arbitrariness, the main working principles of the Impressionists, were replaced with order and a system. Twelve years after the Impressionists' exhibition, this once again outraged the public.

Georges Seurat was born on December 2, 1859 in Paris. At fifteen he studied drawing at the municipal school, and in 1878 he entered the Fine Arts School in the studio of one of Ingres' followers, the painter Lehmann. It was around this time that he became interested in colour theory. Like many of his contemporaries, Georges Seurat was influenced by Impressionism. For him, however, using scientific achievements in art was acceptable. He pushed professionalism in drawing to perfection, concurrently reading essays by a famous chemist Chevreul *The Law of Simultaneous Contrast of Colours* and a scientific paper by the American physicist O.N. Rood *Theory of Colours*. In 1884, the Salon jury rejected his painting *Bathers at Asnières* (p. 63). That same year Seurat exhibited it at the Salon des Indépendants, an organisation in which he was actively involved. At a meeting of the Indépendants in the spring of 1884, Seurat met Signac.

Paul Signac was born in Paris on November 11, 1863 and spent his childhood in the district of the Boulevard de Clichy. He began as a literary critic and writer, but at eighteen devoted himself to painting. Unlike Seurat, Signac admired academic professionalism, yet he did not attend the École des Beaux-Arts. He also spent some months at the studio of the artist Émile Bin; later he switched to open-air painting like the Impressionists.

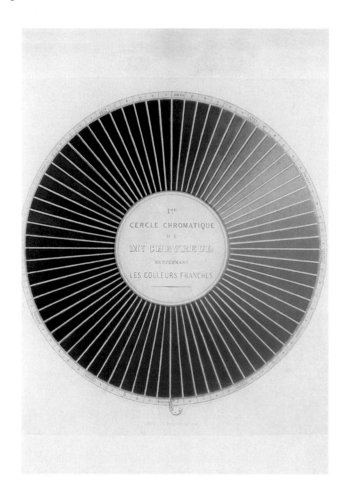

44. **Henri-Edmond Cross**, *Hair*, c. 1892.
Oil on canvas, 61 x 46 cm.
Musée d'Orsay, Paris.

45. First chromatic circle of Mr Chevreul.

Like Claude Monet before him, Signac purchased a small boat in 1883, which he used to sail the Seine near Asnières. He called his boat "Monet – Zola – Wagner" – a tribute to the idols of the Post-Impressionistic period. He even wrote Claude Monet and received and invitation to Giverny. However, they parted icily.

A meeting with Pissarro at Armand Guillaumin's studio in 1885 turned out significantly more important to him. Indeed, Pissarro, after his son, tried working in the style. Pissarro, however, did not long remain an adept of Seurat. In 1888 he expressed doubts to Signac: "Let's be careful. It's dangerous. It's not a question of technique or science. It's about our tradition; it must be safeguarded."[17] Pissarro soon after broke away from the new method, which he said provoked a sensation of lifeless monotony.

The method of painting invented by Georges Seurat achieved its aim, i.e., extending Impressionism on a new foundation. In the late nineteenth century certain scientists had become interested in managing colour. The most prominent one among them was the French chemist Chevreul, whose work Seurat had already discovered on his own. His meeting with Signac helped each of them understand that intuition had to be replaced with laws governing colour.

Using Chevreul and Roods' theories, Seurat constructed his "chromatic circle". Seurat placed the primary and complementary colours of the spectrum in the shape of a circle. Each colour became gradually lighter from the centre to the outside, becoming a white ring, which completed the circle. Thus, the circle not only enabled the representation of all colours but also all tones and halftones. According to the law of contrast, each colour reaches its maximum intensity when close to its complementary colour.

On the chromatic circle the complementary colour is then the colour located directly across from the primary colour. Seurat used his circle to attain the brightness and luminosity of the palette, of which the Impressionists had nearly achieved.

As of the first half of 1884, the artist regularly executed sketches on the Seine, in the park on the island of the Grande Jatte, a little down river from Paris. On small tablets he painted fragments of landscapes, bathers, fishermen and couples strolling. Outdoors his artistic method was purely impressionistic. He worked quickly, trying to render the effects of light precisely, applying strokes of various shapes on wood, forcing himself to use only pure colours. These studies were his work material; he brought them to his studio. Each open-air motif was integrated into a new canvas.

There was no room in his work for the impressionist method, which consisted of creating a painting directly from the observation of nature. Seurat thought that art should be conscious, and that nature had to be observed with the mind's eyes, and not merely one's eyes, because they are but a part of the body.

Once back from the Grande Jatte island the artist stood in his study before the huge canvas holding his chromatic circle. One day Claude Monet commented, "I would like to paint like birds sing"[18] His comment did not apply to Seurat. To his friends who saw poetry in his work, he would point out that he was simply using his method.

His method forced Seurat to execute his paintings by making spots of paint that resembled dots, thus the name "pointillism" (from the French word "dot"). On the other hand, the term "pointillism" annoyed Seurat, who found it imprecise; he felt the stroke

46. **Georges Seurat**,
Bathers at Asnières, 1884.
Oil on canvas, 201 x 300 cm.
The National Gallery, London.

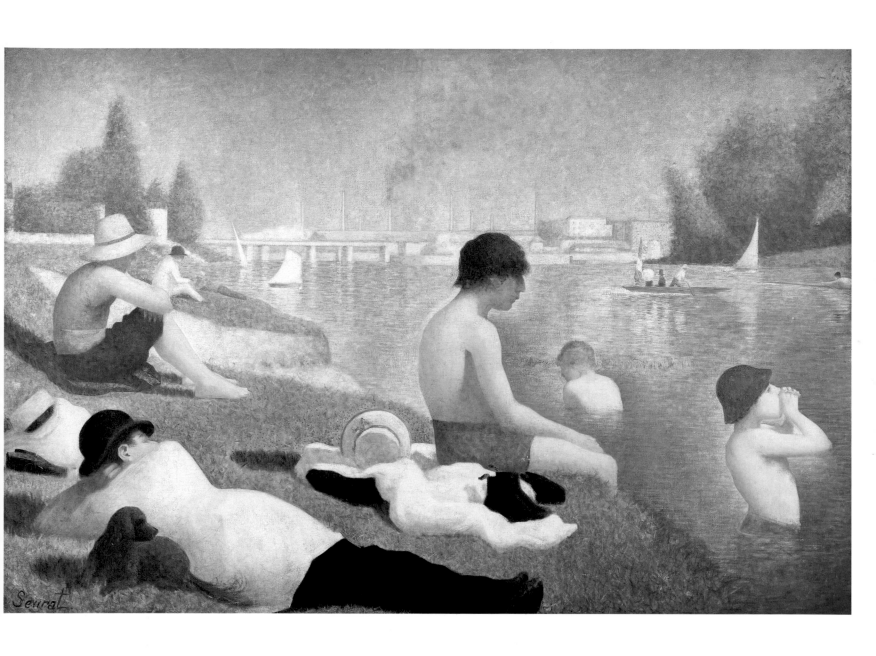

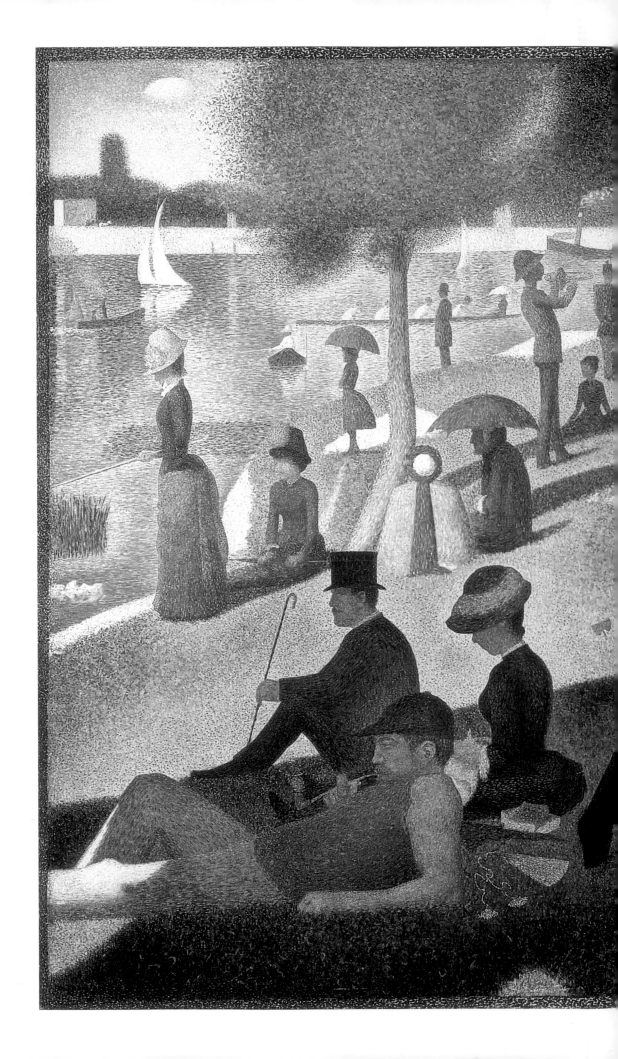

47. **Georges Seurat**, *A Sunday on La Grande Jatte*, 1884-1886. Oil on canvas, 207.5 x 308.1 cm. The Art Institute of Chicago, Chicago.

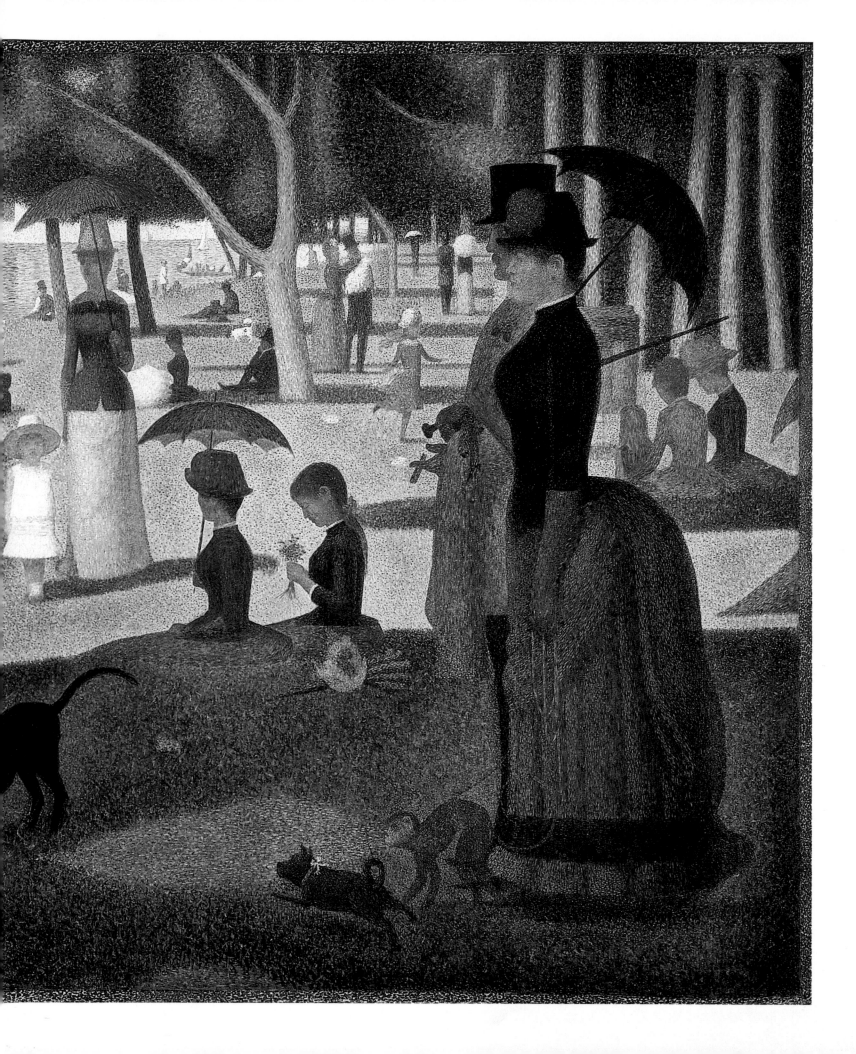

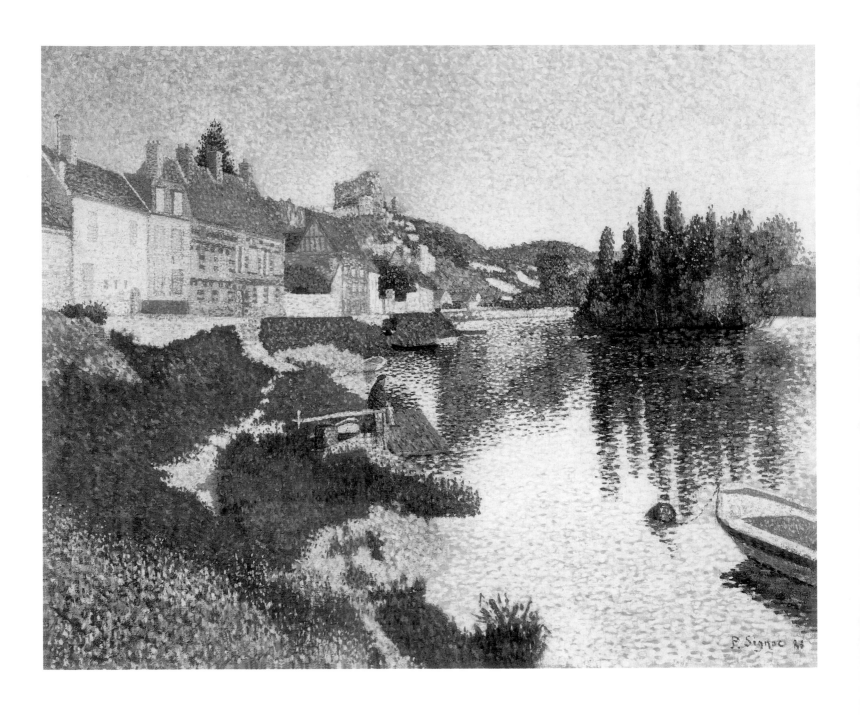

48. **Paul Signac**, *Les Andelys (The Riverbank)*, 1886.
Oil on canvas, 65 x 81 cm.
Musée d'Orsay, Paris.

could vary extremely. Pissarro wrote: "For Seurat and his peers the term 'divisionism' was more acceptable, but didn't satisfy them fully, because Impressionists already were using discrete strokes. For them, the colours did not mix mechanically on the palette but optically in the eye of the observer. Georges Seurat was above all partial to the term 'chromo-luminarism' because pure colour, based on the law of contrast, was supposed to shine on the canvas.

The exhibition of *La Grande Jatte* at the exhibition of Impressionists was a huge triumph for Georges Seurat, however for the artist himself, it was just the first step on his way to combining art with science. Seurat solved his problem of using the law of contrasts and supplemental colours. But to achieve harmony, which is the ultimate goal of the artist,

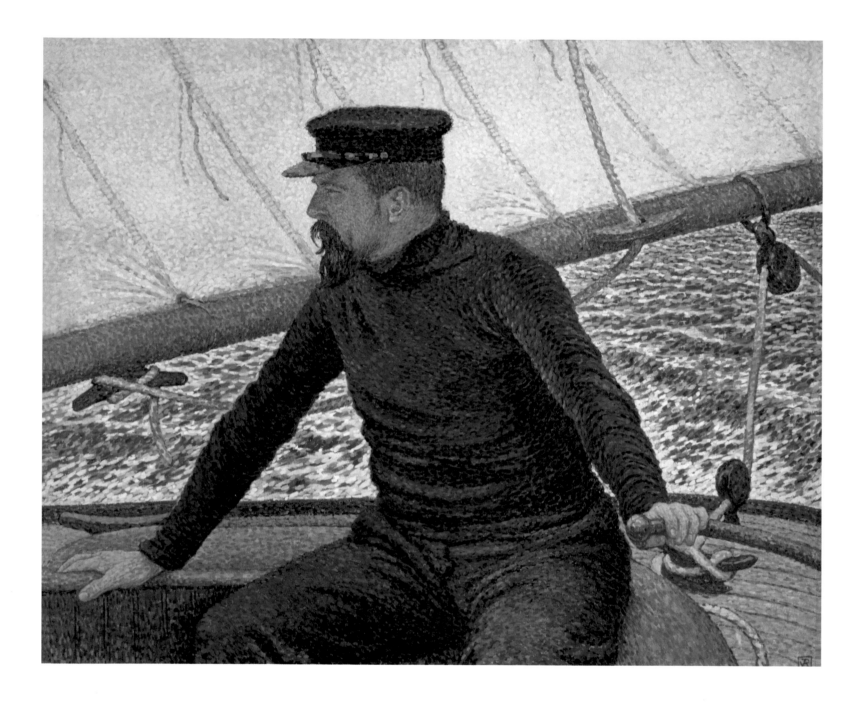

he had to master the science-based laws of composition and lines. He had to find a scientist who could help the artist. And he did find one.

Charles Henry, Georges' friend from the military, was a typical individual at the time of the scientific and technical revolution. Combining different sciences to achieve goals, a widespread practice during Post-Impressionism, was for him a natural way of working. Seurat became a passionate follower of Charles' scientific theories. At the time Seurat was especially interested in problems of harmony of composition and line, and Henry had already spent two years on a treatise regarding lines. The scholar was looking for the answer on how to achieve Expressionism with the help of combination of different lines and how to find a system of lines more pleasant to the eye. Such common interests

49. **Théo Van Rysselberghe**, *Paul Signac aboard his Sailboat*, 1886. Oil on canvas. Private collection, France.

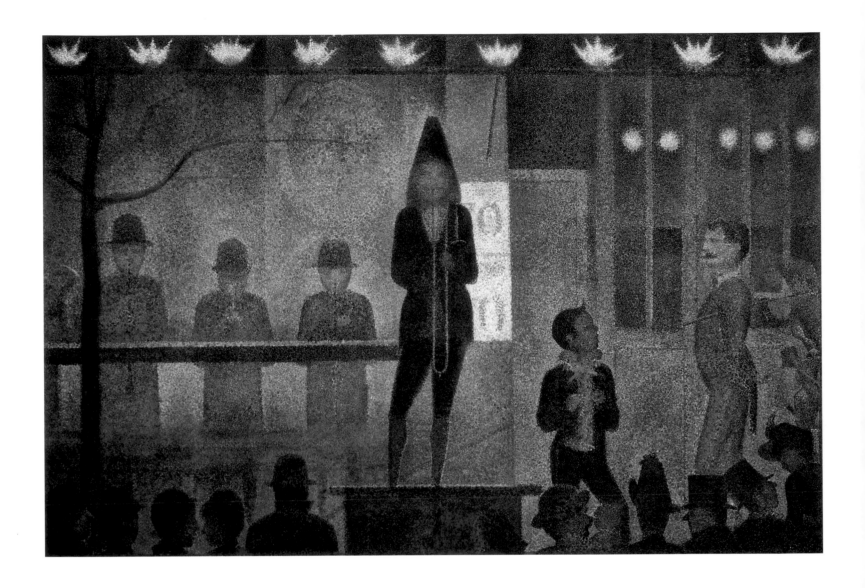

50. **Georges Seurat**, *Circus Sideshow*,
 1887-1888.
 Oil on canvas, 99.7 x 149.9 cm.
 The Metropolitan Museum of Art,
 New York.

51. **Georges Seurat**, *The Models*,
 1886-1888.
 Oil on canvas, 200 x 250 cm.
 The Barnes Foundation, Merion.

created an exceptional alliance of art and science, probably the only one since Leonardo
da Vinci. And even though certain of Charles Henry's contemporaries called him crazy,
his cooperation with neo-impressionists bore fruit. The attention drawn to *La Grande
Jatte* increased the circle of Seurat's followers, though never beyond the five or six artists.
"The Twenty" group, founded in Brussels in 1884 to select the most interesting new art
for its exhibition, in 1887 invited Georges Seurat and Camille Pissarro to participate.
That same year Seurat showed *La Grande Jatte* at the Salon des Indépendants, and Signac
exhibited his canvas *Two Fashion Designers, rue du Caire*. All Neo-Impressionists used
motifs close to those used by the Impressionists. When Seurat returned from "The
Twenty" in Belgium, he locked himself in his studio to work on a new large canvas called
The Models (p. 69). He painted the same model in three positions: sitting and standing,
with *La Grande Jatte* in the background. Like Signac's fashion designers, Seurat's nude
models in their way were a tribute to Edgar Degas, the Impressionist master. In 1891
Seurat created another canvas *The Circus* (p. 71), a strange composition with the red face
of a clown in the foreground. Seurat's painting produced a strange effect: the horse and

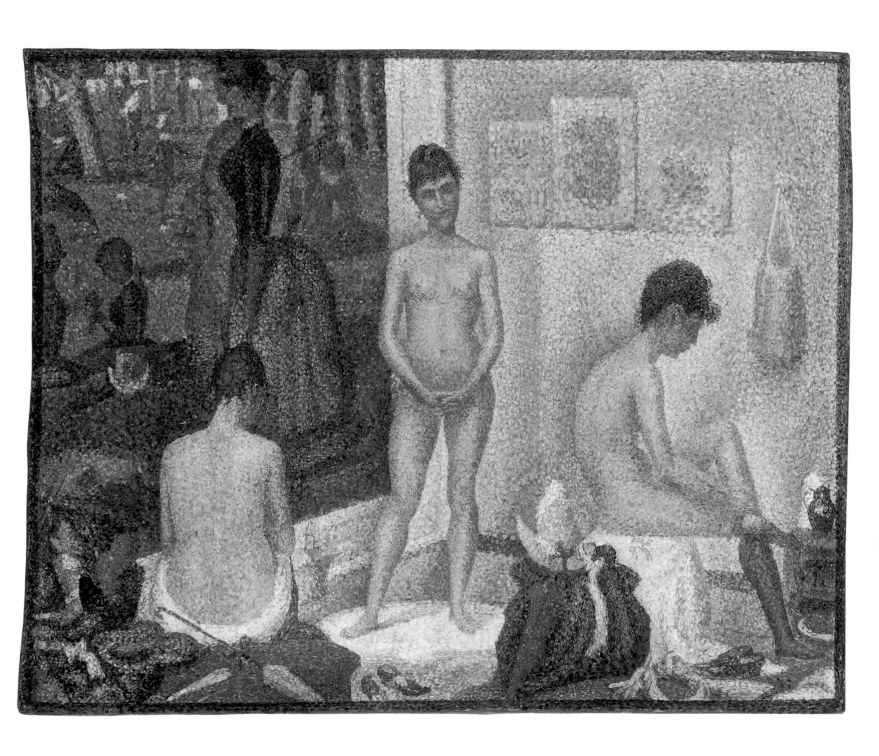

52. **Georges Seurat**, *Le Chahut*,
1889-1890.
Oil on canvas, 172 x 140 cm.
Kröller-Müller Museum, Otterlo.

53. **Georges Seurat**, *The Circus*, 1891.
Oil on canvas, 185.5 x 152.5 cm.
Musée d'Orsay, Paris.

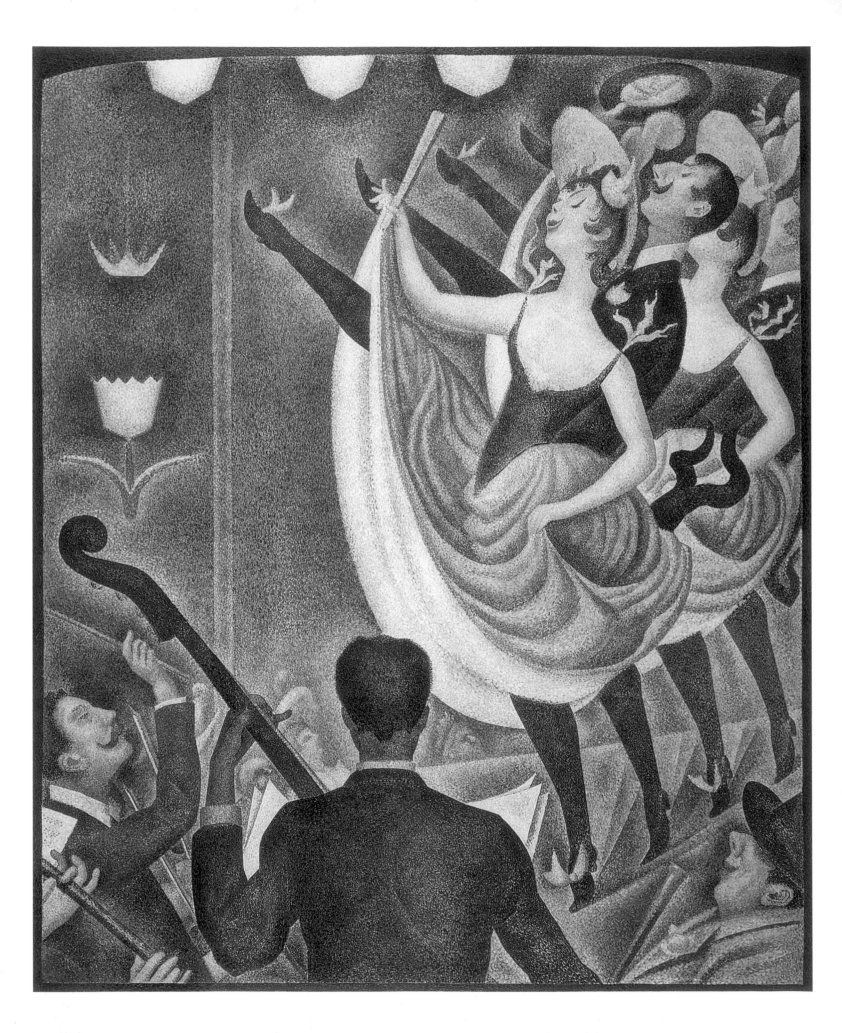

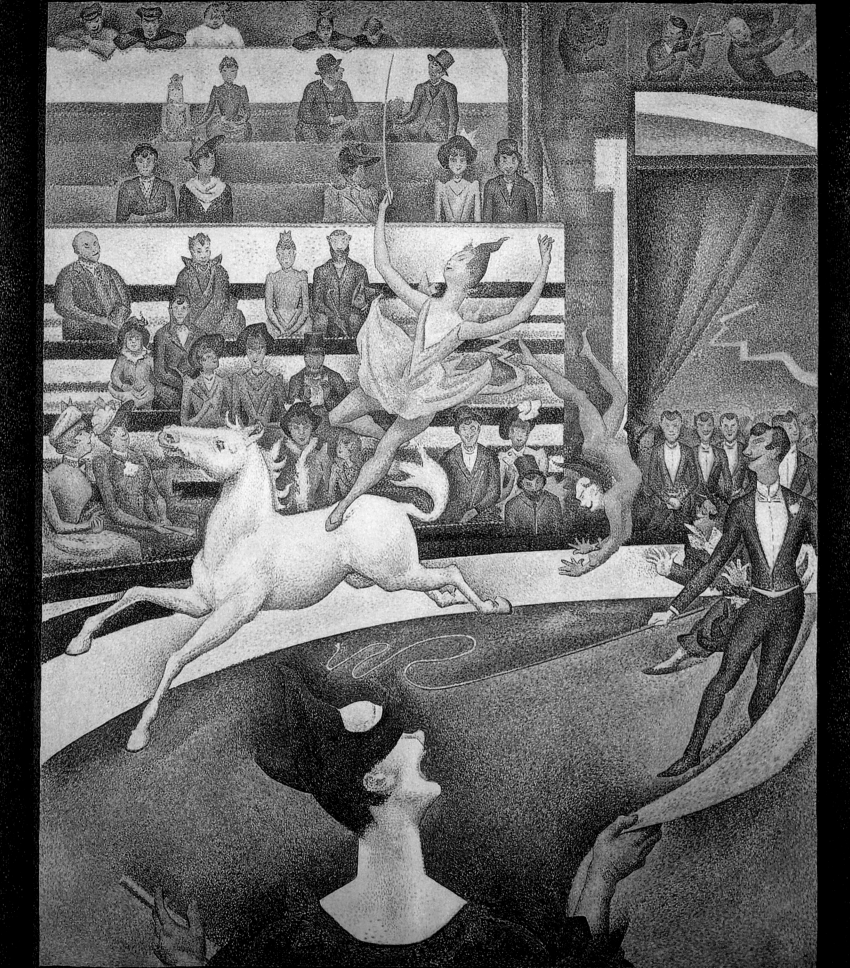

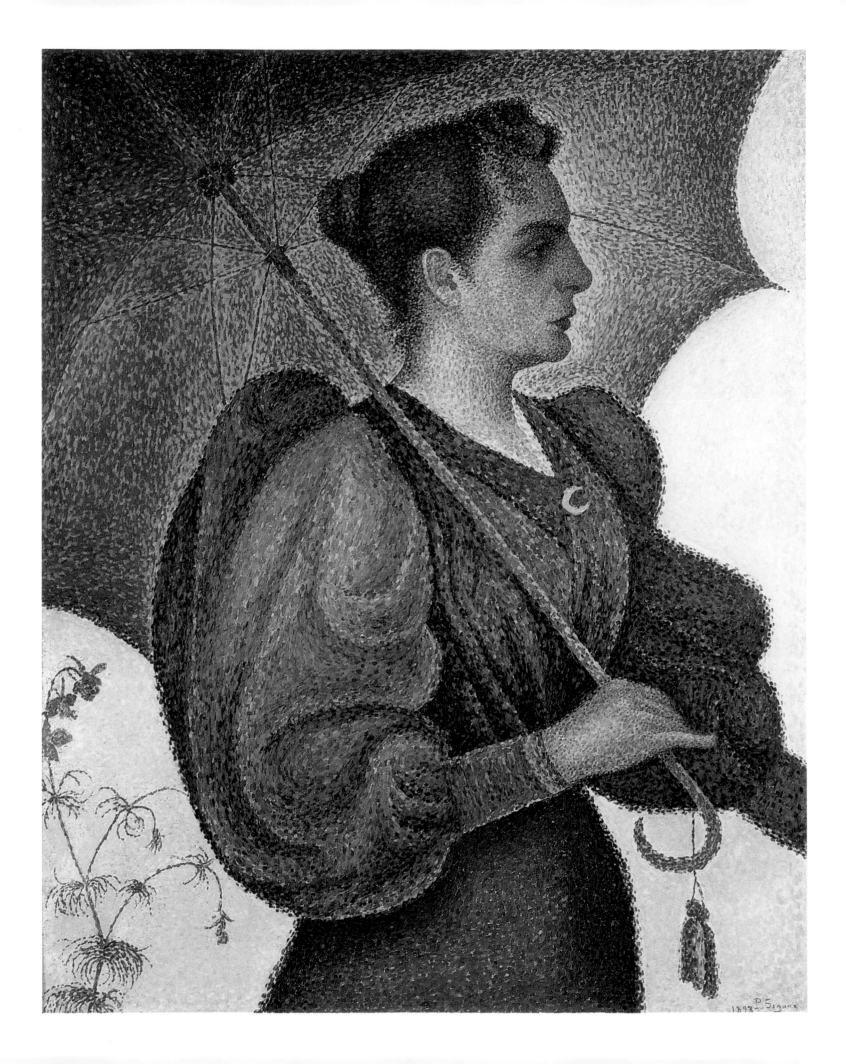

the acrobats appear frozen in action. The harmonious curving lines of the horse, acrobats, and curtains form an ornament that produces a balanced and gracious effect. Charles Henry's science of lines had worked. Seurat's precise touch, the harmonious lines and the beautiful colours combined to produce a decorative canvas that in no way resembled the spontaneous art of Impressionists.

It was a different story with landscapes. Neo-Impressionists did not part with open-air painting. Seurat never ceased working from nature. In Normandy he painted views of Grandcamp, Port-en-Bessin, and Honfleur. He applied increasingly smaller and more elegant strokes of paint. This became possible by an ever more fine analysis of colour contrasts and halftones. Signac also painted the coast of Normandy. He became an experienced sailor. After sailing on the Seine, he often travelled to the Mediterranean, where he painted in Collioure and Saint-Tropez. There, in 1897 he purchased a villa called "La Une", which

54. **Paul Signac**, *Woman with a Parasol*, 1893.
Oil on canvas, 81 x 65 cm.
Musée d'Orsay, Paris.

55. **Paul Signac**, *Opus 217. Against the Enamel of a Background Rhythmic with Beats and Angles, Tones and Tints, Portrait of M. Félix Fénéon*, 1890.
Oil on canvas, 73.5 x 92.5 cm.
The Museum of Modern Art, New York.

56. **Henri-Edmond Cross**, *The Church of Santa Maria degli Angeli near Assisi*, 1909.
Oil on canvas, 73.5 x 92 cm.
The State Hermitage Museum,
St. Petersburg.

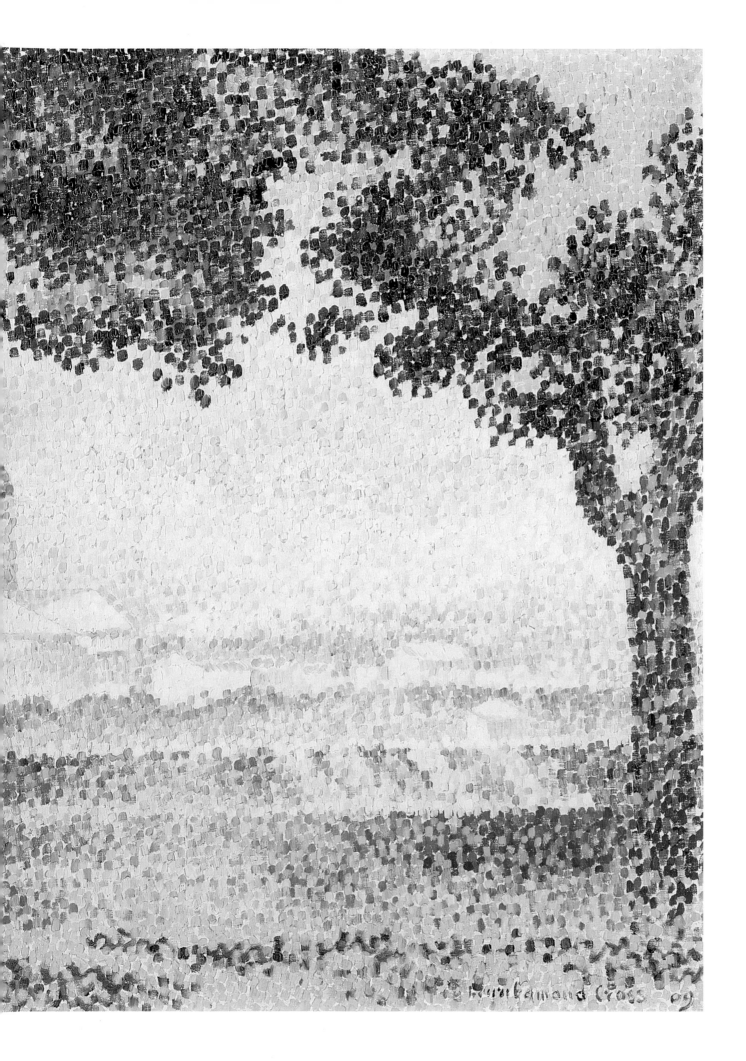

became his favourite refuge from the lively pace of Paris. The Mediterranean coast became a primary theme for Signac's paintings. The criteria of the objective rendition of nature became a secondary consideration in his painting. Signac painted with a larger and more dynamic stroke than Seurat. His landscapes became decorative.

Already at the exhibition of 1886, many critics noticed an amazing similarity between the different Neo-Impressionist paintings. The style of execution – the mechanical application upon canvas of coloured dots – inevitably led to this conclusion. In fact, with time each follower of Neo-Impressionism developed his or her own peculiarities in painting. One of the closets artists to Seurat was Charles Angrand. Albert Dubois-Pillet, who put a lot of effort into organising the Society of Independent Artists with Seurat, painted beautiful still lifes and landscapes by varying the size and shape of coloured dots.

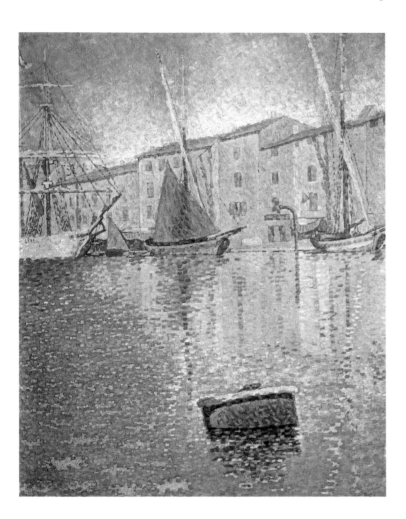

But one of the brightest artists of the group was Henri-Edmond Cross. A graduate of an excellent academic school, he was powerfully drawn to Impressionism. However, Cross was a painter of the 80s, which gravitated toward science, and he joined Seurat. Cross began by experimenting with monochrome compositions, working less with colour than with line drawing. At the same time he painted an even row with dots, which gave a mechanical impression. As time went by, his style of work became more relaxed. Signac admired the logic of his colours. Cross's landscapes contained the sunlight and colourful shades of Impressionists; he painted intense colours and contrasted them sharply. But his art created the impression of a decorative mosaic.

However, the charm of Impressionism was too big, and it was hard to turn around everyone whom the Impressionists had just persuaded regarding the advantages of their art. Seurat, with his new method, lost the main victory of Impressionism: the freedom that was so dear to all artists after the tyranny of academic classicism.

Then, one after another, his supporters abandoned Georges Seurat who continued working energetically. In 1890 he was busy with another exhibition of the Independents, at which he showed two canvases: *Woman Powdering Herself* and *Le Chahut* (p. 70) and six landscapes. The following year, in 1891 he showed with the Independents his "Circus", which had not been completed. The exhibition opened on March 20; on March 29, after two days of illness Georges Seurat died. He passed away at thirty-two, leaving few paintings but his goal accomplished. Seurat demonstrated that Impressionism could not continue and that something altogether different could be created based on modern science.

57. **Paul Signac**, *The Red Buoy*, 1895.
Oil on canvas, 81 x 65 cm.
Musée d'Orsay, Paris.

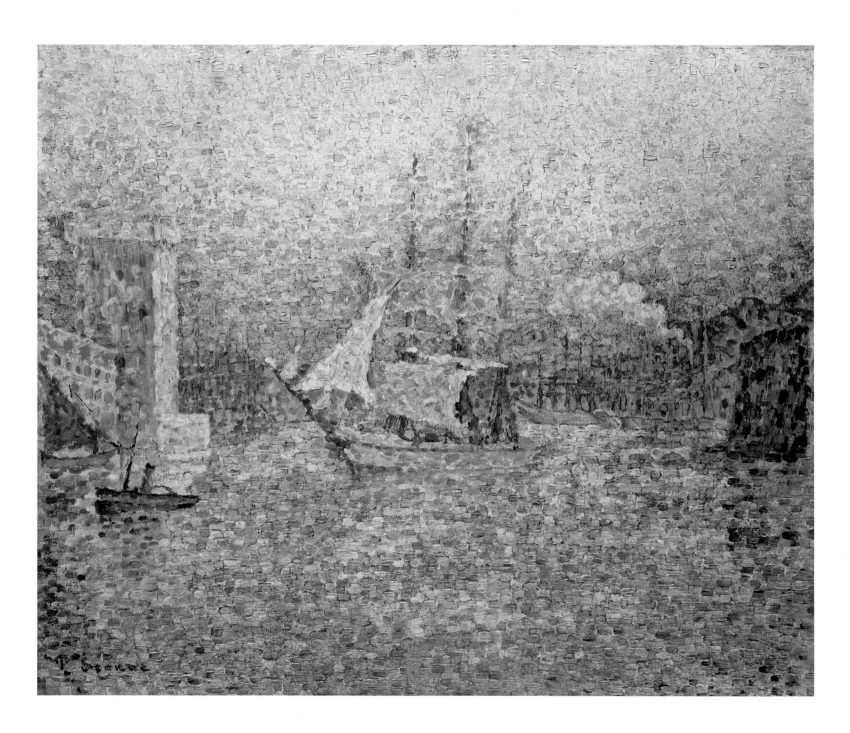

58. **Paul Signac**, *The Harbour at Marseille*, 1907.
Oil on canvas, 46 x 55 cm.
The State Hermitage Museum,
St. Petersburg.

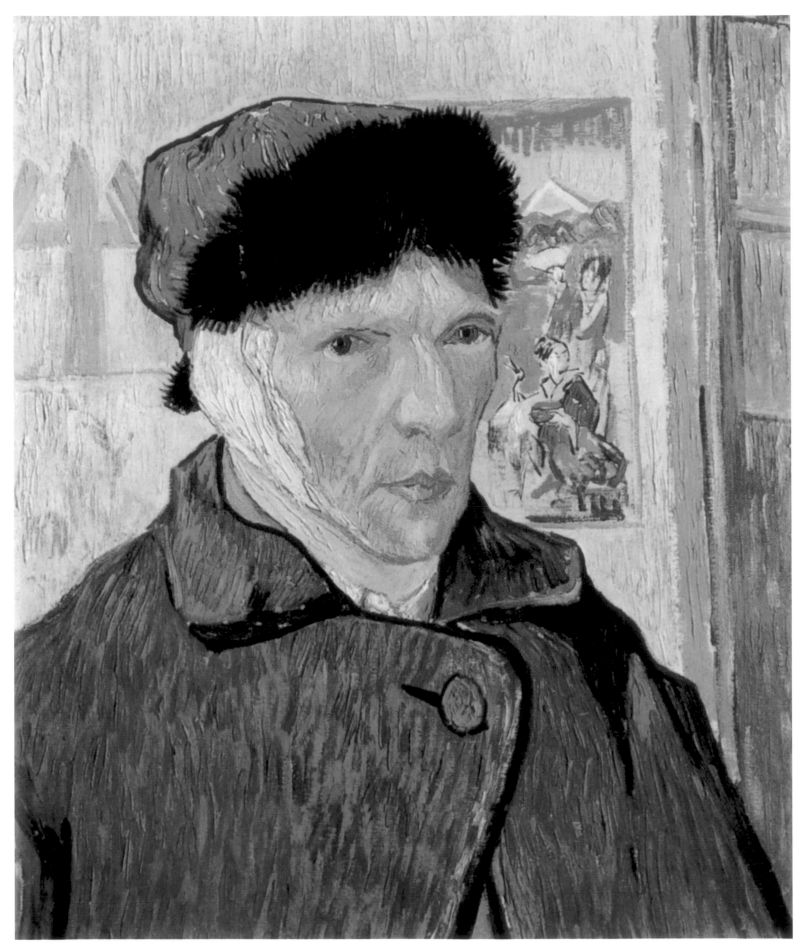

VINCENT VAN GOGH (1853-1890)

*I*n 1885 Vincent van Gogh wrote from Nuenen, a village in Holland, to his brother Theodorus (known as Theo) van Gogh in Paris: "There is, in my opinion, an impressionist school, though I know very little about it."[19] His notions about Impressionism were very approximate. He thought a new school had been formed around Delacroix, Millet and Corot. At the time when Impressionists were truly coming to the end of their shared artistic path, Van Gogh already had some idea as to where he wanted to go. His life was difficult. To escape a Dutch village and move into the realm of great art – not everyone could do it. But Vincent van Gogh was unusually persistent. "I am very glad that you do not object to my intention of coming to Paris", he wrote to Theo. "I think it will help me move ahead; I'm afraid of hitting a dead end if I stay here, to keep repeating the same mistakes."[20] Thus, Vincent travelled to Paris. At the end of February 1886, he met his brother Theo in the Louvre's Salon Carré among the paintings of the great Italian artists.

Van Gogh was born on March 30, 1853 in a Dutch village called Groot Zundert. His father, Theodorus van Gogh, was a Calvinist pastor. According to family tradition, at sixteen and without finishing school, he began working as an art dealer in The Hague. Thus, his contact with and knowledge of painting occurred early. Vincent worked in the branch office of Goupil and Company Art Gallery of Paris, which gave him the possibility to visit Paris and work in London for almost two years, then, until April, 1876 in the same firm in Paris. At twenty-three years old, Vincent knew museums in The Hague, Paris, and London, and was exceptionally widely read. In Etten, a village where his parents lived, there was no suitable work for him, and he changed trades and cities. Vincent worked in the poor quarters of London as a teacher's assistant and read his first sermon there. The Van Gogh family came from a long line of preachers, so Vincent's calling was natural. At his parents' insistence, he began preparation to enter the School of Theology at the University of Amsterdam, and then the Flemish School of Evangelism in Brussels. Having failed in the Evangelism School, Vincent went to work as a preacher in the poorest coal area of Belgium, Borinage, where he self-denyingly helped the poor, even descending into the mines himself. Living in a state of utter destitution among paupers was a kind of test of Vincent's abilities, as if he sensed that life would not be easy for him. Heavy work deprived the miners of beauty, joy and human dignity. These people became the first models of his paintings. When writing his brother in June 1879 from Borinage, Vincent's words already described a future composition: "Not far from here there's a high spot from which you can see in the distance at the far end of the valley a section of Borinage with its chimneys, mounds of coal, workers houses, and during the day much activity of black figures that you could mistake for ants. On the horizon you can make out stands of fir with small white houses nearby, small towers, an old mill, etc. Most of the time a sort of fog hangs above it all, or perhaps it's a capricious effect of light and shadow that reminds you of Rembrandt (...) or Ruysdael's paintings."[21] In Borinage he overcame these tribulations and decided to become an artist.

Vincent began studying where he could. Despite the serious conflict with his father regarding his future, he persistently searched for a school and a teacher.

59. **Vincent van Gogh**, *Self-Portrait with Bandaged Ear*, 1889. Oil on canvas, 60.5 x 50 cm. Courtauld Institute of Art Gallery, London.

60. **Vincent van Gogh**, *Peasant Working*, 1885. Oil on canvas, 42 x 32 cm. The Barber Institute of Fine Arts, University of Birmingham, Birmingham.

61. **Vincent van Gogh**, *Sheaves of Wheat*, 1885. Oil on canvas, 40 x 30 cm. Kröller-Müller Museum, Otterlo.

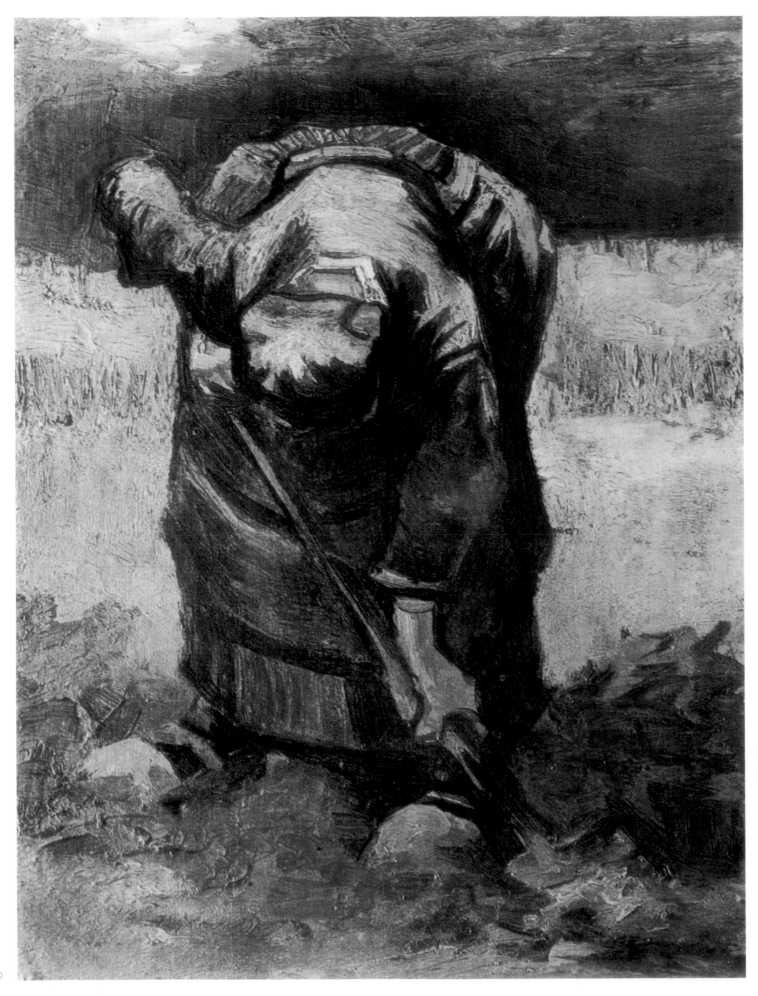

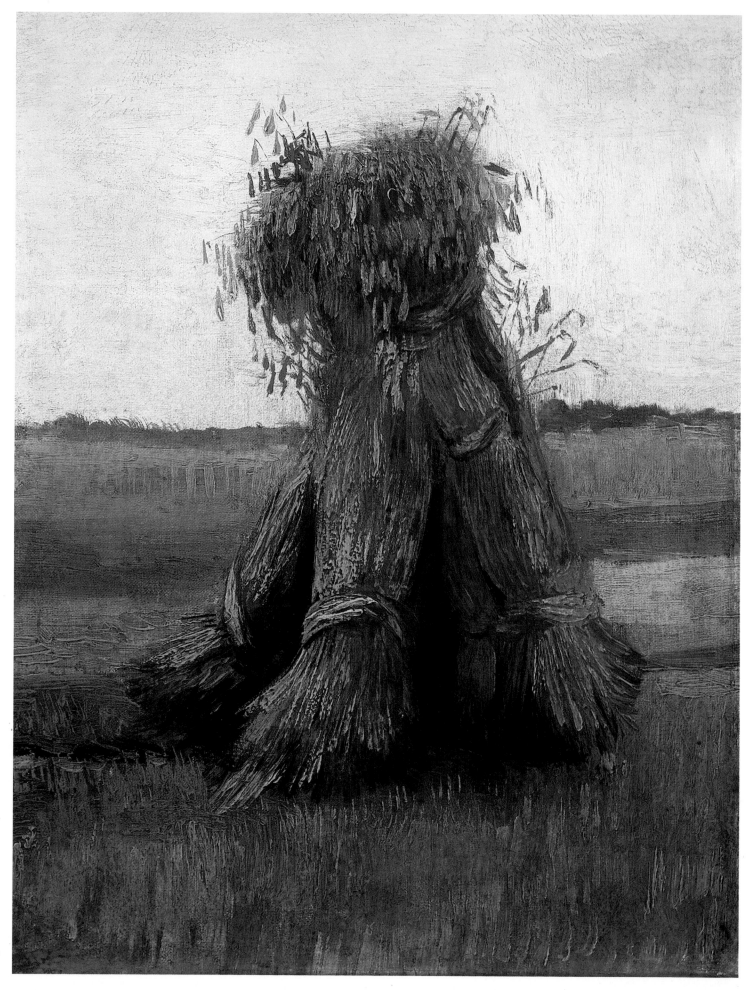

Soon it seemed that progress was being made on the artistic front. Tersteeg, a severe judge and the director at the Salon in The Hague under whose supervision Vincent had worked, gave him a box of paints and an album for his drawings as a present, recognising his right to be a painter. The appraisal of his achievements by well-known Dutch artists was especially important. The usually caustic Weissenbruch admired his drawings. Anton Mauve, a landscape painter from the Hague and a follower of the Barbizon School, played a special role in Vincent's life. Married to one of Van Gogh's cousins, he readily agreed to be the future artist's first instructor. He taught Vincent to use coal and chalk, brush and shading, to make watercolours. And even though they were soon to go their separate ways, Vincent would remain grateful his entire life to Mauve.

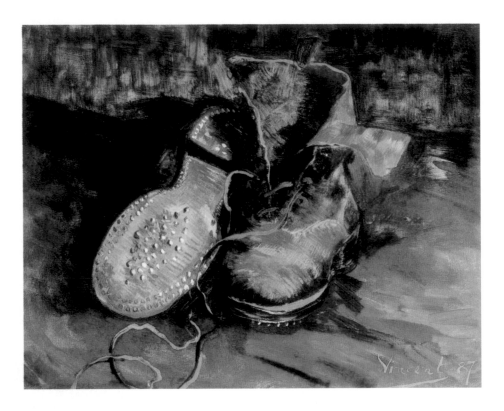

Vincent met the Dutch artist G.A. Van Rappard in Brussels in 1880. Rappard was seven years older than Van Gogh, had studied in the Academy in Amsterdam and worked in his studio in his native city of Utrecht.

His letters to Rappard reveal the breadth of Vincent's interests and erudition, contradicting the legend of the half-educated and uncultured villager. Van Gogh demonstrated a surprising level of culture; not only did he know the classics, ancient authors and philosophers, but also modern French, German, English and even American and Russian literature. Since childhood, Vincent, a man who hadn't completed his studies, spoke three languages fluently, apart from Dutch, his mother tongue, and he assumed this was the same for others.

The discussions with Rappard regarding the role the technical aspect of art should play helped Van Gogh formulate his own credo of painting at that time: "I'm simply saying that correctly drawing a figure according to academic recipe, with a uniform and studied brushstroke, does not respond to the pressing demands of the modern period regarding pictorial art."[22] Regarding themes of painting, Vincent was convinced that he should "paint the peasant at home, among the members of his entourage."[23] In 1885, he achieved his goal by creating his first masterpiece.

The Potato Eaters (p. 83) was painted in the village of Nuenen, where Van Gogh's parents had lived since 1883. Vincent lived there for two years – 1884 and 1885. At that time he had already done 250 drawings and 190 paintings. He sent *The Potato Eaters* to his brother Theo into Paris. "It is not impossible", wrote Vincent, "that I had done *a* real country picture. I even know that it is so".[24] For Van Gogh it was a success, independently from the reception of the work. He had painted it exactly as he had wanted to paint it. Van Gogh said himself that he had worked hard to express what these people felt: these men dug in the ground with the same hands that they used to pick up their boiled potatoes. They possessed an expressivity never before seen – a quality hopelessly lost in the academic art of his contemporaries. He was even pleased then that he had never studied painting.

62. **Vincent van Gogh**,
A Pair of Shoes, 1887.
Oil on canvas, 34 x 41.5 cm.
The Baltimore Museum of Art,
Baltimore.

63. **Vincent van Gogh**,
The Potato Eaters, 1885.
Oil on canvas, 82 x 114 cm.
Van Gogh Museum, Amsterdam.

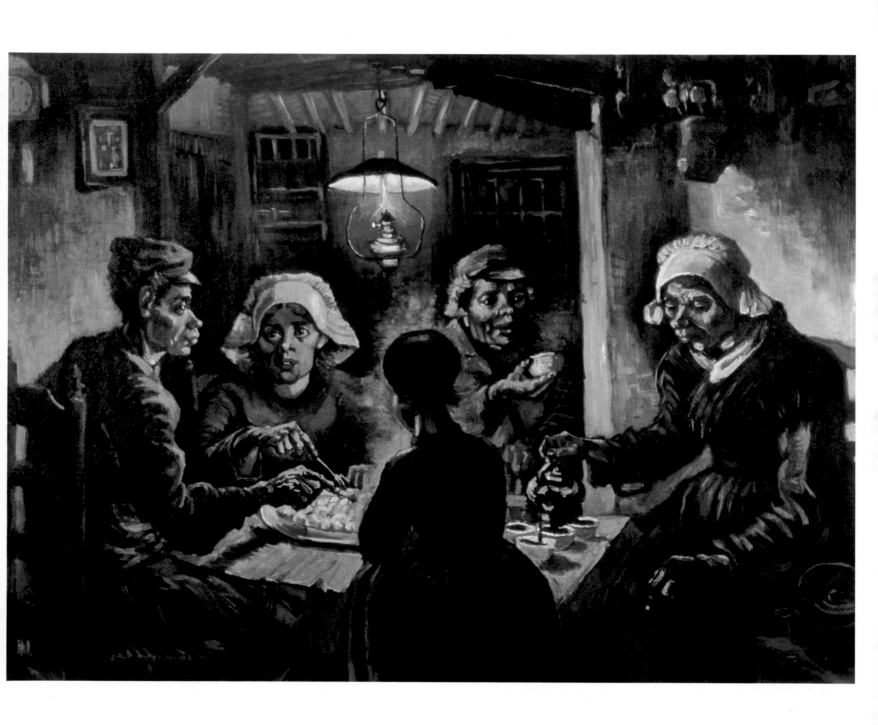

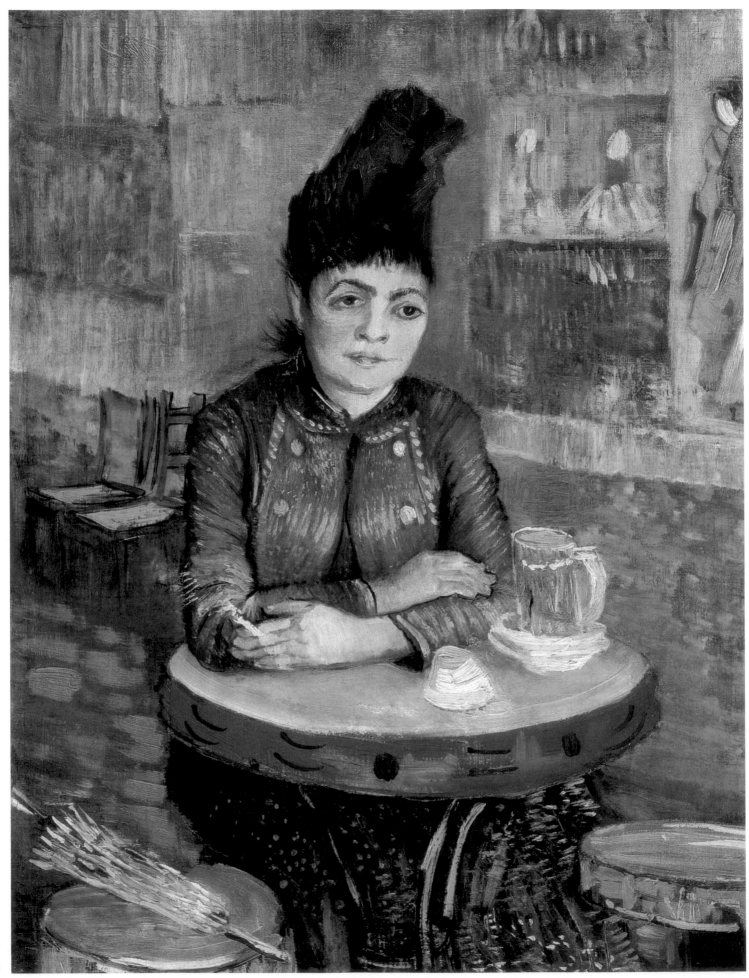

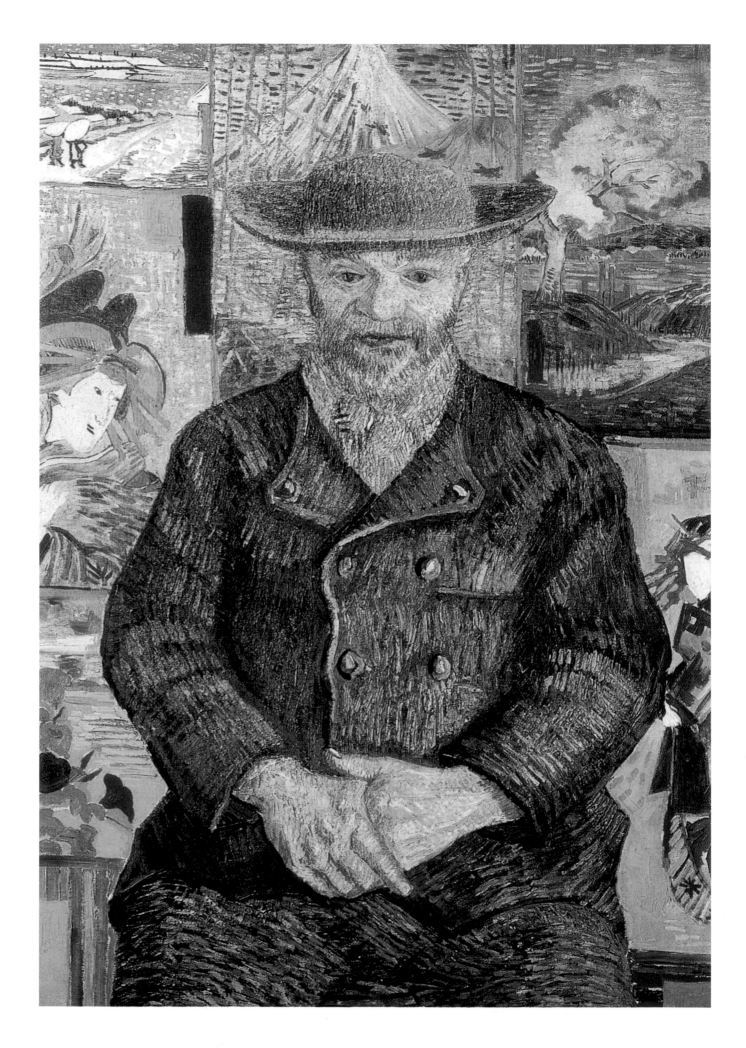

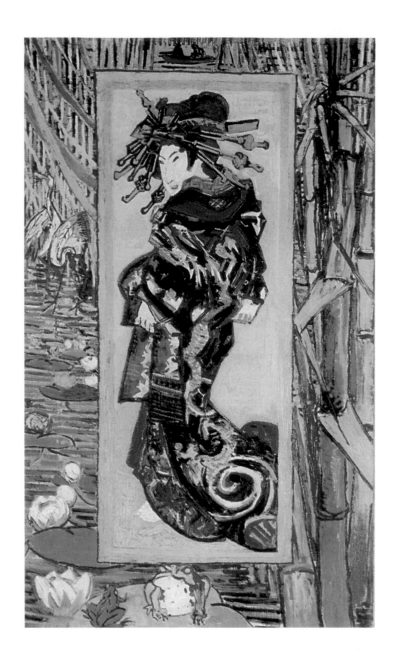

The Potato Eaters arrived in Paris before Vincent. He went there to continue studying and the first thing he did was find a teacher. Vincent chose the studio of Félix Cormon who was well-known for his huge paintings of primitive life scenes. The young students who felt oppressed by the conservatism of the professors from the School of Fine Arts fled here. Cormon followed academic training; however, he was not hostile to new trends. His classes were necessary for Van Gogh mainly because they enabled him to study nudes. In the training studio, he didn't try to show his personality. Besides, there he met artists who had also chosen new paths. He became acquainted with Anquetin and Toulouse-Lautrec.

The Van Gogh brothers lodged together in Montmartre, at 54, Rue Lepic. Theo's attempts to sell his brother's paintings remained unsuccessful; however he considered it his duty to support Vincent. Theo wrote to their mother, "He is quickly improving in his work and is beginning to have some success,(…) He has friends who send him a bouquet of beautiful flowers every week which he uses for his still lifes. He paints mainly flowers, in order to find lighter and brighter colours for his future paintings."[25]

64. **Vincent van Gogh**, *Agostina Segatori in the Café du tambourin*, 1887.
Oil on canvas, 55.5 x 46.5 cm.
Van Gogh Museum, Amsterdam.

65. **Vincent van Gogh**,
Portrait of Père Tanguy, 1887.
Oil on canvas, 92 x 73 cm.
Musée Rodin, Paris.

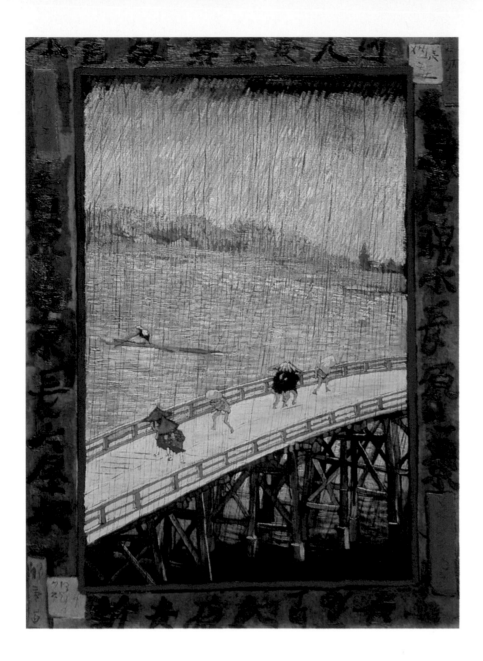

Indeed, Vincent's palette was changing very quickly. Now his views about painting were not limited to the classical masterpieces of the Louvre which would certainly never go out of fashion. He saw a posthumous exhibition of his idol, Francois Millet, which led him to think and re-define a lot of things about himself. Vincent arrived in Paris at the very moment when modern art was showing many different possibilities. Gradually, Van Gogh exchanged his dark Dutch colours for a light palette of the Impressionists.

Vincent revelled in the atmosphere of Paris and poured out his feelings in many landscapes. He painted the slopes of Montmartre with the silhouettes of the mills, workers' simple huts with their small gardens. His pictures of Montmartre recalled those of Holland. At the beginning, his colours were only slightly lighter than the Dutch colours. The fact that he was painting in the open air in the suburbs of Paris, in Asnières and Saint-Ouen, in the company of Signac, probably played a role in the lightening of his scale of colours. Van Gogh let himself be persuaded by Signac's fiery convictions. At first his new style only seemed to be a zealous imitation of Seurat and Signac, too enthusiastic, in fact. But gradually Vincent began to feel

66. **Vincent van Gogh**, *Japonaiserie: Oiran (after Kesai Eisen)*, 1887. Oil on canvas, 105.5 x 60.5 cm. Van Gogh Museum, Amsterdam.

67. **Vincent van Gogh**, *Japonaiserie: The Bridge in the Rain (after Hiroshige)*, 1887. Oil on canvas, 73 x 54 cm. Van Gogh Museum, Amsterdam.

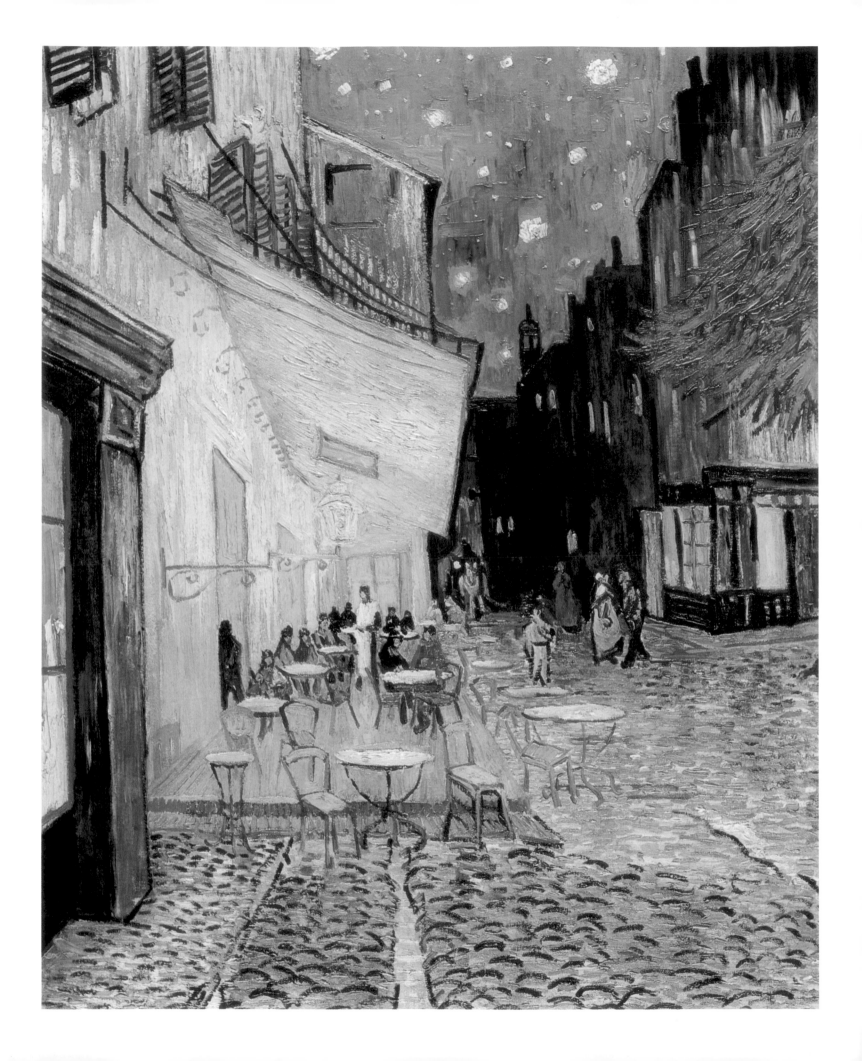

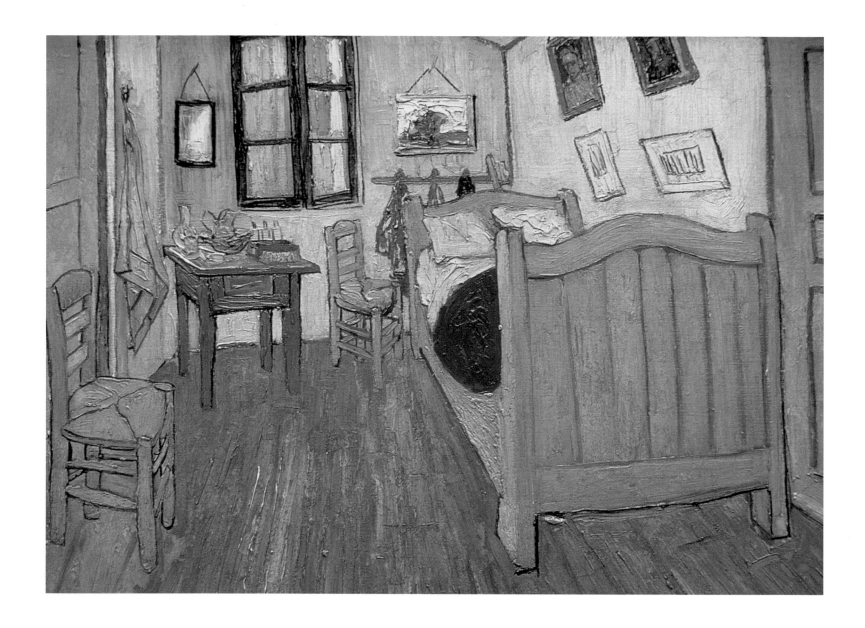

that pointillism did indeed offer new opportunities in painting light. Not only the streets of Montmartre, but also the interiors of small restaurants became more joyful and more luminous than they were in nature (*Restaurant Interior*). He surrounded his subjects with a kind of matching colour halo to intensify the primary colour. Signac became a loyal friend. Once when they were coming back to Paris on foot, Signac later recalled how happy and excited Vincent was: "Van Gogh was wearing a dark blue work shirt whose sleeves were covered with a constellation of tiny drops of paint. Walking beside me, he shouted, gesticulated, and swung the freshly painted canvas, soiling himself and passers-by with paint."[26]

In 1887 Vincent met Émile Bernard with Signac at the paint dealer "Père" Tanguy. Van Gogh saw Cézanne's paintings for the first time in this shop. Its owner was such a picturesque person that Vincent immediately began painting portraits of Père Tanguy, Madame Tanguy and their friends. Van Gogh had placed great hope in these portraits, thinking in this manner he would be able to generate orders in Paris. Like many other artists, his hope was not justified. His portraits were fine and expressive, but lacked even a hint of the lustre sought by customers. What's more, the artist's manner of painting seemed strange, careless and non-professional. This type of painting remained limited to portraits

68. **Vincent van Gogh**, *Café Terrace at Night* (*Place du Forum*), 1888.
Oil on canvas, 81 x 65.5 cm.
Kröller-Müller Museum, Otterlo.

69. **Vincent van Gogh**, *The Bedroom*, 1888.
Oil on canvas, 72 x 90 cm.
Van Gogh Museum, Amsterdam.

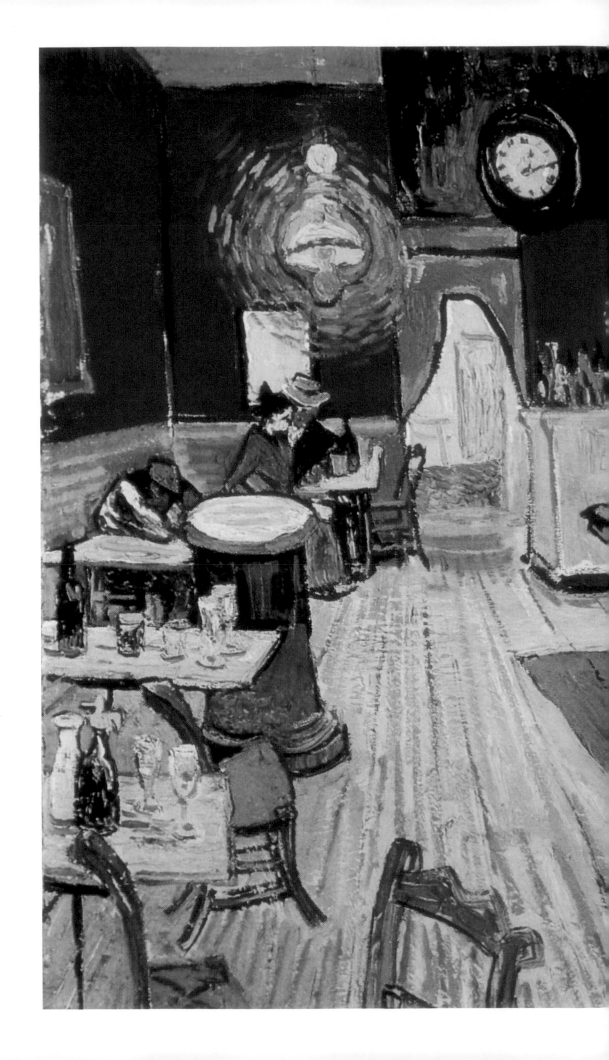

70. **Vincent van Gogh**,
The Night Café (detail), 1888.
Oil on canvas, 72.4 x 92.1 cm.
Yale University Art Gallery,
New Heaven.

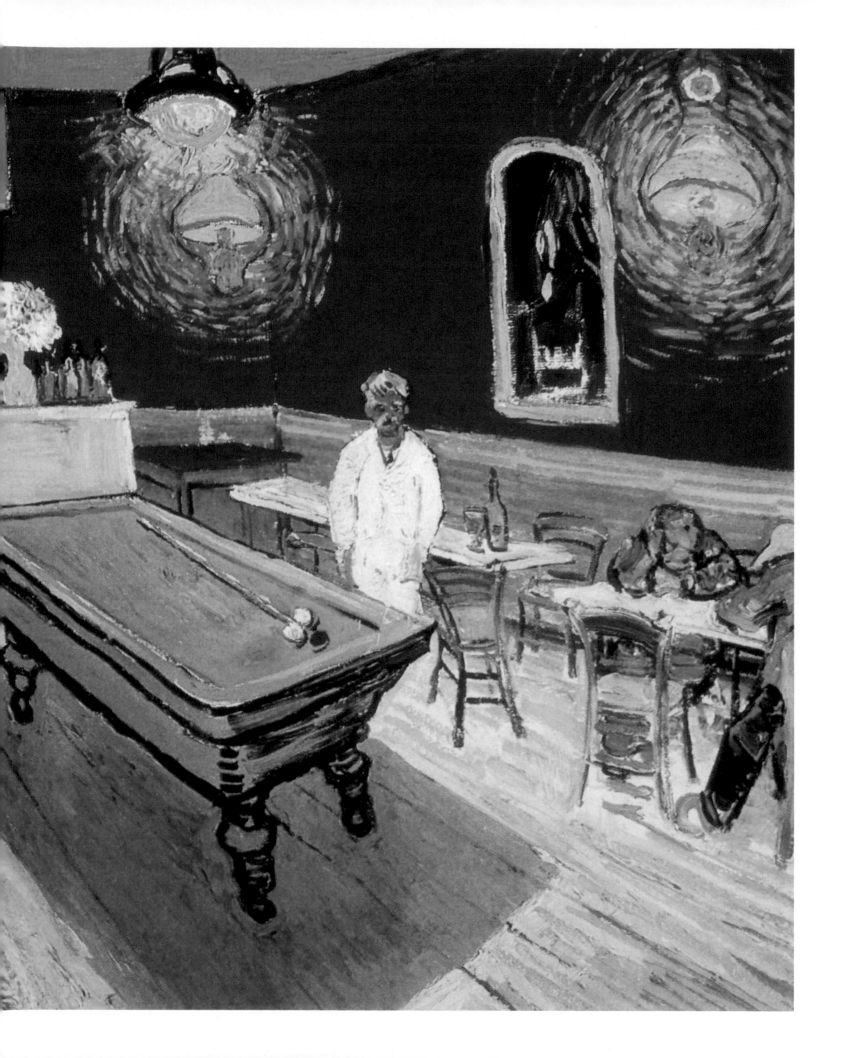

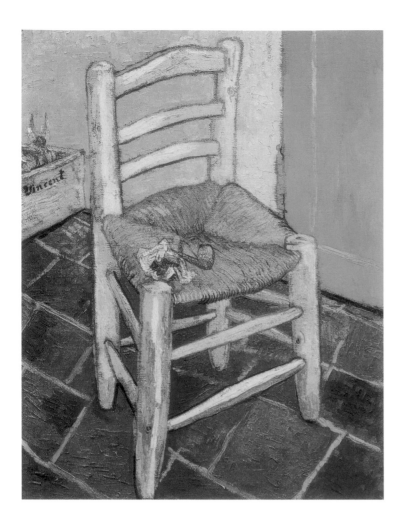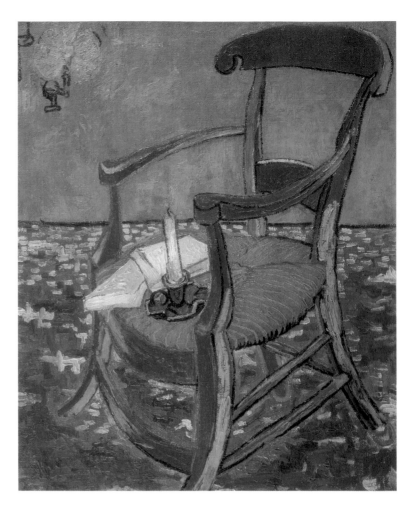

of close friends and self-portraits. Since painting his own portrait, the middle-aged Dutchman with the ill-fitting felt hat regarded the world with suspicion and caution (*Self-Portrait with Felt Hat)*. The brown brushstrokes of paint in his beard alternated with red and green, and the hat shone against the background of the dark green through oblong dark green brushstrokes – Signac's lessons had not been wasted!

Before that, in November 1886, Van Gogh had met Gauguin, who had come back to Paris from Brittany.

Vincent succumbed to the Parisian craze for Japanese art. He frequently visited the Bing gallery which specialised in Eastern art, buying Japanese engravings and even exhibiting them in Tambourin during the period of his friendship with Segatori. Using oil, Vincent copied Hiroshige's landscapes and figures in Japanese clothes. On one hand, these copies are evidence of his admiration of the Japanese [prints]. On the other, these studies applied the Japanese system of perspective to European landscapes.

Living in a new environment as restless as Paris was not easy for Vincent, who was of a nervous and unbalanced nature. His feeble physical health could not take the experience of Paris. It was even more difficult for his brother Theo. "Life at home is nearly intolerable", he wrote to the sister, "Nobody wants to visit any more because each visit ends in a scene; besides that he is so sloppy our apartment has taken on a repulsive look"[27] Even so, Theo had resolutely decided to continue backing his brother; he believed in his talent and his great future. However, it had become clear to everybody that Vincent could no longer live such a life. In February 1888,

71. **Vincent van Gogh,** *Vincent's Chair with his Pipe*, 1888.
Oil on canvas, 91.8 x 73 cm.
The National Gallery, London.

72. **Vincent van Gogh,**
Gauguin's Chair, 1888.
Oil on canvas, 90.5 x 72.5 cm.
Van Gogh Museum, Amsterdam.

73. **Vincent van Gogh,** *L'Arlésienne: Madame Joseph-Michel Ginoux (née Marie Julien, 1848-1911),* 1888-1889.
Oil on canvas, 91.4 x 73.7 cm.
The Metropolitan Museum of Art, New York.

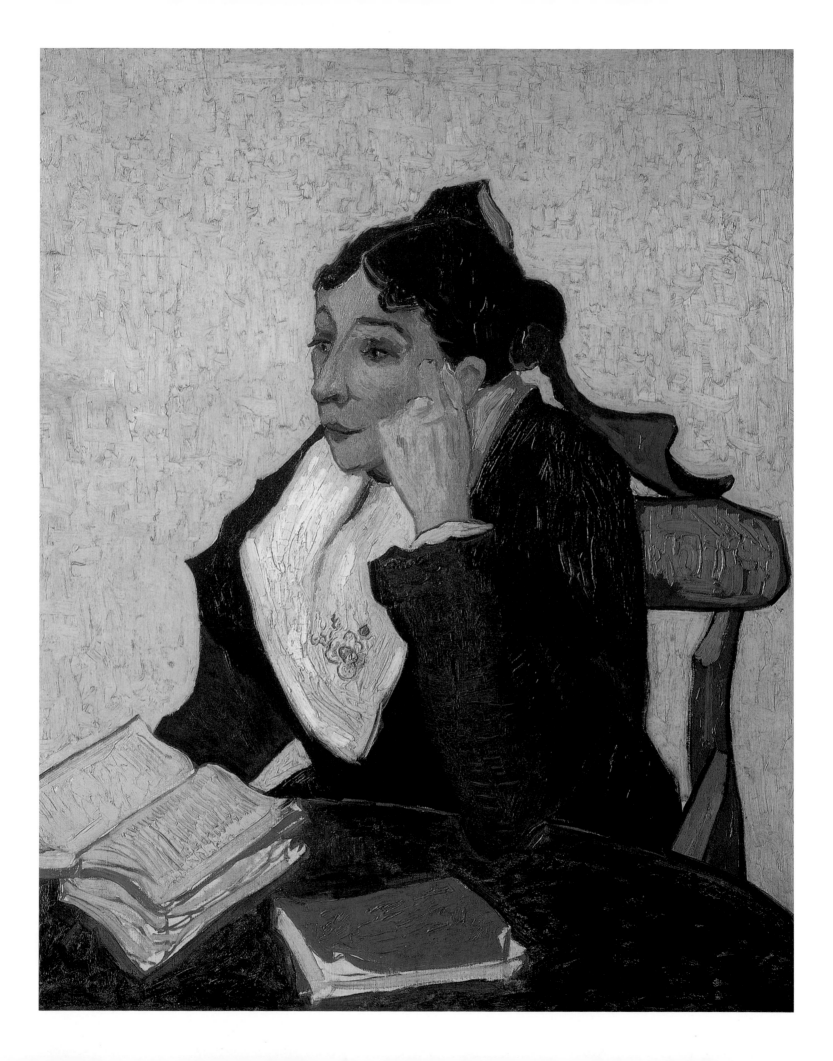

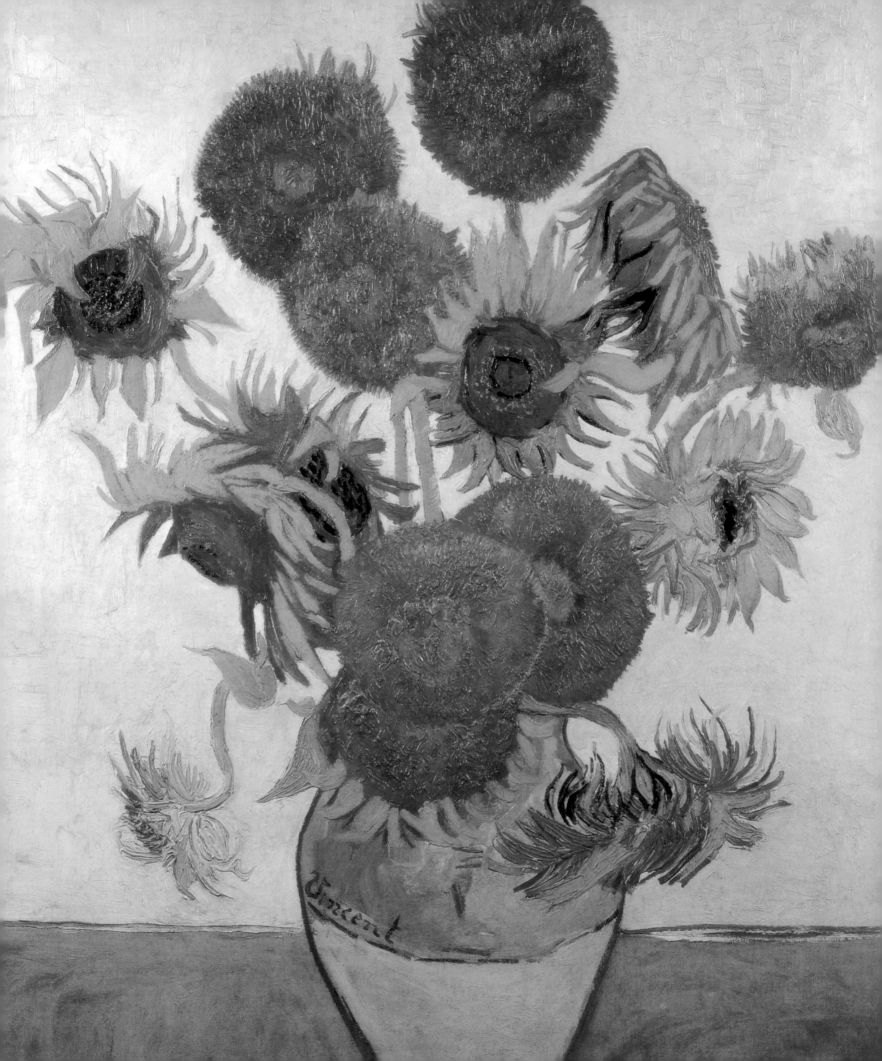

Vincent van Gogh went to Provence. Later, from Arles, he wrote to Theo: "All the same, Paris is an odd city: you have to die to survive and only when you're half dead can you do something."[28]

He immediately began to paint and draw small studies to become accustomed to the new environment. He produced the small, characteristic details of Provencal nature: stones, squat pines hardened by local winds, gnarly olive trees or wide panoramas: ploughed meadows and fields on parallel, horizontal planes that stretched into the distance. Van Gogh's early Dutch drawings already distinguished themselves by their remarkable expression. Presently, his schoolboy shyness had disappeared – his hand became firm, his stroke assured. – Instead of a student's washed-tint shading, he was using small, dispersed strokes he'd got from the pointillists. Each of Van Gogh's Provencal drawings constitutes a work of art on its own, surpassing the minor role of preparation for a future composition.

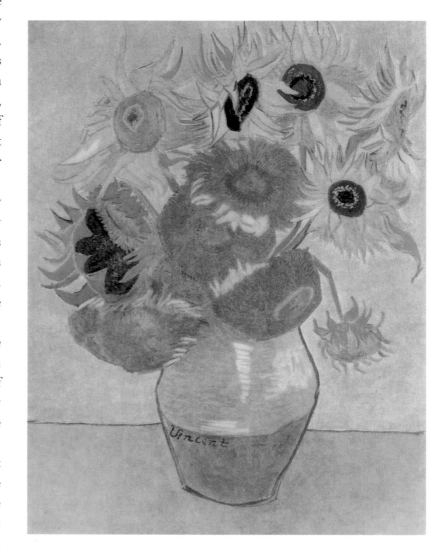

In Provence's unique nature, Vincent was meticulously choosy in what amounted to his new conception of new painting. This is why there are no depictions of Arles in his works. Van Gogh did not draw the majestic Roman arenas that capture the imagination of everyone visiting the city. He had no interest in the Medieval heritage of which the people of Arles were so justifiably proud.

The only aspect he would use in his painting was the crowd of the bullfight (*Arena in Arles*). He made quite an impressionistic, fragmentary composition, with figures of spectators turning in various directions and cut off by the edges of the canvas, and barely perceptible in the background were the silhouettes of the bulls.

He was much more attracted by the fields of wheat under the harsh sun of Provence. He painted them in the open air, suffering from the burning sun, sometimes to the limit of his physical strength. In the past, when he had lived in Holland, he had been fond of Millet's "Sower". The Provencal landscape had once again aroused in him a desire to turn to this theme by placing peasant figures in the fields; the symbolical meaning was found in the motif itself: the golden fields symbolised the world's invaluable riches created by Man. In his painting the important element was colour, which should give the picture symbolic meaning. Van Gogh struggled with different variations of this painting for more than a month. "Yesterday and today I worked on 'Sower' which I have completely finished," he wrote Theo in mid summer. "The sky is yellow and green, the ground violet and orange"[29] (*The Sower (after Millet)*, p. 102). Later, he had to recognise *The Sower* as a failure. Although he aspired to working with nature, working without it suited him better.

All the same, the path to painting from imagination lay in nature, which was so rich in Provence that it left Van Gogh no opportunity to preserve even an instant. Vincent tirelessly

74. **Vincent van Gogh**, *Sunflowers*, 1888.
Oil on canvas, 92.1 x 73 cm.
The National Gallery, London.

75. **Vincent van Gogh**, *Sunflowers*,
1888 or 1889.
Oil on canvas, 92.4 x 71.1 cm.
Philadelphia Museum of Art,
Philadelphia.

76. **Vincent van Gogh**,
Portrait of Dr. Rey, 1889.
Oil on canvas, 64 x 53 cm.
The Pushkin State Museum of
Fine Arts, Moscow.

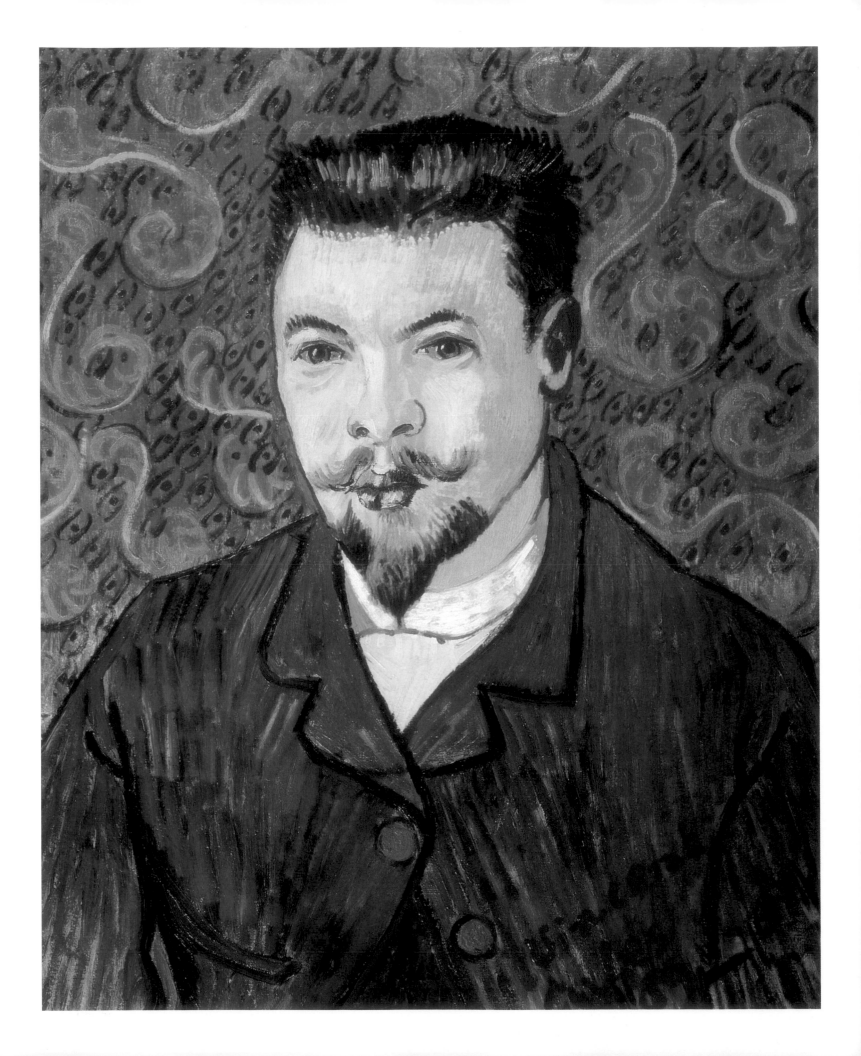

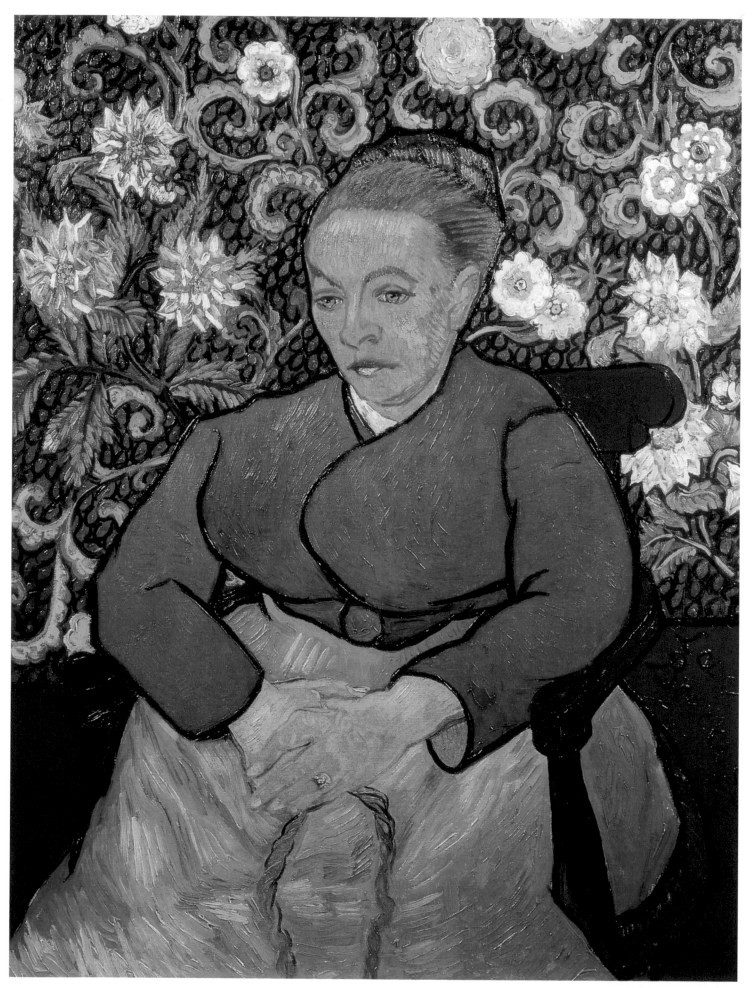

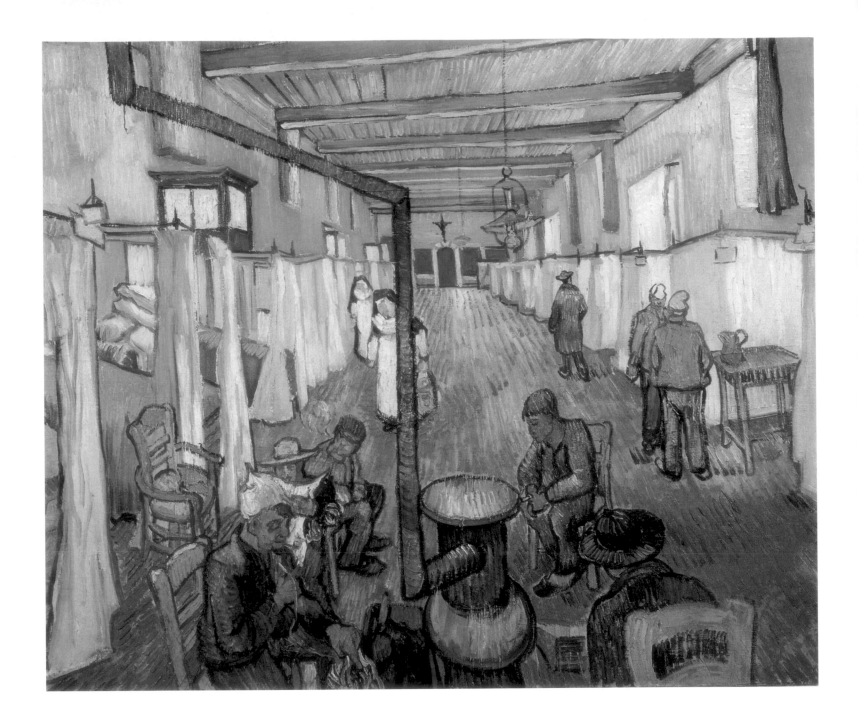

77. **Vincent van Gogh**, *La Berceuse (Portrait of Augustine Roulin)*, 1889. Oil on canvas, 92 x 73 cm. Kröller-Müller Museum, Otterlo.

78. **Vincent van Gogh**, *The Ward in the Hospital at Arles*, 1889. Oil on canvas, 74 x 92 cm. The Oskar Reihart Collection "Am Römerholz" Winterthour.

79. **Vincent van Gogh**, *The Exercise Yard* (after *Gustave Doré*), 1890. Oil on canvas, 80 x 64 cm. The Pushkin State Museum of Fine Arts, Moscow.

drew and painted the blossoming fields, gipsy tilt carts, gardens, olive groves, vineyards and streets of Arles. Finally, he discovered the Mediterranean sea; the old fishing port *Saintes-Maries-de-la-mer* was near Arles, and Vincent went there to spend a few days. He painted fishing boats on the high sea (*Fishing Boats at Sea*) and beached on the sand (*Fishing Boats on the Beach*). At times these motifs again evoked memories of the Japanese engravings. Van Gogh had already painted the sea in Holland, and now water had become one of his preferred motifs for colour.

On the subject of his new motifs, Van Gogh had to solve the problem of black and white. In Impressionist and Pointillist painting, the world was full of colour overtones; black or white did not exist. For Van Gogh, colour consisted of a little of both, but he refused to abandon black and white, and attempted to integrate them into his contrast system to strengthen colours.

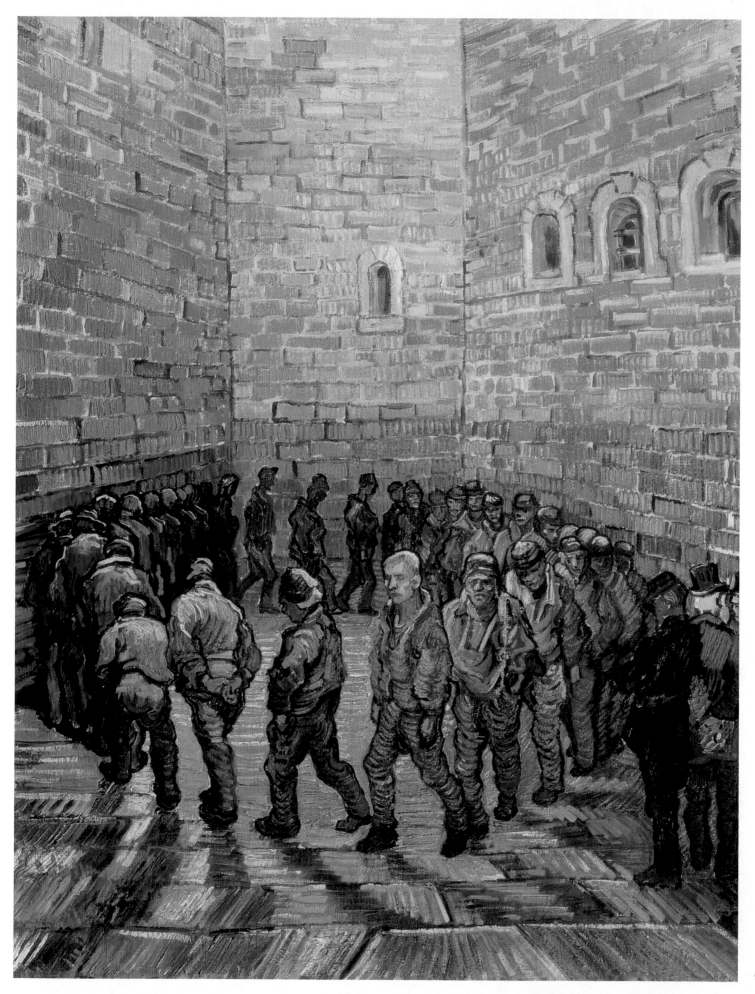

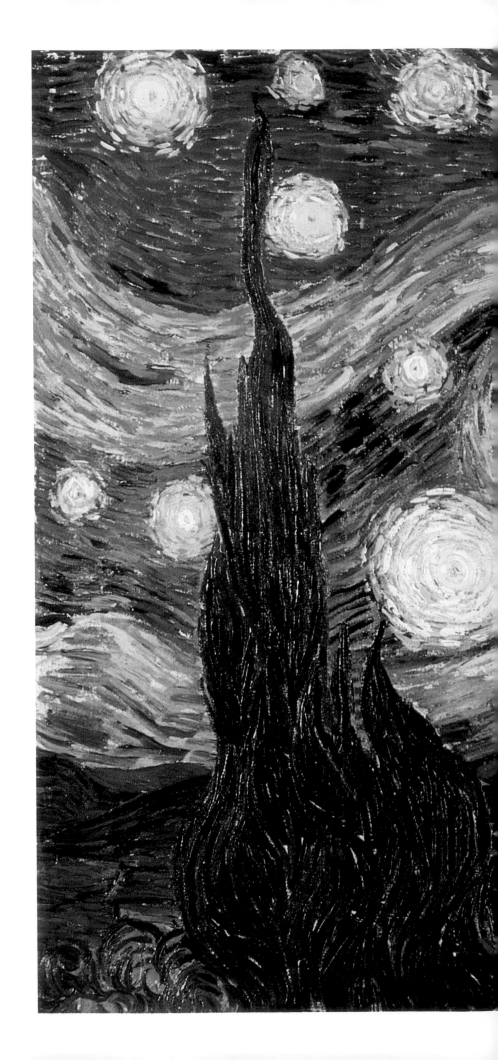

80. **Vincent van Gogh**,
The Starry Night, 1889.
Oil on canvas, 73.7 x 92.1 cm.
The Museum of Modern Art,
New York.

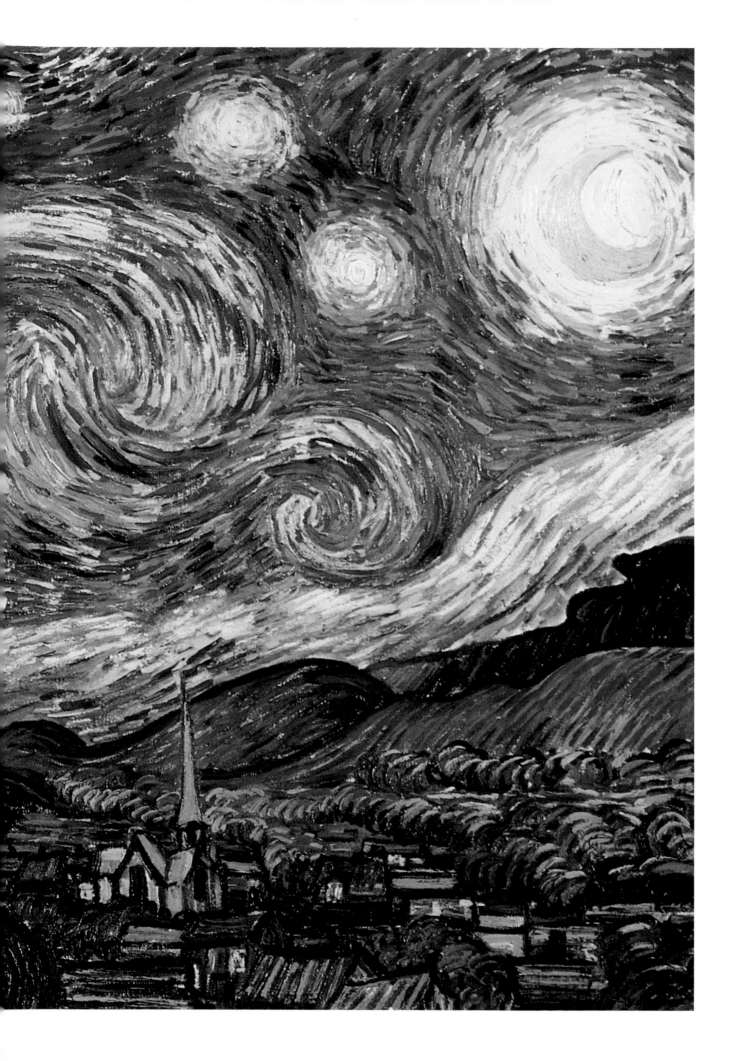

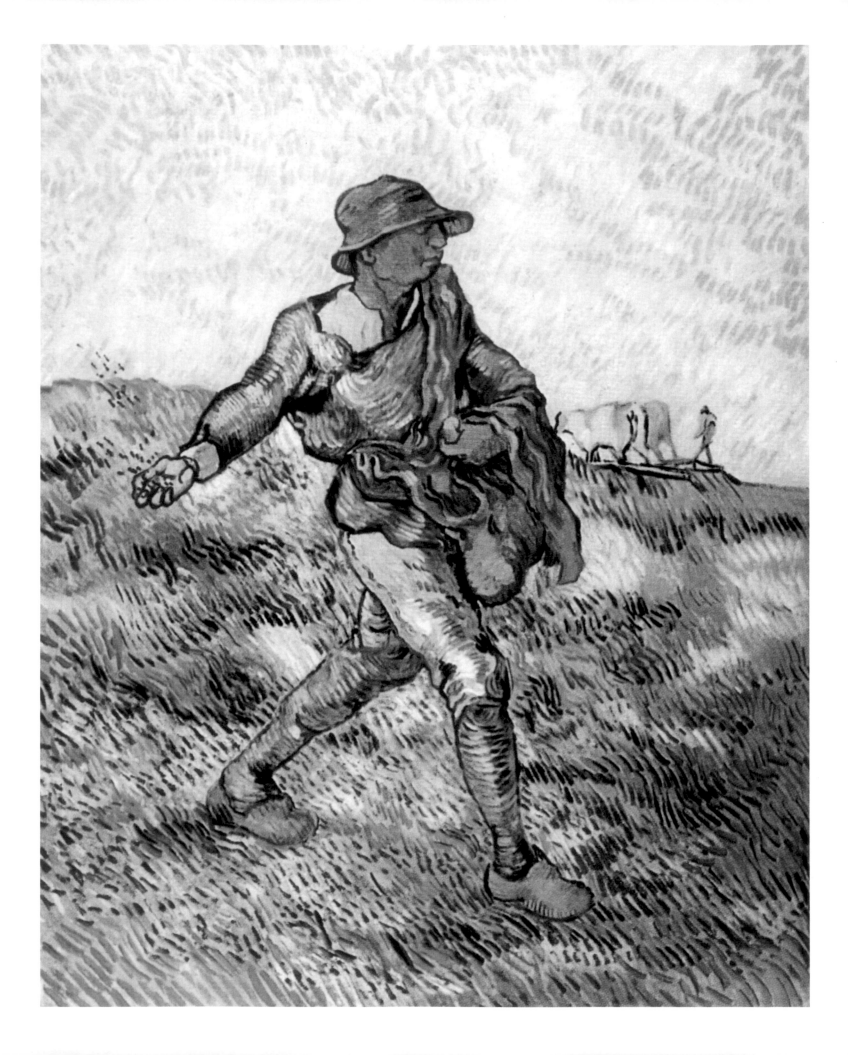

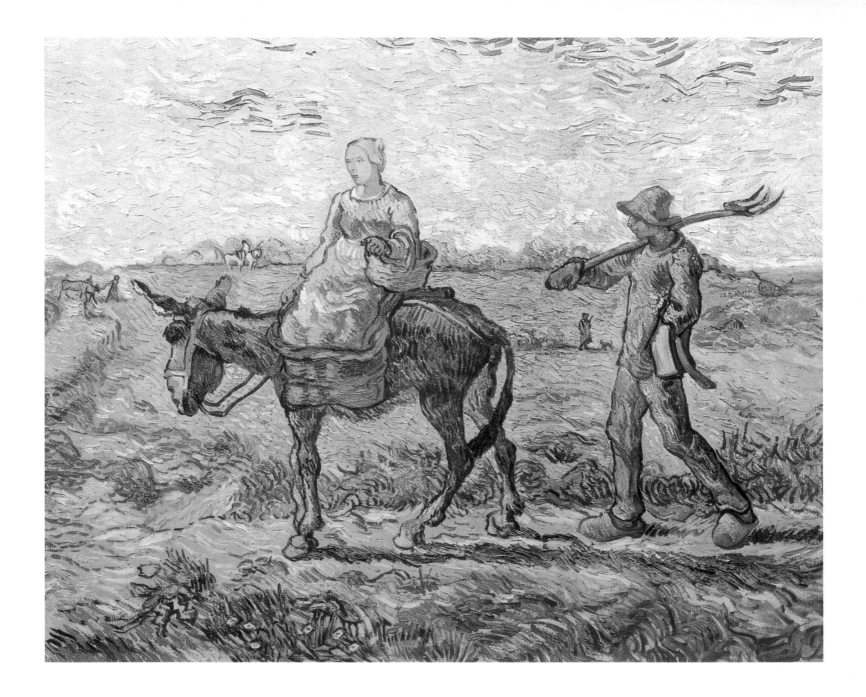

Another motif was the people of Provence. From the very beginning, Van Gogh's eye caught the remarkable variety in Arles: young and old women, loaders on barges, fishermen. Gradually, he began distinguishing among them those that interested him the most. In his portraits, colour was just as important as character. From that time on, colour was an expression of his tension, of his all-consuming passion for self-expression, his zeal to capture with paint the rhythm of life. It was in Arles that he became the Van Gogh who blazed a trail where no one had gone before.

Vincent was finally able to rent a small house to work, but also to house a future community of artists, a dream he had never ceased to have. In September 1888 he moved into the house and began decorating it. To Theo he wrote, "One fine day you will receive a painting that represents my small house on a sunny day". (*The Bedroom*, p. 89). He painted the bedroom of the house. The yellow furniture, yellow floor, and red blanket contrasted with the blue shadows of the white walls. Despite the closed shutters, the room appeared filled with light.

81. **Vincent van Gogh**, *The Sower (after Millet)*, 1889.
Oil on canvas, 80.8 x 66 cm.
Stravos S. Niarchos Collection.

82. **Vincent van Gogh**, *Morning: Going out to work (after Millet)*, 1890.
Oil on canvas, 73 x 92 cm.
The State Hermitage Museum, St. Petersburg.

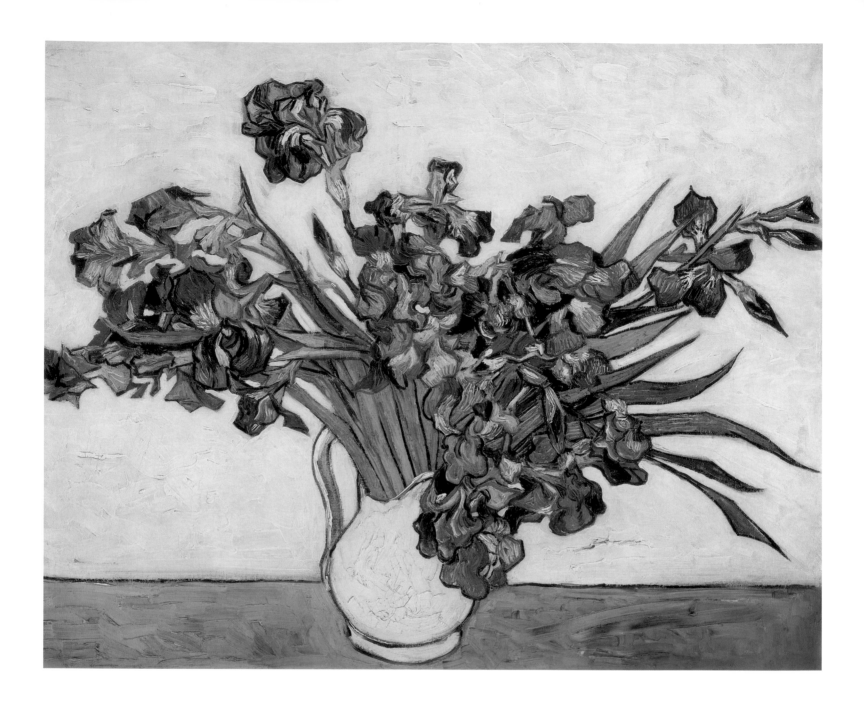

83. Vincent van Gogh, *Irises*, 1890.
Oil on canvas, 73.7 x 92.1 cm.
The Metropolitan Museum of Art,
New York.

84. Vincent van Gogh,
Still Life with Irises, 1890.
Oil on canvas, 92 x 73.5 cm.
Van Gogh Museum, Amsterdam.

"In the room where you or Gauguin will stay, if he comes, the white walls are decorated with large yellow sunflowers," continued Vincent.[30] He had already painted sunflowers in Paris. The dazzling yellow sunflowers from Arles shone in a ceramic vase before a blue wall. (*Sunflowers*, p. 95). Van Gogh painted them several times. The painter sculpted the heart of the flower in dense layers, producing the feeling of real and rough brushwork the hand wants to touch.

Van Gogh worked remarkably in Provence, but it did not give him a sense of peace and well-being. Vincent was thinking more and more often of Holland. In November 1888, he made a painting of two girls from Arles walking in the garden; this garden was surprisingly similar to the garden of his parents in the village of Etten (*Arlésiennes. Souvenir of the Garden of Etten*).

All these months Vincent had worked frantically, under constant pressure. Thus, it was truly in Arles that the great painter Van Gogh was "born".

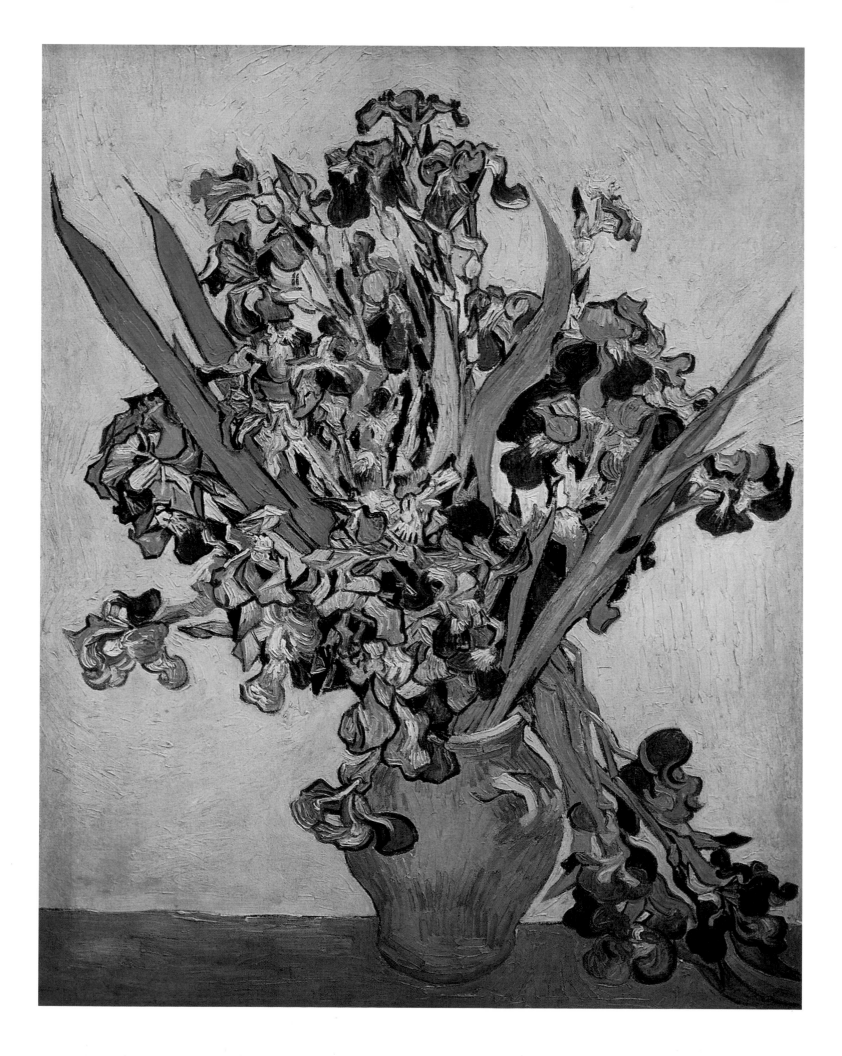

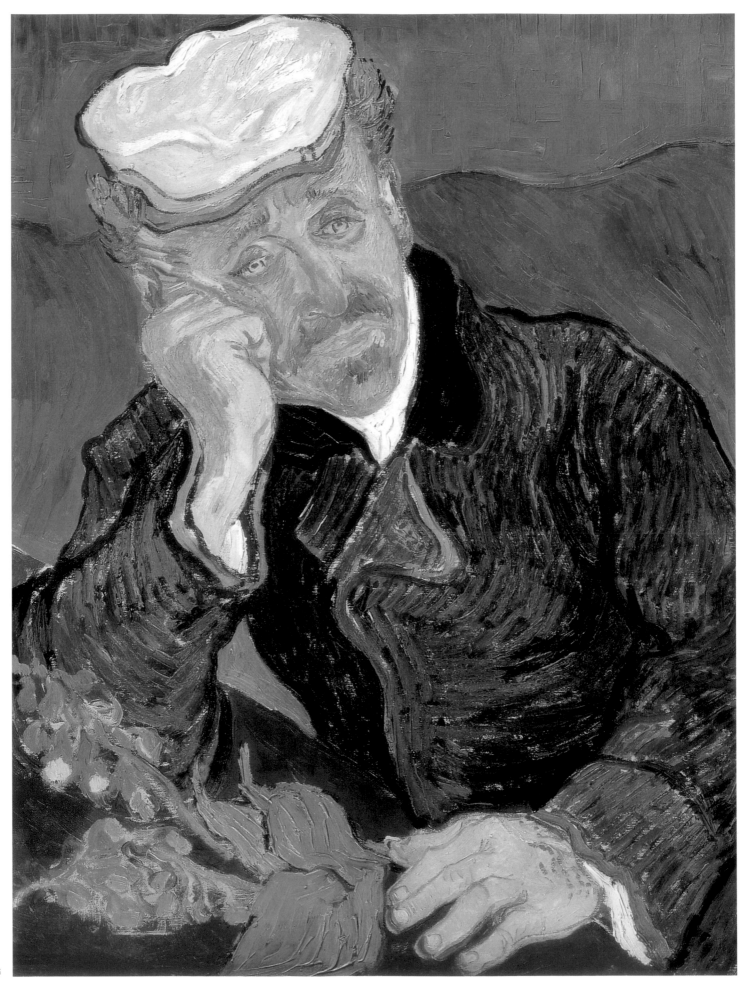

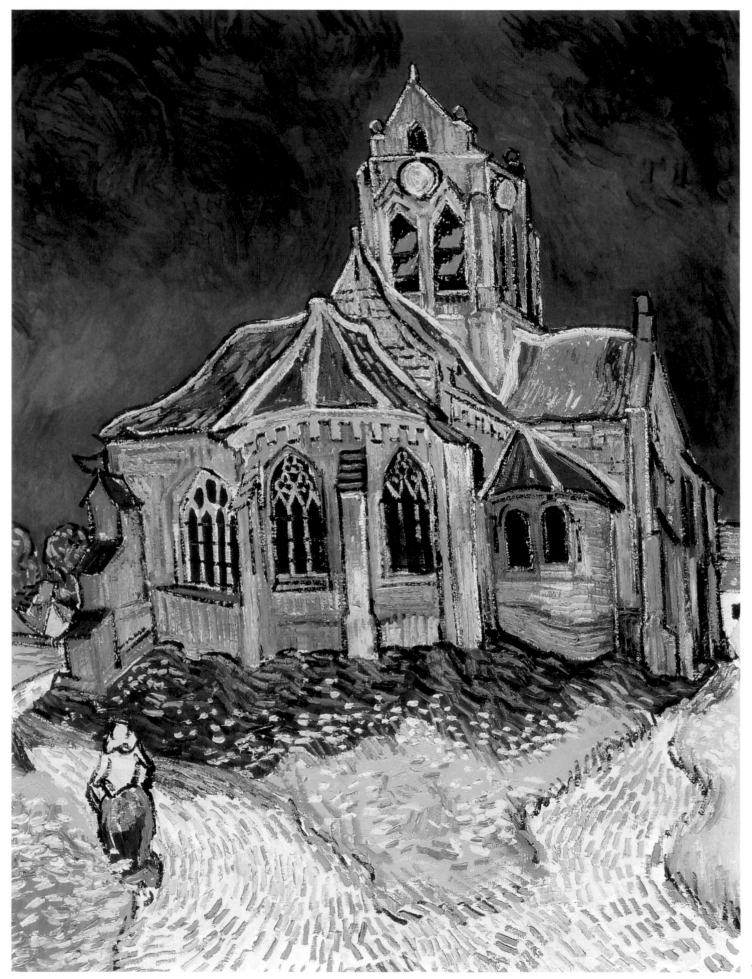

In this period, Vincent was already working with Gauguin. Paul Gauguin arrived in Arles on October 20, 1888. Van Gogh's dream to organise an association of artists came true, even if Gauguin was the only one who had agreed to participate in his project.

Despite this, Vincent considered Gauguin to be a great artist and wanted to give him the opportunity to breathe and work quietly and peacefully, in a style befitting a free artist."[31] He hoped that by working together in a few years they would end up becoming successful.

Vincent's letters were full of admiration for Gauguin's talent and human qualities. He was proud that Gauguin praised his paintings. Van Gogh very much wanted their communal life to work. Gauguin, however, did not share Vincent's naive confidence.

Their diverging opinions regarding painting were the greatest obstacle to a peaceful communal life. They went to Montpellier to visit a museum where they saw the paintings of Delacroix, Courbet and many other artists. "Gauguin and I discussed at length Delacroix, Rembrandt, etc. Our discussions were extremely heated. And after them we sometimes felt as empty as a discharged electric battery."[32] This was the cause of the tragedy that occurred December 23. Van Gogh brought part of an ear that he had cut off to one of the prostitutes in a local brothel. The increasingly heated atmosphere in their common house, as well as Gauguin's constant teasing, set off Vincent's first attack. Finding Vincent in a pool of blood in his bedroom, the terrified Gauguin had his friend sent to hospital and called Theo to Arles. He then left for Paris and never saw Vincent again. In hospital Vincent was placed under the care of Doctor Rey, a twenty-three-year-old physician. The doctor reassured Theo, assuring him that his brother would quickly recover. When he left the hospital on January 7, Vincent showed the studio to Rey. Thankful for the doctor's care and friendship, Vincent painted his portrait (*Portrait of Dr. Rey*, p. 96). He tried to reassure his family in every possible way, and believed himself, that he had escaped with nothing worse than a fright. Right after his discharge from the hospital, Van Gogh painted a self-portrait with his bandaged ear. In it, he appears to be very calm. There is no despair in his face. At the beginning of February his strength seemed to have returned, and he wanted to work in the open air. But on February 9, he was re- admitted to hospital, having suffered from hallucinations. February 22, Vincent wrote to his brother, "The weather remains sunny and windy. I am spending a lot of time outdoors, but still sleep and board in the clinic."[33] The doctors were going to send him to Aix for treatment, but Van Gogh felt better in Arles, to which he was accustomed, and where he had friends. However, in March neighbours complained of his behaviour to the mayor of Arles, who ordered Vincent to again be sent hospital. This time, in his own words, "in a locked, solitary cell, under the supervision of a nurse".[34] The house where he worked had been sealed up. It could be opened only with the help of Signac, who had arrived in Arles to took an active part in Van Gogh's destiny. Despite his constant agitation, Vincent only painted when he felt capable of doing so. Several times he rented a small room at Dr. Rey's, who gave him his support. But even Van Gogh himself felt that he had to leave for his recovery and agreed to treatment at the asylum of Saint-Paul de Mausole in Saint-Remy-de-Provence.

The director of the hospital in Saint-Rémy allowed Van Gogh to work and even gave him a studio – there were many free rooms at the hospital. Vincent started painting what he saw. He was not allowed to go outside the limits of the hospital garden, but that did not bother him.

Vincent drew everything he saw: a "death's head" moth, grasshoppers, irises and even simple blades of grass. As soon as he was allowed to go beyond the gate, he started to paint

85. **Vincent van Gogh,**
Dr. Paul Gachet, 1890.
Oil on canvas, 68 x 57 cm.
Musée d'Orsay, Paris.

86. **Vincent van Gogh,** *The Church at Auvers-sur-Oise seen from the Chevet*, 1890.
Oil on canvas, 94 x 74.5 cm.
Musée d'Orsay, Paris.

87. **Vincent van Gogh,**
Two Little Girls, 1890.
Oil on canvas, 51.2 x 51 cm.
Musée d'Orsay, Paris.

blossoming meadows, and later yellow fields. He painted olive trees and the huge plane trees on the streets of the small town of Saint-Rémy. His illness, however, never left him. One day he suffered an attack in the field where he was working. Nevertheless, he managed one day to go to Arles and bring back the paintings still there, which he planned on correcting and redistributing.

Vincent was not going to surrender. He drew and painted as if possessed, hoping that his thirst for work would help him recover. When there was no model, he copied with oil the engravings that his brother had sent to him at his request. He had always loved Millet, and now copied his scenes of labouring peasants. Van Gogh's copies, painted with his nervous energy and passion, gained a life of their own, independent of their original source.

In his letters to Theo, he never mentioned the studies he painted at night. In Arles, Vincent had already been captivated by the unusual beauty of the southern night sky, which he immediately pictured with the colours of his palette, "The dark blue sky was studded with darker clouds, bluer than the most intense cobalt, or paler than the bluish whiteness of the Milky Way. Against this blue background stars shone bright: greenish, yellow, white, pink; shinier, more similar to jewels, than what we have in our country and even in Paris; they can be compared to opals, emeralds, lapis lazuli, rubies, sapphires"[35] (*The Starry Night*, p. 16-17). In his present condition, when days full of despair alternated with moments of hope, the night sky shone with new beauty. Dark blue, stretched above tiny houses, the sky in this painting is filled with that mysterious life beyond human perception. The stars and the moon are brightly wreathed, while celestial bodies move among one another in entangled spirals. And man appears small and helpless in the vortex of life in the universe (*Starry Night*, p. 100-101). In this world all scales are modified. Small human figures dream on a terrible, rough path resembling an impetuous river. Huge cypresses rush into the night sky like flames. (*Country Road in Provence by Night*). Until then, no one before Van Gogh had managed or even tried to express human passions so powerfully through colours on canvas.

But Vincent was still hopeful. Theo wrote to him about a remarkable physician named Dr. Gachet, who was a friend of the impressionist artists and cured with homeopathy. In the spring of 1890, Vincent wrote to his brother that his last attack had passed like a storm, and that he was working with frenzied fervour. He was ready to return to Paris. On May 17, 1890 Theo met his brother at the Gare de Lyon in Paris. Vincent made the acquaintance of Theo's wife and their young son, then three days later, on May 20, left for Auvers-sur-Oise.

Vincent began working on Dr. Gachet's portrait at once. In a letter from June 4, he described his colour plan to Theo, "…the head with a white cap, very fair, bright hair, his fingers are also light-coloured, a blue jacket against a cobalt blue background. He is sitting, leaning on a red table on which lies a yellow book and a twig of violet fox-glove"[36] (*Dr. Paul Gachet*, p. 106). The extraordinary intensity of the colours, their sharp contrast, the deformed features of the doctor's face and the twisting line of the contour contribute to the image of a nervous, unbalanced and sad person, as Vincent saw him. It is difficult to determine just whose character was revealed in this painting – the model's or the artist himself? For Van Gogh, each painting, regardless of its subject, was an opportunity and a means for immodest disclosure of his own private world, his pains and despair.

88. **Vincent van Gogh**, *Wheat Fields with Crows*, 1890.
Oil on canvas, 50.5 x 103 cm.
Van Gogh Museum, Amsterdam.

89. **Vincent van Gogh**, *Japanese Vase with Roses and Anemones*, 1890.
Oil on canvas, 51.7 x 52 cm.
Musée d'Orsay, Paris.

90. **Vincent van Gogh**, *Pink Roses*,
1890.
Oil on canvas, 32 x 40.5 cm.
Ny Carlsberg Glyptotek,
Copenhagen.

Van Gogh left the hotel where he had been staying, to move to a tiny room at Ravoux's on the main street, opposite the town-hall. He worked with unprecedented energy, even for him, spending each day painting. He had many projects, encompassing all possible motifs in Auvers.

The local church received the most fantastic embodiment in Van Gogh's painting. A Roman construction finished in Gothic style, this church stood above the village, next to the hill where a rural cemetery lay nearby. On Van Gogh's canvas, the broken lines set the church in motion, the sandy paths run about the building like rivers, and the contrast of the red tiles with the blue sky filled the painting with anguish (*The Church of Auvers-sur-Oise seen from the Chevet*, p. 107).

He and Dr. Gachet did indeed become friends. He painted the portrait of Dr. Gachet's nineteen-year-old daughter sitting at a piano. When it was possible to find models in the village, he painted the local countrywomen.

Most of all, Van Gogh was drawn by the fields. He went to the neighbouring hills to paint the wide spaces that surrounded him "with green, yellow and green-blue tones"[37] in the same way he had painted the panorama of Provence from the hills of Arles (*Landscape near Auvers After the Rain*). He went to the fields every day, like going to work. He lived in a constant state of agitation, and Dr. Gachet, who was also too nervous, was not living up to his expectations. Vincent saw him as another sick individual. Van Gogh was afraid of renewed attacks and wanted to have enough time to concentrate as much as possible on his painting. He worked under such strain that it led to complete exhaustion. On July 27, Vincent went to the cornfields and shot himself in the chest with a revolver. Vincent died on July 29 in Auvers, in the presence of Dr. Gachet and Theo van Gogh, who had come from Paris. He was buried in the rural cemetery on the hill behind the church. Later, his brother Theo joined him there for his last sleep. Auvers became a monument of Vincent van Gogh's tragic destiny and dazzling creativity.

91. **Vincent van Gogh**,
Almond Blossom, 1890.
Oil on canvas, 73.5 x 92 cm.
Van Gogh Museum, Amsterdam.

PAUL GAUGUIN (1848-1903)

*I*n 1886, the works of Gauguin were presented at the Eighth Impressionist Art Exhibition. Paul Gauguin was ten years younger than the Impressionists, which in this case is of major importance. Indeed, when Gauguin was still a child, Monet, Renoir and Sisley already used to meet up in Professor Gleyre's studio and were starting their artistic journey. Nadar, the great photographer who offered them the premises for their first exhibition, was a friend of Gauguin's tutor, Gustave Arosa. It is thus hardly surprising that Gauguin, an amateur painter of twenty-six, followed the turns taken by the newly born Impressionist movement with emotion. And it was of course an honour for him when Félix Fénéon counted him as one of them in his reviews of the exhibitions. Indeed, for Gauguin, to belong to Impressionism was first of all the proof that he was standing against the whole classical system of the *Académie des Beaux-Arts*.

Paul Gauguin was born on June 7, 1848 in Paris. His mother, Aline Chazal, was the daughter of the painter and engraver André Chazal and Flora Tristan, a writer of notorious fame and a strong believer in Saint-Simon's theories. His father, Clovis Gauguin, was a journalist at the *National*, a moderate Republican newspaper during the 1848 Revolution. At the end of the revolution, in 1849, he left Paris and sailed with his wife and children for Peru where his wife's family was settled, but he died on the way. Paul Gauguin, his mother and sister were joyfully welcomed by his great uncle Don Pio Tristan Moscoso in Lima. All his life, Gauguin kept wonderful memories of the six years that he spent in a marvellous climate with Don Moscoso's welcoming family.

The return to France was hard for Gauguin. He had to learn French for he had only spoken Spanish so far. His memories from childhood attracted him towards faraway exotic lands, but his average results in school did not allow him to enter the *École Navale*. In 1865, Gauguin embarked on the *Lizitano* in Le Havre as an ordinary seaman. During his years of service in the merchant navy, as well as during his military service in the navy, Gauguin travelled all over the world visiting Latin America, India, the Mediterranean sea and Scandinavia. He only came back to Paris in 1871 at the end of the Franco-Prussian war. His mother died around the same time, leaving her old friend, the photographer and collector Gustave Arosa, in charge of her children.

Arosa did everything that he could for his godson. With some help from his brother who was a banker, he managed to have Paul recruited at the age of twenty-three by the stockbroker Paul Bertin, whom he left at the end of the 1870s to join a bank. His relatively stable financial security allowed Gauguin to marry Mette Gad, a beautiful Danish girl who had been staying in Paris on holiday in 1873 and to live a moderately bourgeois lifestyle.

Gauguin was a devoted employee and a model father. He only had one obsession, which was to spend his free time painting landscapes outdoors. Gauguin's interest in drawing and painting was mostly due to Arosa who, along with his daughter, an amateur painter too, was encouraging him. Paintings by Courbet, Delacroix, Corot or even Pissarro were to be found in Arosa's large collection. It seems that it would be at Arosa's that Gauguin met Pissarro for the first time. In 1879 he spent the summer in Pontoise painting outdoors beside the patriarch of Impressionism and listening to his advice. "He has been one of my masters and I do not disown him" Gauguin wrote later.[38] A successful deal in the stock exchange allowed Gauguin to buy a few paintings, mostly

92. **Paul Gauguin**, *Nafae faa ipoipo? (When Will You Marry?)*, 1892. Oil on canvas, 101.5 x 77.5 cm. Kunstmuseum, Basel.

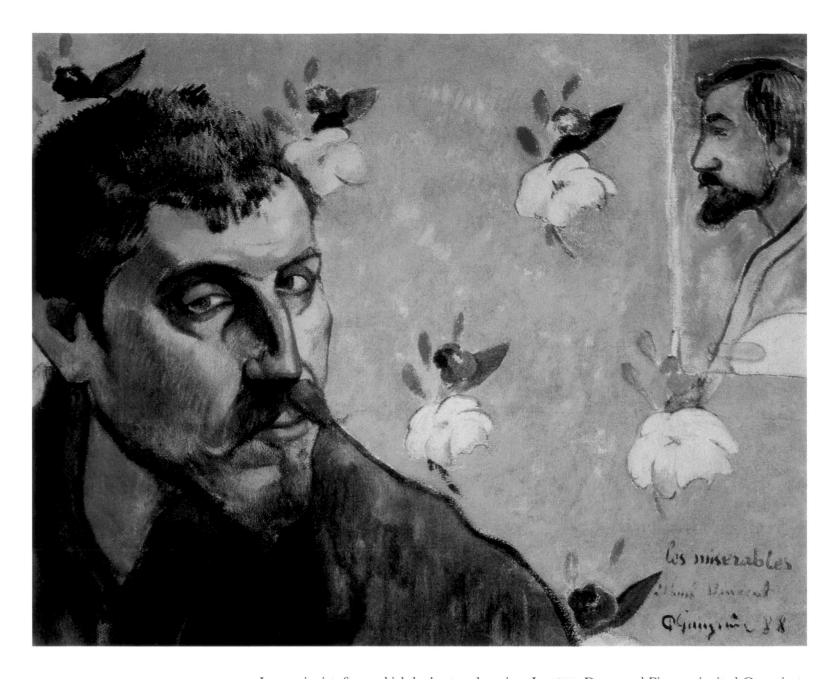

93. **Paul Gauguin**, *Self-Portrait
 "Les Misérables"*, 1888.
 Oil on canvas, 45 x 55 cm.
 Van Gogh Museum, Amsterdam.

94. **Paul Gauguin**, *Woman Sewing*,
 1880.
 Oil on canvas, 114.5 x 79.5 cm.
 Ny Carlsberg Glyptotek,
 Copenhagen.

Impressionist, from which he kept on learning. In 1879, Degas and Pissarro invited Gauguin to take part in the fourth Impressionist exhibition where he showed a painting and a sculpture.

Of course, the works of this amateur, this 'Sunday painter' did not go unnoticed and were not only recognised as impressionist but also as those of a pupil of Pissarro. Such recognition is not really surprising for, at the time, the works of Gauguin were stylistically very close to those of the Impressionists.

In 1883, at the age of thirty-five, Gauguin finally decided to resign from his job in order to fully dedicate himself to art. At the time he was gaining a growing authority amongst his art colleagues. He was a recognised and most respected participant in the Impressionist exhibitions. At the fifth Impressionist exhibition in 1880, eight of his works were on display; at the sixth in 1881, six paintings and two sculptures; at the seventh in 1882, eleven paintings, one pastel and a sculpture. Paul Gauguin was always loitering in the Nouvelle Athènes Café where he spent time with Édouard Manet, Impressionist artists and critics. At the last exhibition in 1886 Gauguin displayed nineteen paintings and a wooden bas relief.

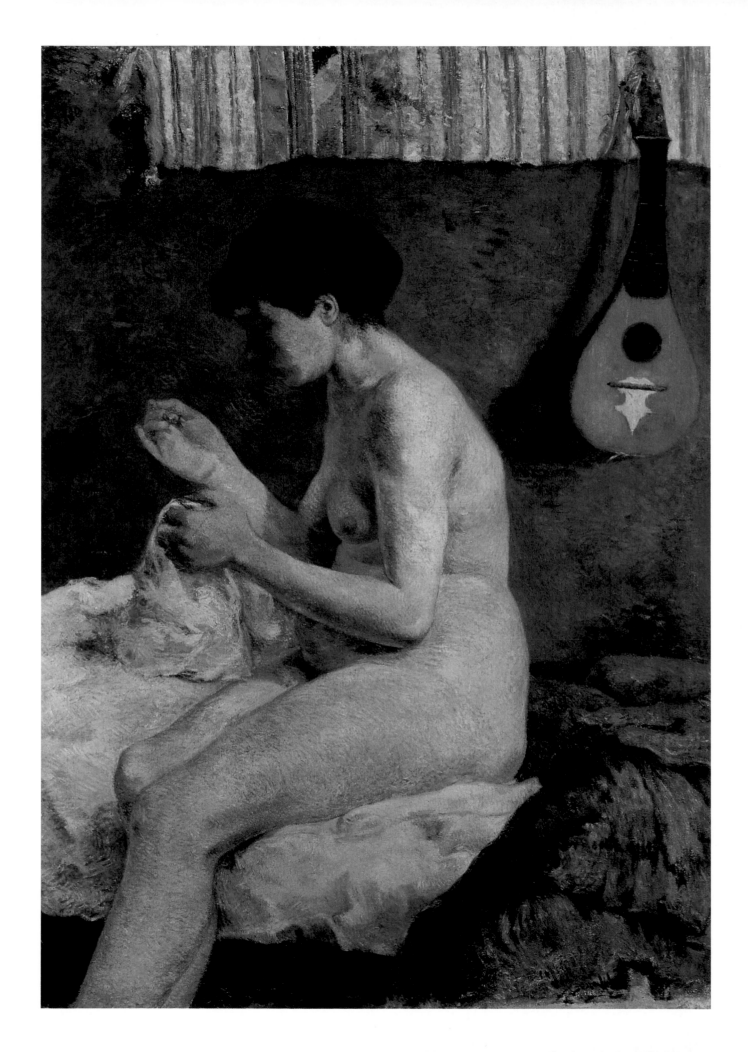

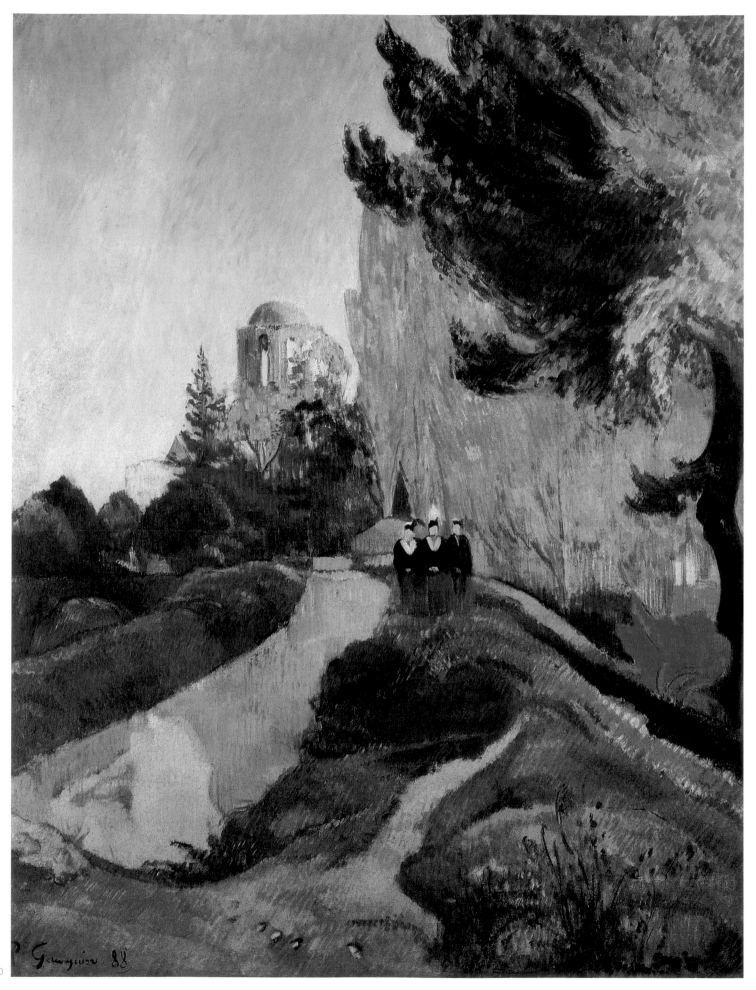

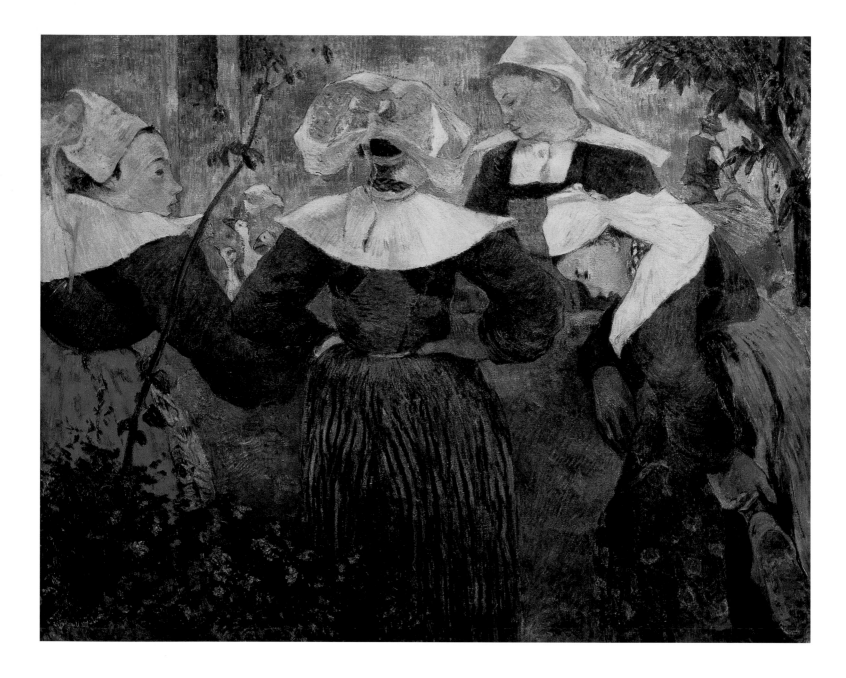

However, it was difficult for him to sustain the family without a permanent job. At that time, he and Mette already had five children. Gauguin first took his family to Rouen, then to Copenhagen, Mette's native city. But the painter found himself in an unbearable situation there; his wife's family reproached him with being incapable of earning money and, in fact, he became very isolated.

During the summer of 1885, Gauguin came back to Paris and started his new life as an artist. He was not yet forty. As an artist he was incredibly prolific, carrying out numerous paintings and sculptures. Having been introduced to the ceramist Ernest Chaplet by the Impressionist engraver Félix Bracquemond, he passionately took up ceramics. He travelled throughout France, showing his work in the exhibitions of various cities. However, his life in Paris turned out to be more difficult than he could have imagined. "I have no money, no home, no furniture," he writes to his wife in August 1885. "(…) If I manage to sell a few paintings, next summer I will stay in an inn in a hole of a place in Brittany to paint and live on a budget."[39]

95. **Paul Gauguin**, *The Alyscamps*, 1888.
Oil on canvas, 91.5 x 72.5 cm.
Musée d'Orsay, Paris.

96. **Paul Gauguin**,
Four Women from Brittany, 1886.
Oil on canvas, 92 x 71 cm.
Neue Pinakothek, Munich.

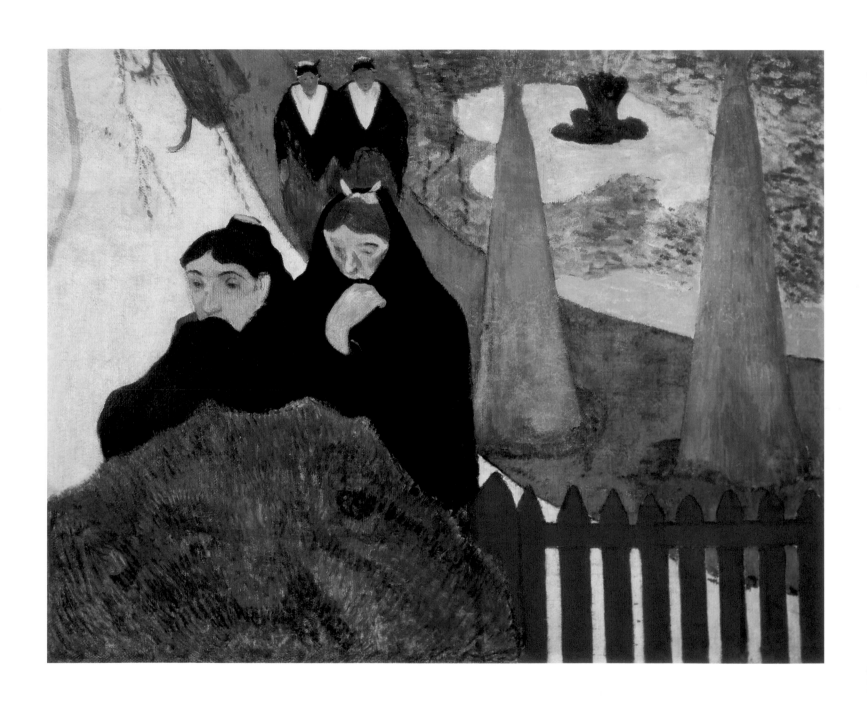

97. **Paul Gauguin**,
The Arlésiennes (Mistral), 1888.
Oil on canvas, 73 x 92 cm.
The Art Institute of Chicago,
Chicago.

98. **Paul Gauguin**, *Café in Arles*,
1888.
Oil on canvas, 72 x 92 cm.
The Pushkin State Museum of
Fine Arts, Moscow.

99. **Paul Gauguin**,
The Schuffenecker Family, 1889.
Oil on canvas, 73 x 92 cm.
Musée d'Orsay, Paris.

Souvenir à bon Schuffenecker 1889

Towards the end of the summer of 1886, Gauguin indeed discovered Brittany. He spent three months in the charming little town of Pont-Aven, at Gloanec's inn, the same place where painters usually met during the summer. It appears clearly in his Breton works that his style started to change slightly. His way of painting got rid of the Impressionists' spontaneity and objectivity. The touches of colour, whilst still split up, started getting rigorously applied in the shape of a wooden round crown. But above all the relationship of the painter with nature's colours changed. The intensity of colours and the contrasts between the reddish-brown and green, noted by Félix Fénéon at the exhibition of 1886, suddenly came out. In Brittany Gauguin met Charles Laval who became his 'partner in crime' in the colourful life that he lived.

On April 10, 1887, Gauguin embarked on a ship for Panama, accompanied by his friend Laval of course.

But Panama did not come to their idealistic expectations. In order to earn some money they had to work as navvies during the building of the Panama Canal which only brought them nasty diseases. He finally got back to France as an ordinary seaman on a sailing ship. Other adventures were to happen to him later.

In January 1888, he stayed at Mrs Gloanec's inn. The loneliness of Pont-Aven in winter and the austerity of nature itself in Brittany had a positive influence on his thinking. Gauguin realised that painting was the only way for him.

First of all, time was needed for him to assimilate everything that he had learned and that was awaiting him in the Parisian artistic world. As ever, he continued to have a lot of respect for Impressionism and admired Cézanne. But he had not ceased dreaming of the tropics and he thought that a new stay in Martinique would be fruitful and give off the results that he was waiting for.

"I have done a painting for a church; it got rejected of course," he writes from Pont-Aven in October.[40] *Vision of the Sermon: Jacob Wrestling with the Angel* (p. 127) takes place in a village in Brittany. Coming out of the church after the sermon some Breton women see with their own eyes the struggle of Jacob with the Angel, which the priest has just talked about. Gauguin offered that painting to the little church of the village of Nizon near Pont-Aven, but the priest rejected it on the grounds that he feared that his parishioners would not understand it. The new painting by Gauguin was different not just from classical paintings, but also from the style of his contemporaries. There is no point in looking for realistic life or the objective representation of it in his works. In that painting, the field, which is not green but vivid red, is cut in two strictly diagonal parts by a tree trunk. The figures of Jacob and the Angel become entangled in the process of struggling, which creates a green flat zone over the red background. The women's white bonnets are flat too, and constitute the compositional limit of the foreground. Each patch of colour is surrounded with a contour, colours are amplified as much as possible and the whole composition reminds one of stained-glass windows or of compartmentalised enamel work.

In the summer, as in the past, Gloanec's inn was full of artists belonging to two rival groups: the classic and their opposite, the avant-garde followers who were grouped around Gauguin. He was himself indisputably recognised as the leader of the group which took the name of The École de Pont-Aven. The young Émile Bernard, who was strongly drawn to Symbolism, admired Gauguin. He was keen on theory and first painted Breton women in their national costume in a style close to compartmentalisation. Unarguably Bernard's works played a major role in Gauguin's quest for a new type of language. However, due to his

100. **Paul Gauguin**, *Vision of the Sermon (Jacob Wrestling with the Angel)*, 1888.
Oil on canvas, 72.2 x 91 cm.
National Galleries of Scotland, Edinburgh.

101. **Paul Gauguin**, *Breton Children on the Seaside*, 1889.
Oil on canvas, 92 x 73 cm.
The National Museum of Western Art, Tokyo.

102. **Paul Gauguin**, *The Yellow Christ*, 1889.
Oil on canvas, 92.1 x 73.4 cm.
Albright-Knox Art Gallery, Buffalo.

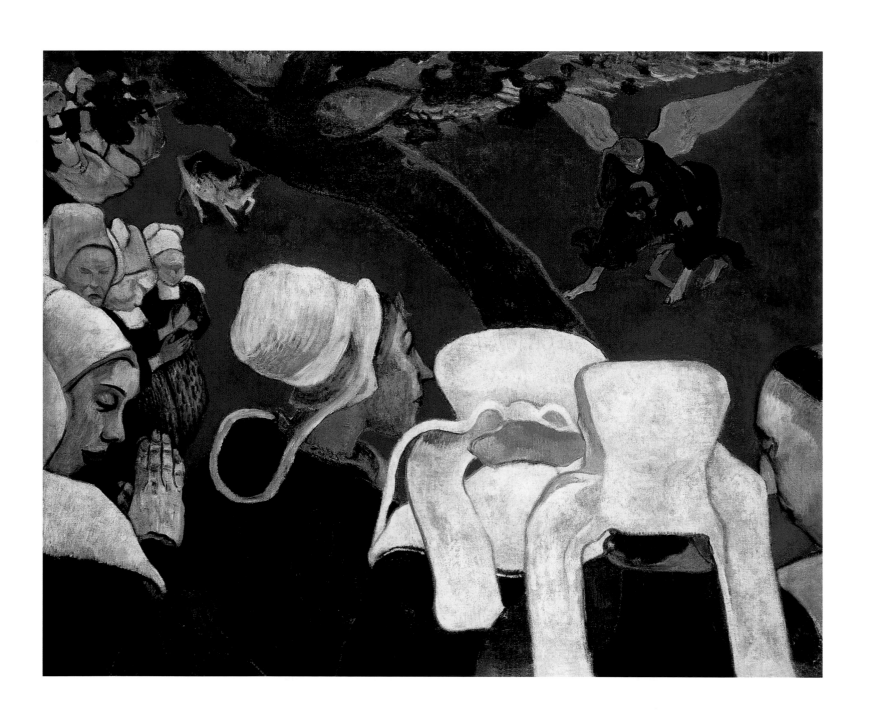

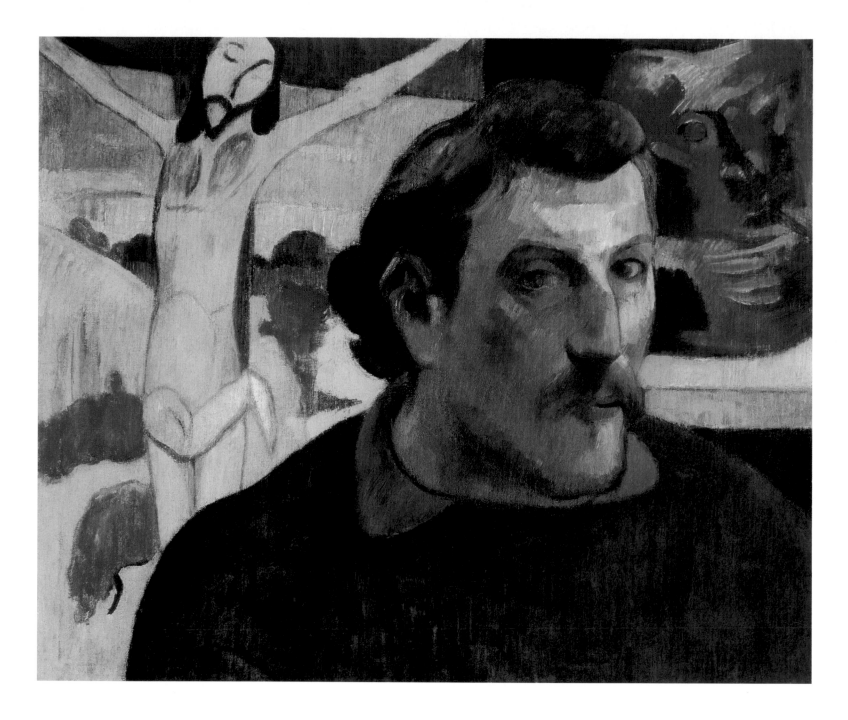

strong personality and original talent, Gauguin developed the decorative style to its most brilliant and individual form.

The still lifes painted in Brittany – *Still Life with Three Puppies* and *The Celebration Gloanec* – give testimony of Gauguin's quest for a decorative composition. These paintings show no trace of the Impressionists' spontaneity: no natural lighting, no shade interferes in the composition of the painting, the surface of the table is laid on canvas, the form and colour of objects are carefully balanced. Brittany's solitude and nature seem to have allowed persistent research in successive waves. Its austere rocks where yellow, purple and orange flowers grow together making a great patch of local colours, and even the heavy stones of prehistoric monuments so common in Brittany have facilitated a complete revision of the Impressionist concept of colour. Instead of decomposing colours in little spots, Gauguin denied them an infinity of refined nuances only keeping the main local resonance that he would amplify

103. **Paul Gauguin**, *Bonjour Monsieur Gauguin!*, 1889. Oil on canvas, 113 x 92 cm. Národní Galerie, Prague.

104. **Paul Gauguin**, *Self-Portrait with the Yellow Christ*, 1890-1891. Oil on canvas, 38 x 46 cm. Musée d'Orsay, Paris.

105. **Paul Gauguin**, *The Breton Calvary (The Green Christ)*, 1889. Oil on canvas, 92 x 73.5 cm. Musées royaux des Beaux-Arts de Belgique, Brussels.

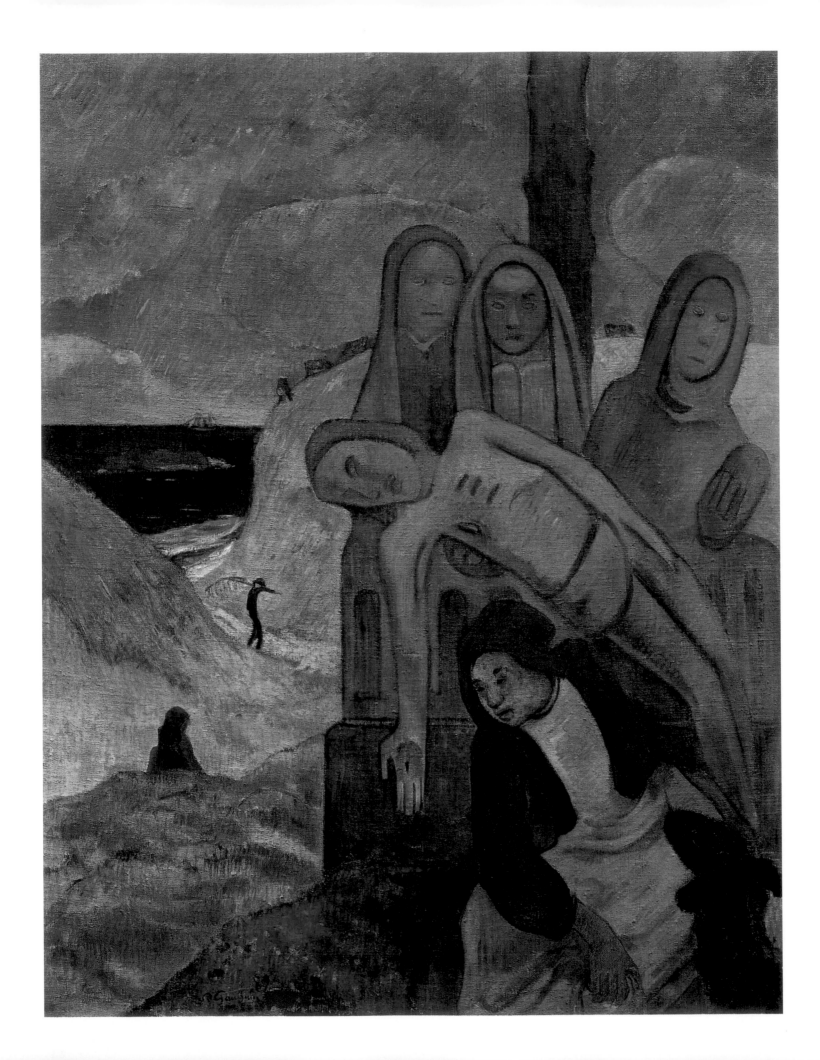

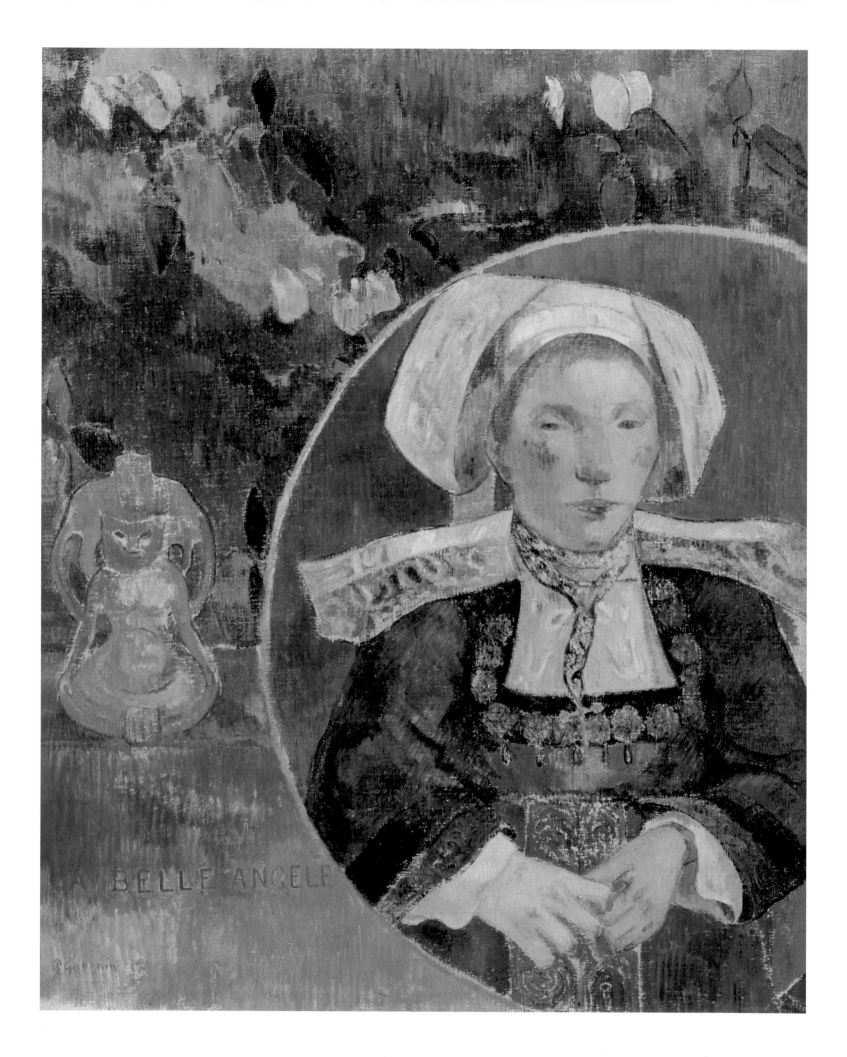

several times. He was still working on nature but kept a right to create, from it, a work based on a new concept, which is what he himself called abstraction. Hence his painting *Vision of the Sermon* was the best expression of his new way of conceiving colour in painting.

Gauguin was fully aware that his new style was a real invention. So he offered the young, enthusiastic and shy painter Paul Sérusier to give him a lesson about working outdoor in the village of Pouldu near Pont-Aven. Gauguin was indeed surrounded by a group of followers who listened to him with respect. Amongst them were Émile Bernard, Armand Seguin, Charles Laval, Filiger, Anquetin and some others as well as Sérusier who would not dare joining them. When he eventually showed his studies to Gauguin, the master suggested painting a landscape over a wooden cigar box that he was carrying with him. A friend of Sérusier, Maurice Denis, told the story later: "How do you see this tree? Gauguin had said in front of some corner of the wood called Bois d'Amour, is he really green? So put some green, the most beautiful green on your palette; and that shade, is it rather blue? Don't be afraid of painting it as blue as possible."[41] The result was a landscape that Sérusier and the painters in his friends that belonged to the Nabis group called the *Talisman* (p. 178)

Gauguin was aware that he was taking an exceptional, personal way that was driving further and further away from Impressionism.

In the autumn of 1888, there was a break in Gauguin's isolation in Brittany. Vincent van Gogh, whom Gauguin had met in Paris in 1886, had been asking him to come to Arles for a long time. Vincent had a dream: to create in the south of France a community of painters that could help them all to overcome the difficulties of life. Theo van Gogh had negotiated a contract with Gauguin according to which the painter had to carry out twelve paintings per year for him whilst Theo would pay him 150 francs of monthly salary. On October 21, 1888, Gauguin finally made the journey to Arles.

For the rational Gauguin, the splendour of Arles did not make the same impact on him as it did on the spontaneous Van Gogh. He said that he needed some time to get accustomed to a new environment. The absence of shades in the south only reinforced his belief that colour was to be laid on canvas with heavy patches of maximum intensity. Everything that he painted there was in the compartmentalised style practised in Brittany. Gauguin failed in becoming accustomed to Arles and Vincent. Nevertheless Gauguin was convinced that he had much to learn from Van Gogh. Gauguin's portrait of Vincent in front of his easel remains as a reminder of their short life together (*Van Gogh's Portrait*). Gauguin's permanent bad temper and Vincent's sensitiveness had a tragic outcome that Gauguin tells in his book *Avant et après*: during a fit of madness Vincent cut his ear and was taken to hospital.

On December 26, 1888, Gauguin returned to Paris.

Gauguin attended the World's Fair with enthusiasm and he spent a lot of time there. Everything was of interest to him, to begin with the modern building of the various pavilions and the Eiffel Tower. The exhibitors of the pavilions dedicated to colonial culture

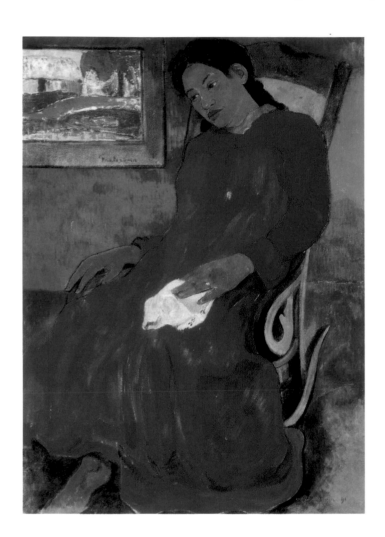

106. **Paul Gauguin**,
The Beautiful Angèle, 1889.
Oil on canvas, 92 x 73 cm.
Musée d'Orsay, Paris.

107. **Paul Gauguin**, *Faaturuma
(Melancholic)*, 1891.
Oil on canvas, 93.9 x 68.2 cm.
Nelson Atkins Museum of Art,
Kansas City.

108. **Paul Gauguin**, *La Orana Maria
(Hail Mary)*, 1891.
Oil on canvas, 113.7 x 87.6 cm.
The Metropolitan Museum of Art,
New York.

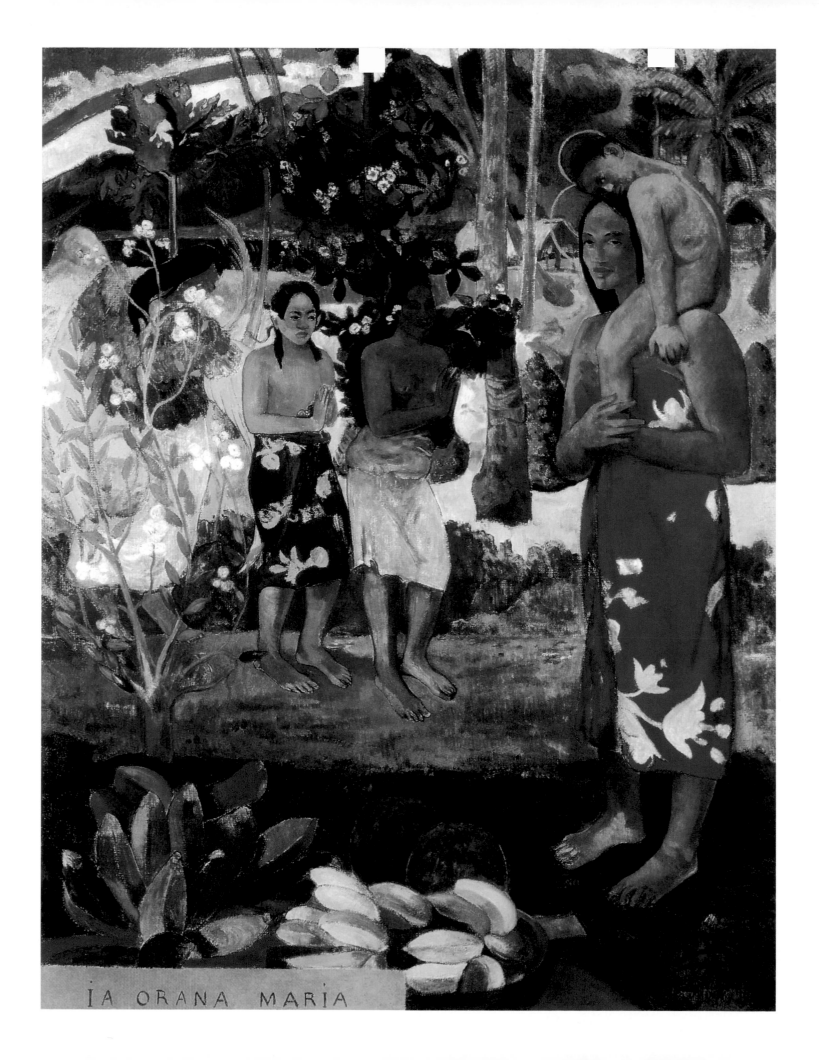

IA ORANA MARIA

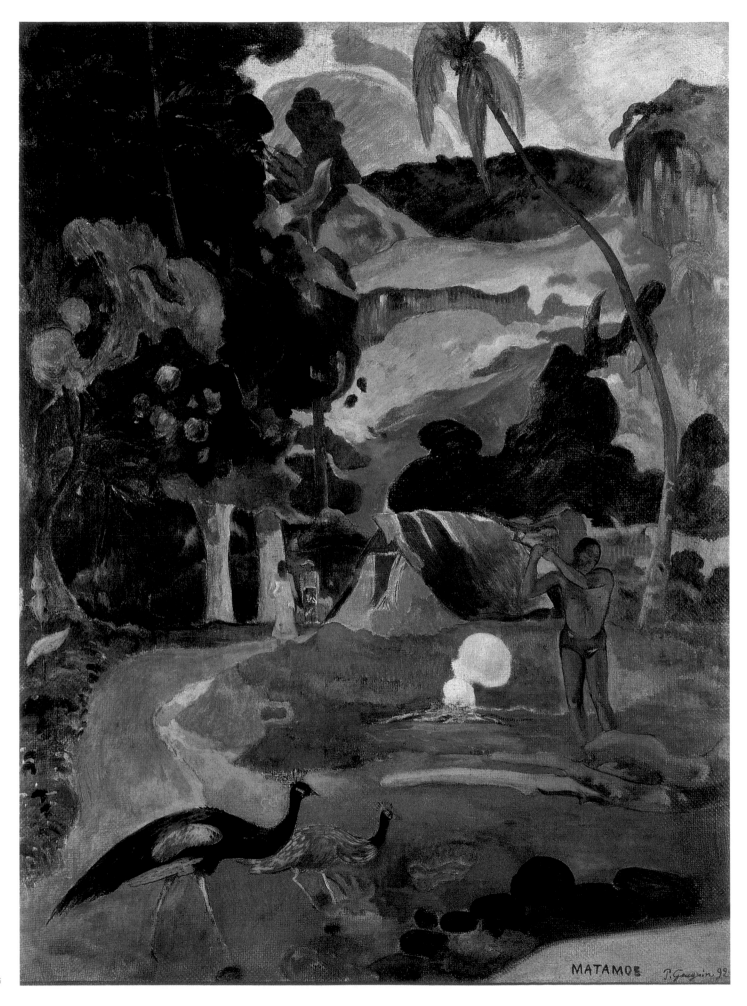

MATAMOE P. Gauguin 92

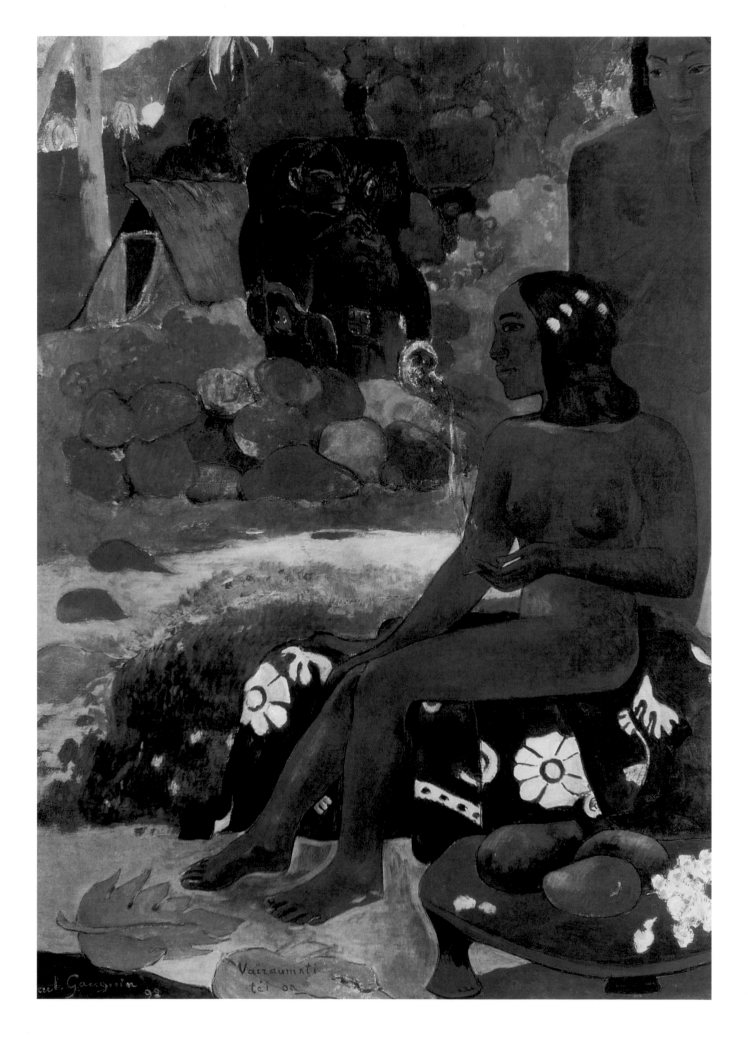

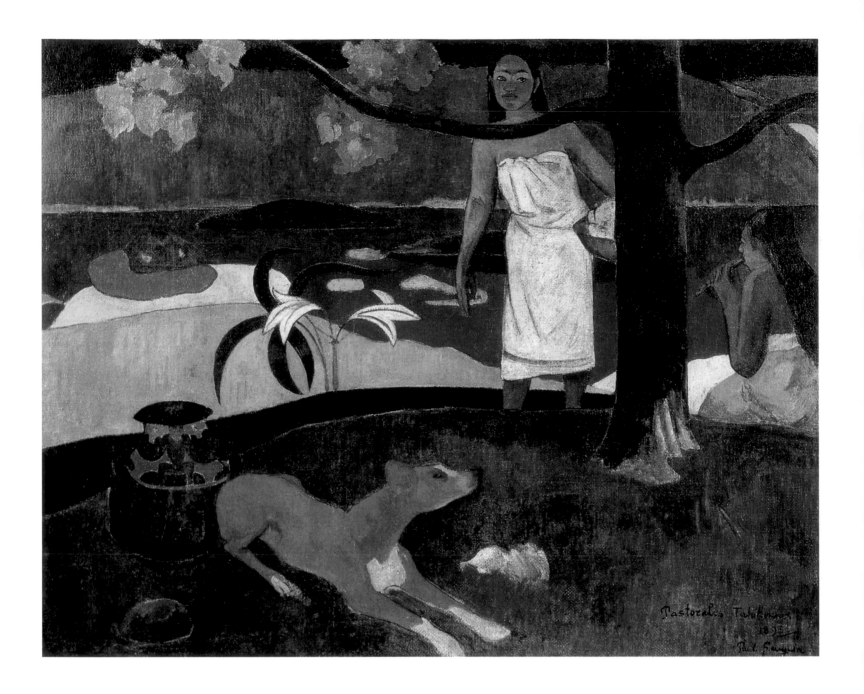

109. **Paul Gauguin**, *Matamoe*
(*Landscape with Peacocks*), 1892.
Oil on canvas, 115 x 86 cm.
The Pushkin State Museum of
Fine Arts, Moscow.

110. **Paul Gauguin**, *Vairaumati Tei Oa*
(*Her name is Vairaumati*), 1892.
Oil on canvas, 91 x 68 cm.
The Pushkin State Museum of
Fine Arts, Moscow.

greatly satisfied his penchant for the exoticism of the East and of faraway islands. In the summer of 1889, he hoped to get a small ordinary post in the civil service in the Tonkin. Before he could get to travel again he went back to Brittany.

Apart from some short stays in Paris, Gauguin spent most of 1889 and 1890 in Pont-Aven and in the little village of Pouldu that he already knew. Brittany urged him to perfect compartmentalisation and to go deeper into it. Still staying at Gloanec's inn, Gauguin once more shocked the inhabitants of Pont-Aven and the conservative side of the painters that used to meet up there with his *Beautiful Angèle* (p. 133). The portrait of Mrs. Satre, the very beautiful wife of a respected man who was to become the mayor of Pont-Aven, was perceived as truly offensive to the model. Angèle Satre herself felt outraged by it and refused the portrait. By putting the representation of the young woman in a magic circle, Gauguin transformed the portrait into a sort of symbol of Brittany. The model was dressed with the national Breton costume.

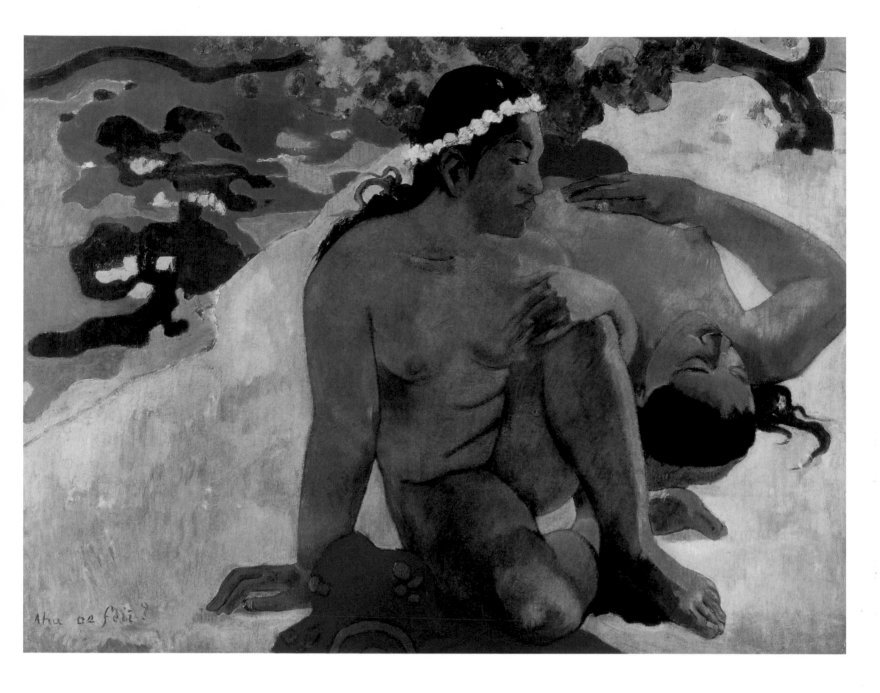

Gauguin was an artist whose work precisely needed Brittany. Indeed, that region seems to be jealously guarding its secret; one can feel there a connection to time nearly physically. The simplicity and wilderness of Brittany, its dolmens and standing stones keep the spirit of primitive times. Traditional crosses made of stone and calvaries, often of complex compositions and numerous characters dating from the Middle Ages to the nineteenth century, were found at crossroads. Gauguin used one of them as a motif in one of his paintings: *Breton Calvary (The Green Christ)* (p. 132), where the sculpture of a group of women with the dead body of Christ is put together over a single green patch contrasting strikingly with the orange rocks in the background. Breton-style sculpture was not only the source of the decorative aspect in Gauguin's paintings but also of the deep meaning that the artist injected into it. He had never been a practising Christian but he still associated the great hardships that he had suffered with the destiny of Christ. In Brittany, those paintings acquired a deep personal content.

111. **Paul Gauguin**, *Tahitian Pastorals*, 1892.
Oil on canvas, 87.5 x 113.7 cm.
The State Hermitage Museum, St. Petersburg.

112. **Paul Gauguin**, *Aha oe Feii? (What! Are You Jealous?)*, 1892.
Oil on canvas, 66 x 89 cm.
The Pushkin State Museum of Fine Arts, Moscow.

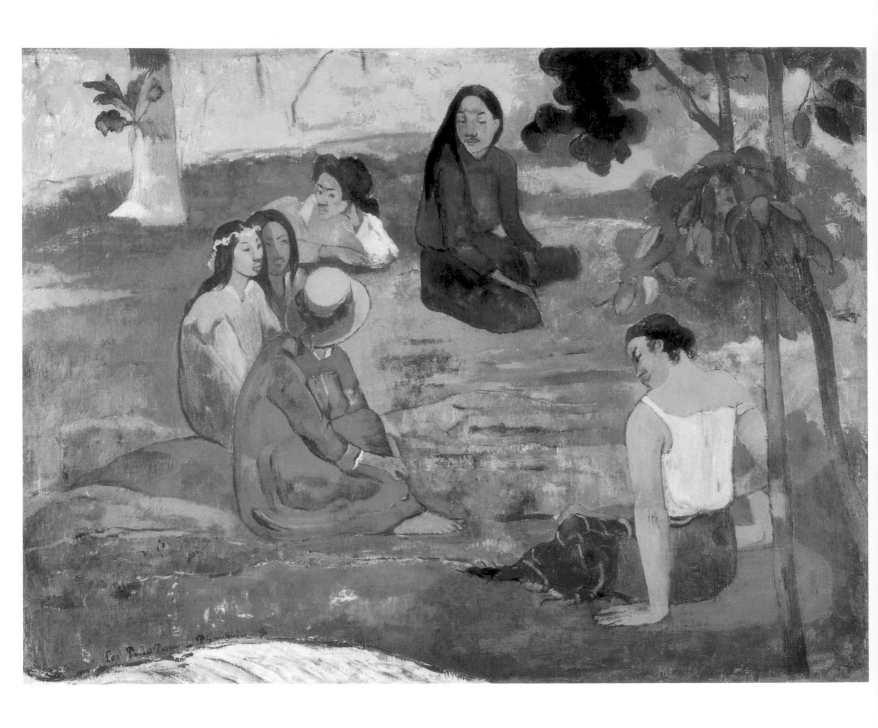

The calvary of the painting stands in the village of Nizon near Pont-Aven. In the same way, as one goes out of the Bois d'amour made famous by the school of Pont-Aven, there is a stone chapel in the Gothic style. There the arms of Guillaume du Plessis are kept along with the date of the building, 1558. Inside there are stone sculptures and a painted wooden crucifix from the seventeenth century. Gauguin painted it several times and represented it in two of his paintings. In *The Yellow Christ* (p. 129), this ancient crucifix dominates a Breton landscape with its fields and hills laid as far as to reach the distant horizon. The hill of Sainte-Marguerite becomes a Breton Golgotha. The simplicity of stone sculpture echoed the efforts of generalisation that Gauguin was trying to make. Moreover, the nearly schematic face of Christ reminds one of Gauguin's own face. In the *The Yellow Christ*, that symbolic similarity is manifest. Gauguin has already represented his face much earlier in the past in many drawings and in the portrait for Van Gogh. Here, he reproduces it on the background of two of his own creations: *The Yellow Christ* and the ceramic *Pot Portrait in the Form of a Grotesque Head*. The painter thus appears in three different ways, each of them symbolising one of the aspects of his nature. Though he intended to give the self-portrait in ceramics to his friend Schuffenecker, he gave it in the end as a gift to Bernard's sister, the beautiful Madeleine. Gauguin used to say that ceramics in the infernal heat of the furnace reminded him of Dante's martyrdom in hell. The cracked surface of the pottery, the streaks made by the glazing process recalling blood symbolised the torments of creation that Gauguin had gone through. Ceramics became the symbol of the painter's suffering in Brittany when he was ill, lonely, feeling guilty for the sorrow of his family. "I carry my old body through the northern wind that blows on the Pouldu's banks! Mechanically I carry out a few studies. (…) May they watch my last paintings carefully (if they have a heart to feel with) and they would see how much resigned suffering there is in them."[42] At the same time, he urged Bernard to resist the temptation of hatred: "There is a truly intoxicating beauty in the goodness of the one who's suffered."[43] Here the poetry and self sacrifice of the painter are embodied in the image of *The Yellow Christ*. It seems that this self-portrait of Gauguin, rational and full of symbols, would actually be a cry of despair: "I'm going through a phase of such disillusion that I can't prevent myself from shouting it out nowadays," he wrote to Bernard.[44]

After the scandals and mockery that he had been subjected to in Pont-Aven, the quietness of the fishing village of Pouldu was welcome for his creativity. Gauguin worked in the studio rented to him by his new friend, the Dutch painter Jacob Meyer de Haan, who enjoyed a comfortable financial situation. He painted landscapes of surrounding villages, the sea shore and fields with hay bells as if he was working on a project of stained-glass window. Indeed, each patch of orange, green or deep blue is delimited by a contour.

Gauguin was pleased with his paintings of the autumn 1889. At the same time he carried out a sculpted panel foreshadowing his Tahitian style. It seems like he had done everything that he could in Europe; it was time for him to embark for distant lands again.

Gauguin was still dreaming of a studio in the Tropics, an idealistic community of painters; it did not matter in which remote corner of the world it would take place, in Martinique, Madagascar or Tahiti. He was hoping that Bernard and De Haan would go with him and he dreamt of living there out of "ecstasy, calm and art".[45] In 1890 and 1891, Gauguin prepared for his departure. Indeed, he would frequently see the symbolist writers that were helping him sell his paintings. Mirbeau, Roger-Marx and Aurier were talking about his work a lot and Rachilde ordered Gauguin to illustrate her new play *Madame La Mort*. At the beginning of March he

113. **Paul Gauguin**, *Les Parau Parau (Conversation)*, 1891.
Oil on canvas, 70.5 x 90.3 cm.
The State Hermitage Museum,
St. Petersburg.

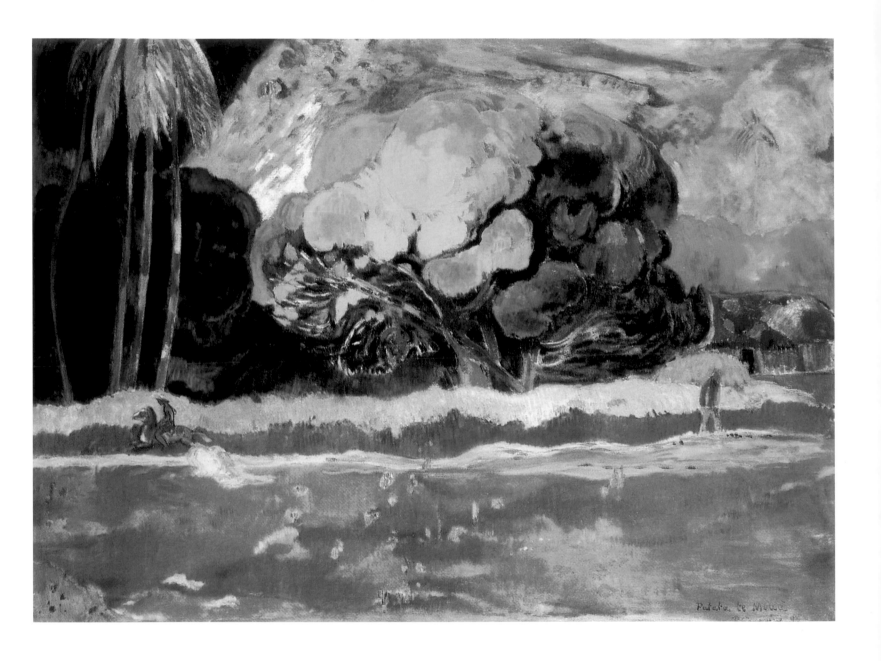

114. **Paul Gauguin**, *Fatata te Mouà
(At the Foot of a Mountain)*, 1892.
Oil on canvas, 68 x 92 cm.
The State Hermitage Museum,
St. Petersburg.

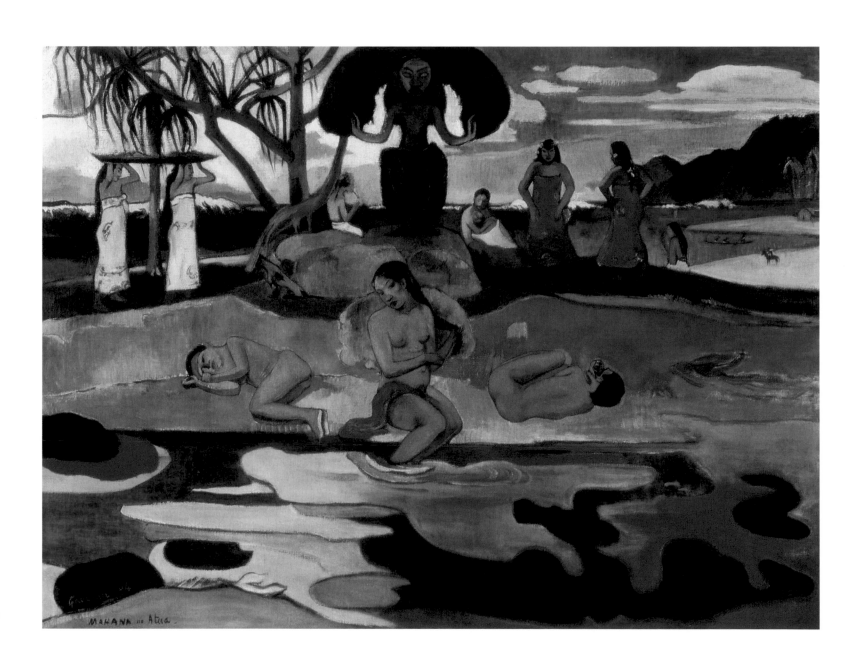

115. **Paul Gauguin**, *Mahana no Atua
(Day of God)*, 1894.
Oil on canvas, 68.3 x 91.5 cm.
The Art Institute of Chicago,
Chicago.

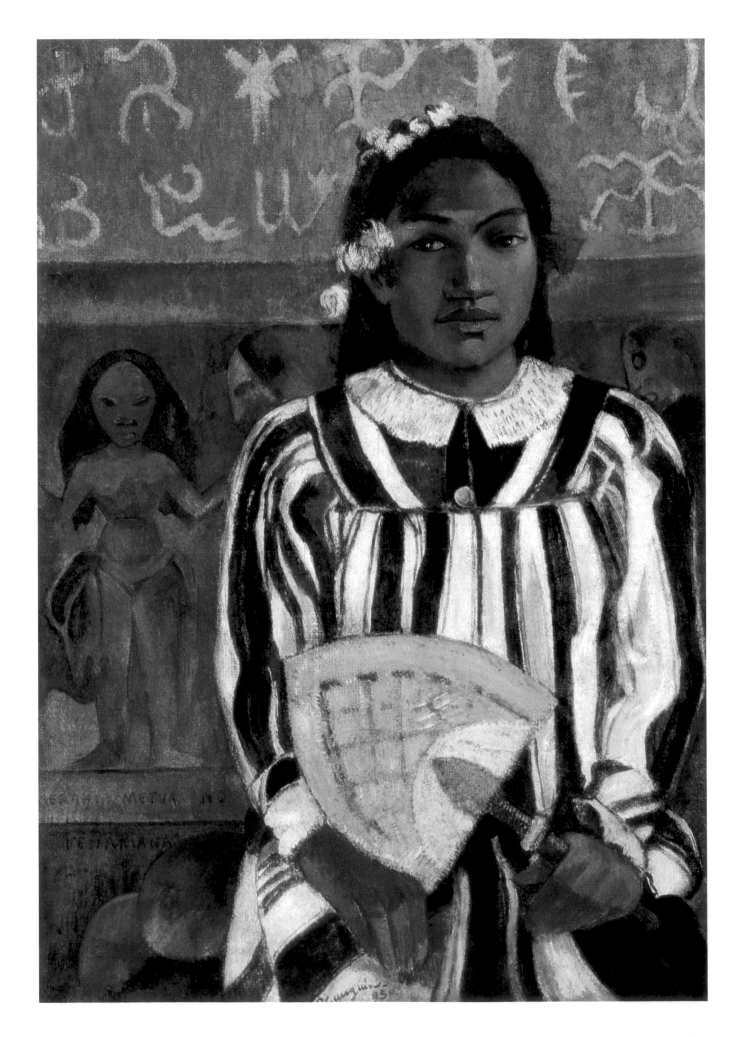

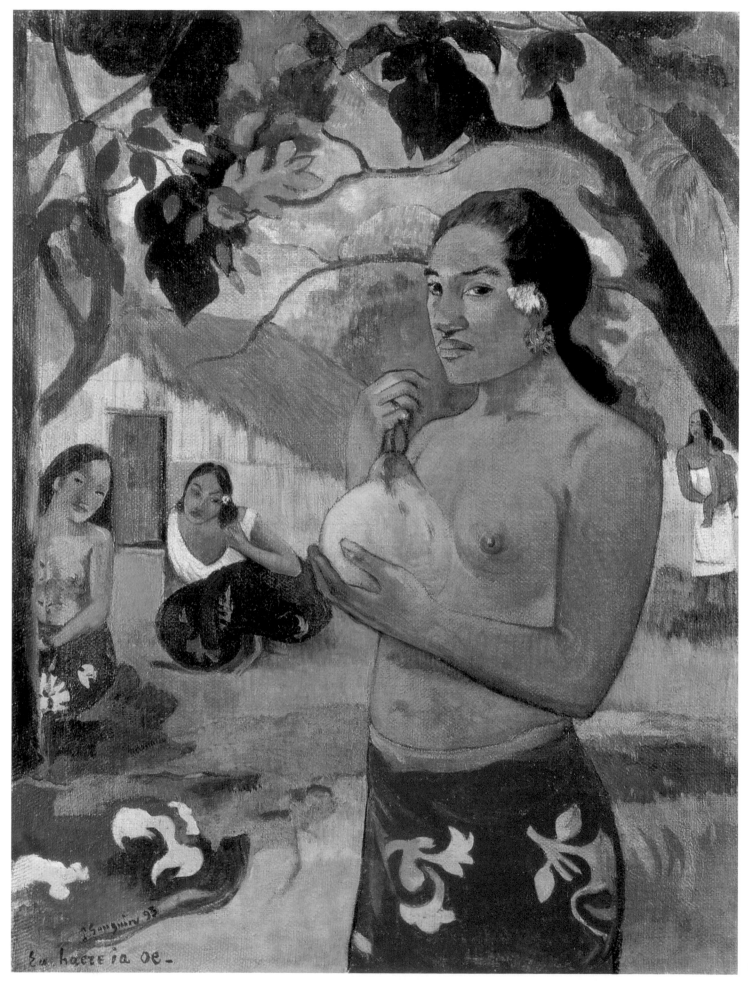

went to Copenhagen for the last time in order to say goodbye to Mette and the children. At the end of the month, he received the reply to his inquiry: the ministry of Education and the Beaux-Arts Academy had accepted to pay for him to go on an official mission in Tahiti to study and represent nature as well as the customs of the island. On March 23, he had a leaving party with all his friends (writers, painters…) at the Café Voltaire and Stéphane Mallarmé was the guest of honour. On April 1, Gauguin embarked on the Oceania from Marseille.

On June 9, 1891, after a series of stops at the Seychelles, in Australia and New Caledonia, Gauguin arrived in Tahiti's capital city, Papeete. Early on it seems that circumstances were rather in his favour and that he could rely on French civil servants to help him. As usual, he took his time to get used to the environment and did not start painting at once. He observed, listened and was seduced by everything: Tahiti's nature, its mysterious nights, its inhabitants. Immediately Gauguin started to learn the local language which, apparently, gave him difficulties. In his opinion, aborigines were neither the stupid nor savage people described by the colonial policy.

At the autumn of 1891, Gauguin decided to leave the civilised city of Papeete for the village of Mataiea where aborigines were living a natural life. As an Impressionist he started his study of the place by painting a landscape. He painted the sand on a shore, immense trees and mountains. Nature was unusual for a European person but working outside appealed to him. He caught the effects of the blazing sun revealed by the sculpted volume of the tree. The humid atmosphere blurred the limits between the patches of colours. It mattered to him to give each painting a title in Tahitian. (*Fatata te Mouà (At the Foot of a Mountain)* p. 142) Nevertheless, Tahitian nature itself reminded him of Breton compartmentalisation. He delineated flats of bright colours patches with contours. Little figures of Tahitian women – whom Gauguin never stopped drawing pictures of doing their activities – began to appear in the landscape. (*Matamoea (Landscape with Peacocks)* p. 136).

Little by little, Gauguin got used to his new environment. He observed the people's lives, catching nuances known by Europeans. He admired young Tahitian women, their sturdy beauty and their spontaneity. But Gauguin kept in mind everything that he had seen at the Louvre and during his travels around the world. The real market scene gets transformed into a stylised frieze recalling the memory of friezes in ancient Greece, Egyptian bas relief and Gauguin's own Breton paintings (*Ta Matete' (The Market)*).

In the book that he was to write later, *Noa Noa* (Tahiti's name in Tahitian, meaning 'delicious land', 'sweet-smelling land'), Gauguin tells the story of how a female aborigine gave him her daughter to marry under one condition only: if after eight days she was feeling unhappy she could go back home. The painter's wife was called Tehamana (Tehura in his book). Gauguin imagined her painted when he described her: "Through her excessively see-through pink muslin dress, one could see the golden skin of her arms and shoulders. Her chest had two buttons pointing straight; her delightful face was not of a type that I had seen before anywhere on the island; she also had exceptional hair like a bush and slightly frizzy. In the sun all that was an orgy of chromium."[46] Life was happy.

Tehura knew all the customs of aboriginal life, told Gauguin the local legends and initiated him to Tahitian gods. Local religious symbols and images were mixed with Christian and oriental images and symbols to produce a medley, a synthesis that carried in itself some mystery cherished by symbolists. Gauguin painted a Tahitian Madonna wrapped in a red pareo with a Christian aureole round her head. (*La orana Maria (Ave Maria)* p. 135).

116. **Paul Gauguin**, *Merahi metua no Tehamana (The Ancestors of Tehamana* or *Tehamana Has Many Parents)*, 1893.
Oil on canvas, 76.3 x 52.3 cm.
The Art Institute of Chicago, Chicago.

117. **Paul Gauguin**, *Eu haere ia oe (Woman Holding a Fruit; Where Are You Going?)*, 1893.
Oil on canvas, 92.5 x 73.5 cm.
The State Hermitage Museum, St. Petersburg.

118. **Paul Gauguin**, *Be Mysterious*, 1890.
Painted wood, 73 x 95 x 5 cm.
Musée d'Orsay, Paris.

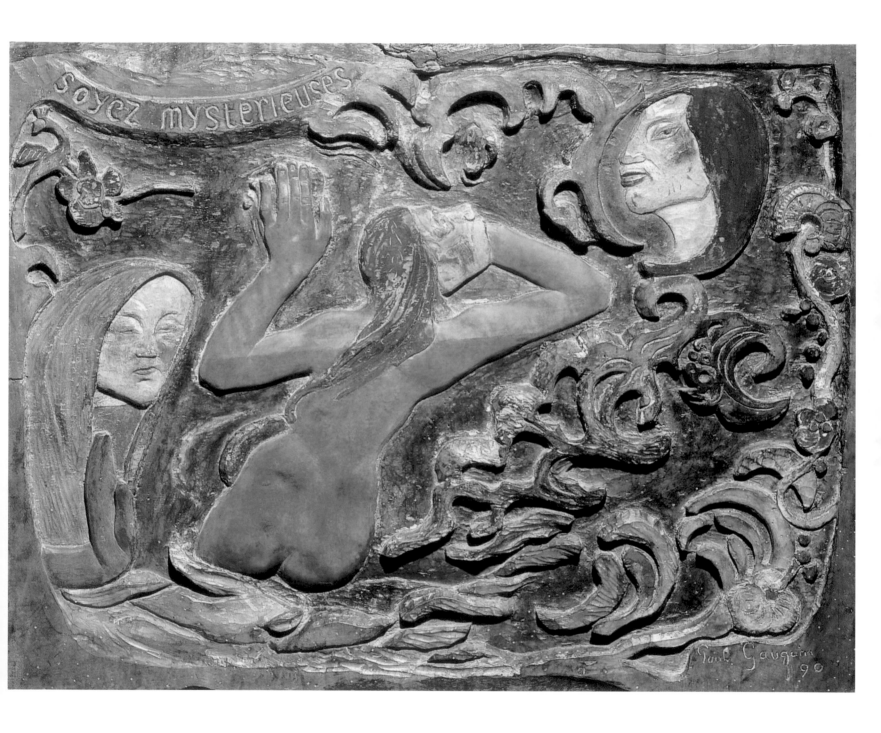

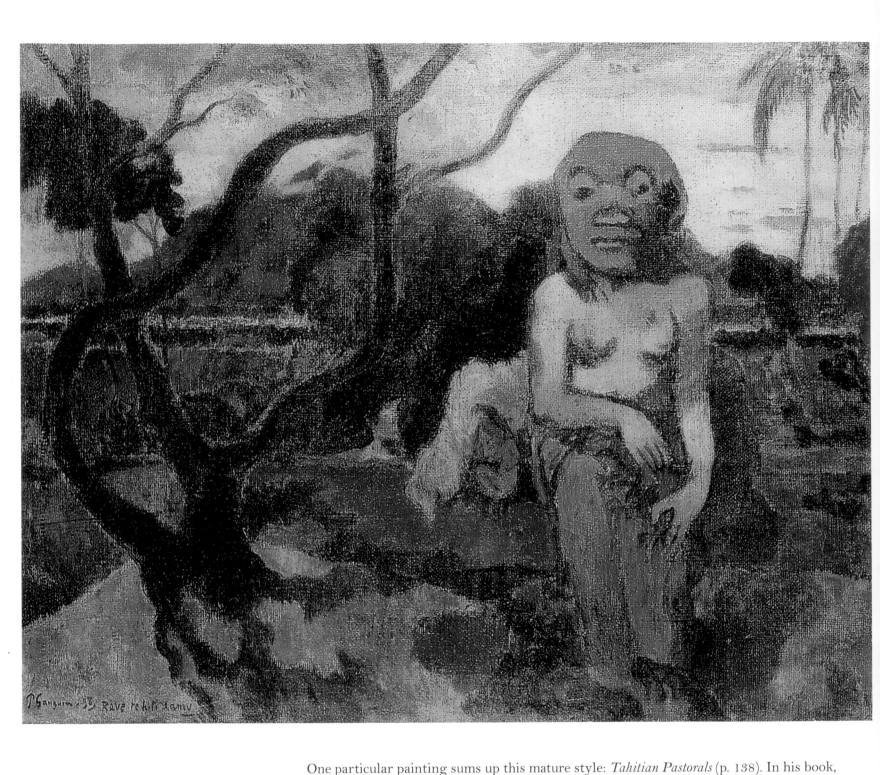

119. **Paul Gauguin**, *Rave te hiti aamu*
(The Idol), 1898.
Oil on canvas, 73.5 x 92 cm.
The State Hermitage Museum,
St. Petersburg.

One particular painting sums up this mature style: *Tahitian Pastorals* (p. 138). In his book, Gauguin devoted a chapter to the local musical instrument, the vivo. "Complaining together, close or distant, my heart and the vivo sing," he wrote. "What is the musical savage thinking of on the shore, and to whom do his vivo's modulations go? Wild too, what is this wounded heart thinking of, and tell me for whom is it beating in this solitude?"[47] In this painting a Tahitian woman plays the vivo whilst another listens to it motionlessly. Her blind look, the ritual vase and the strange orange dog in the foreground constitute a network of mysterious symbols. One tries to understand them in vain. Indeed that did not matter to Gauguin. He had finally gained independence from the Impressionists' ideas. Each patch of colour resonates with balanced intensity losing the impressionist fragmentation. Even the

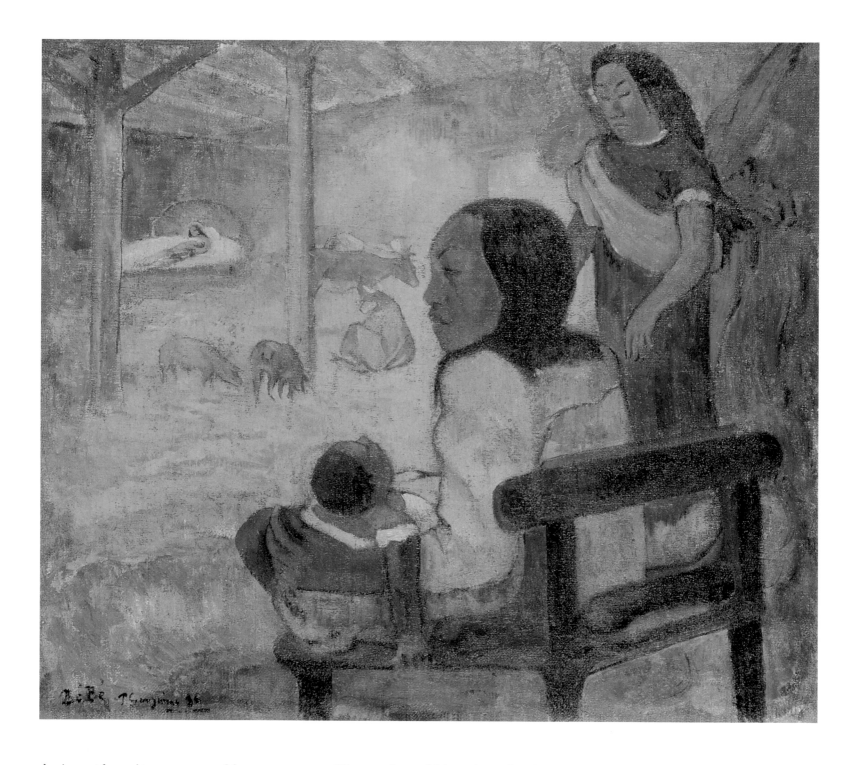

dog's coat loses its nuances and becomes orange. The exotic world here is made of patches of colours – red, green, pink, black, yellow – delineated with contours.

On June 4, 1893, Gauguin left to return to France. The period before his departure was difficult. Gauguin became seriously ill; he lacked money to buy canvases but the state that he was in didn't allow him to work. Simultaneously in Paris Albert Aurier presented Gauguin as the father of the Symbolist movement. The painter took with him to Paris seventy paintings, a few sculptures and the hope that he would at last get the status that he deserved in the artistic life of his time. But his expectations did not materialise. He spent his two years in Europe trying to organise exhibitions, working on manuscripts about Tahiti and on engravings to illustrate *Noa Noa*. However, his expectations were not fulfilled. The distant tropical islands

120. **Paul Gauguin**,
Baby (Nativity), 1896.
Oil on canvas, 66 x 75 cm.
The State Hermitage Museum,
St. Petersburg.

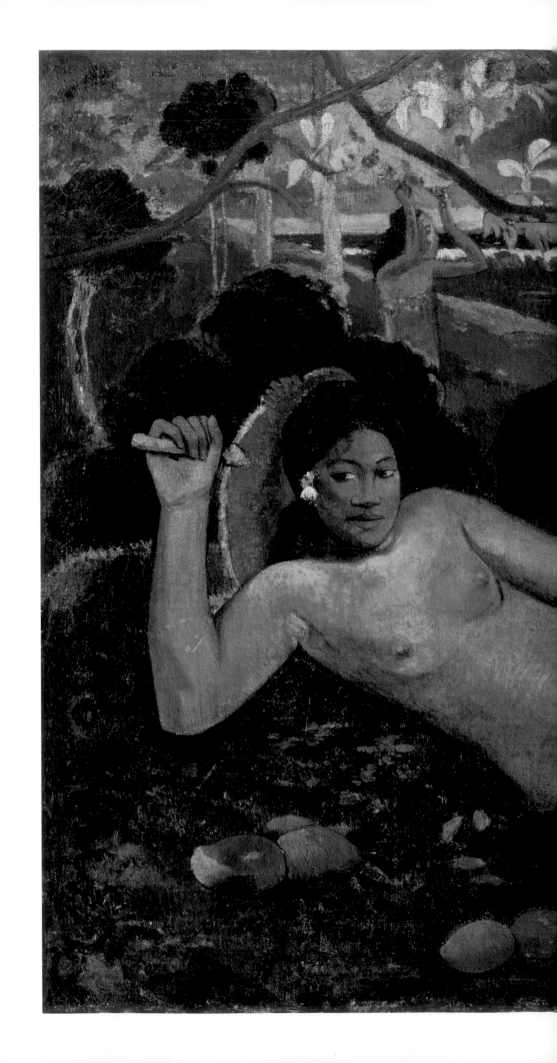

121. **Paul Gauguin**, *Te Arii Vahine*
(*The King's Wife*), 1896.
Oil on canvas, 97 x 130 cm.
The Pushkin State Museum of
Fine Arts, Moscow.

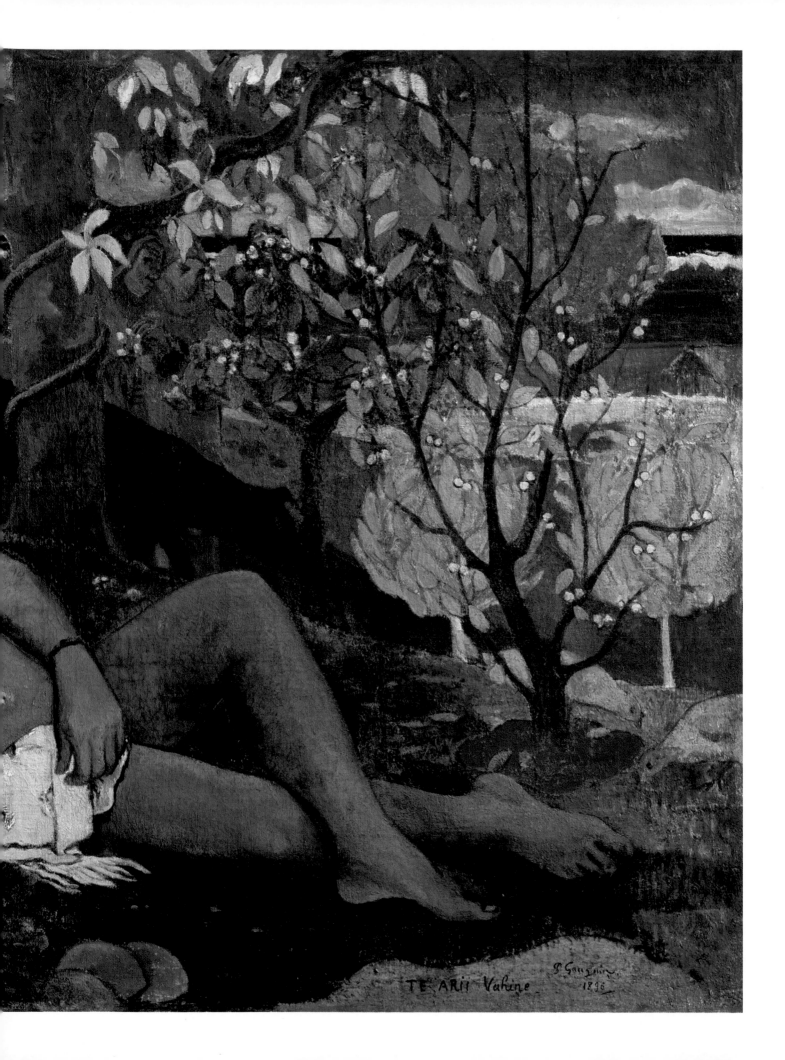

TE ARii Vahine P. Gauguin
1896

151

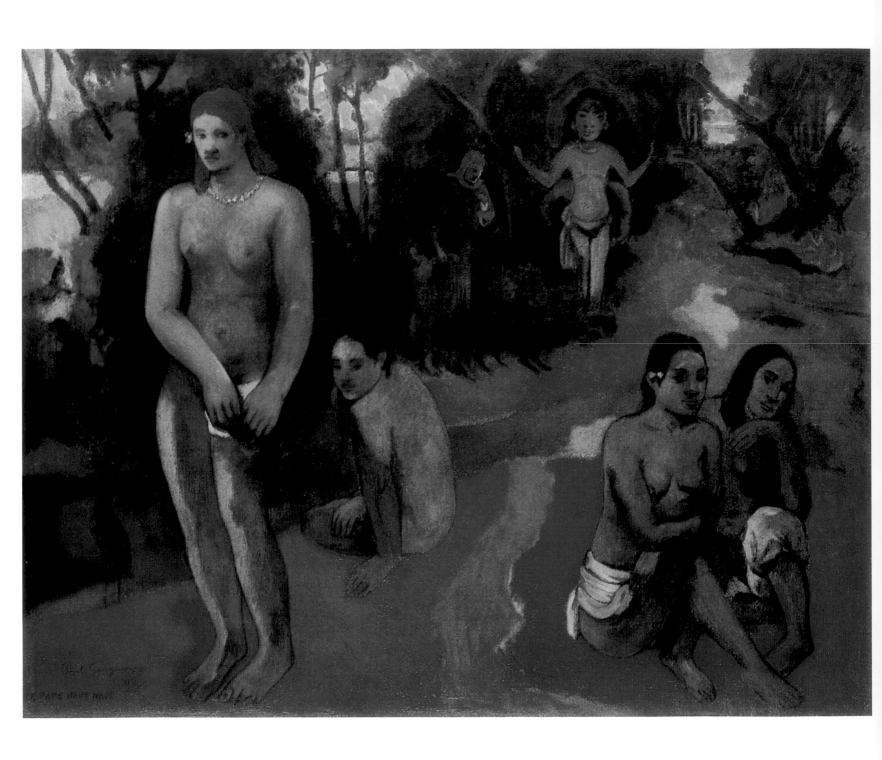

now appeared to him like a paradise. In Paris, he painted something strange that he called *Nave Nave moe* which meant 'Delicious mystery' according to him but 'Sweet dreams' would be a more accurate translation. Nowadays that painting is known by the name that it received later, *Delectable Waters* (p. 152). Gauguin used fragments of earlier paintings in it – flowers, landscape, posing women – that he assembled in a chorus of his style. His Tahitian Madonna and Eve are present. It seems that he had found happiness there in Tahiti. On June 28, 1895 he said goodbye to his friends and got on the train for Marseille where he embarked for Oceania again.

Gauguin arrived in Papeete on September 9, 1895. He had brought with him two landscapes that he had painted in Brittany, (*Breton Village under the Snow*). Many things had changed in Tahiti: civilisation had brought its sad fruit. The colonial authorities could not maintain order and the army could turn up on the islands at any time. Gauguin was annoyed by everything from political speeches to electric lighting. He started to envisage going further to Saint-Dominique in the Marquisas archipelago where he had planned to live a quiet life cheaply, but things were not that simple. He first settled in one village by the water, then moved to another. Gauguin had brought back a range of infections from Europe. Tehamana, who had come back to him, ran away for she had been frightened by his horrible sores. He took Pahura – who was fifteen – with him. He had no money left at all: he even was categorised as indigent on the list of patients of Papeete hospital. He was in total despair. In April 1897, he got the news of his beloved daughter's death, Aline, at twenty. Exhausted by diseases and suffering from a heart condition, he tried to commit suicide. He went into the mountains and called for hell but stayed alive, which only worsened his unhappy situation.

He hardly had any energy left to paint. Nevertheless he carried out some remarkable works in that difficult period of his life. In 1896, he painted *Te arii vahine (The King's Wife)* (p. 150-151). It shows a beautiful Tahitian woman of which Pahura is likely to have been the model; she is represented like Giorgione's *Venus* or Manet's *Olympia*. And the artist was right to be proud: his Tahitian Venus/Olympia can stand aside its classical predecessors.

Suffering and adversity forced Gauguin to try and interpret the world in a philosophical way. Several drawings and painted studies were the basis for a large painting summing up his whole life in a way: *Where do we come from? Where are we? Where are we going?* (p. 154-155). Painting was Gauguin's only language and one that was unconventional.

On several occasions, he managed to get some work doing drawings for the civil service. He moved to the suburbs of Papeete with Pahura, who left him soon after.

Misfortune continued to strike him: he could not paint anymore, his house was destroyed, rats ate his drawings and, being ill, he did not manage to send his paintings on time for the World's Fair of 1900. At last on September 10, 1901, he managed to embark on a ship for the Marquesas Islands.

He arrived on Hiva Oa Island and settled in Atuana with a new woman, but life was no easier there. Gauguin was still as sick as before. By not paying his taxes and defending the rights of the local people he managed to make the colonial authorities angry against him. Despite all these hardships, Gauguin carried out many paintings during the last years of his life. There are paintings of a particularly tragic tone amongst the scenes of local life that he painted in Tahiti and Hiva Oa. In 1896, Pahura gave birth to a girl who lived for ten days only. That was probably the trigger for the painting *Baby (Nativity)* (p. 149). An ugly Tahitian woman with a dead child and the green Angel of Death are represented with

122. **Paul Gauguin**, *Te Pape Nave Nave (Delectable Waters)*, 1898. Oil on canvas, 74 x 95.3 cm. National Gallery of Art, Washington, D. C.

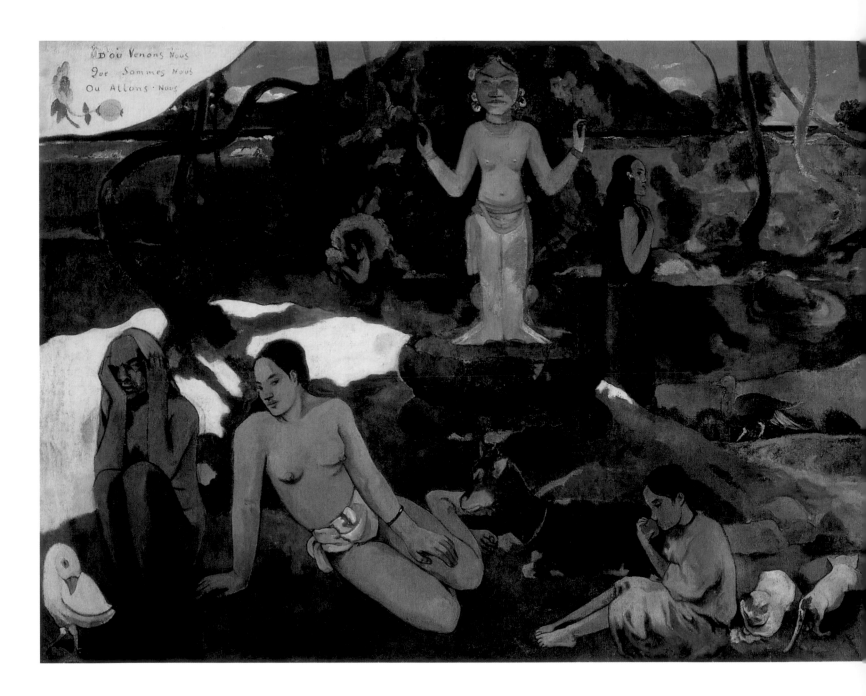

123. **Paul Gauguin**, *Where Do We
Come From? What Are We?
Where Are We Going?*,
1897-1898.
Oil on canvas, 139.1 x 374.6 cm.
Museum of Fine Arts, Boston.

124. **Paul Gauguin**, *Ruperupe
(Gathering Fruits)*, 1899.
Oil on canvas, 128 x 190 cm.
The Pushkin State Museum of
Fine Arts, Moscow.

125. **Paul Gauguin**,
Two Tahitian Women, 1899.
Oil on canvas, 94 x 72.4 cm.
The Metropolitan Museum of Art,
New York.

a traditional Christian nativity scene in the background. A threatening and inflexible local idol dominates the world where the branches of the trees shake in the air like kites. It is probably the deity Oviri symbolising both death and fertility. Gauguin asked Monfreid to send him the little statue of Oviri that had remained in France in order to put it on his grave. Those gloomy paintings amplified Gauguin's exceptionally dark palette. Because he did not have the canvases that he needed, he painted on burlap, often with nothing under it hence the colours were absorbed by the material and the painting was irreversibly darkened.

Gauguin's last house in Atuana, built in 1902, showed joy in life in its entire decor. Gauguin called it the *Maison du jouir* (*House of enjoyment*). That name was represented on a horizontal panel with naked female figures along both edges. The figures, heads and animals of the bas-reliefs echo Gauguin's previous paintings. There were sculptures everywhere in that house, and no reminder of Christian art; these sculptures were intensively primitive. The bedroom's entrance is trimmed with wooden panels bearing Gauguin's favourite watchwords: *Soyez mystérieuses* (Be mysterious) (p. 147) and *Soyez amoureuses et vous serez heureuses* (Be in love and you will be happy). These bas-reliefs are some of only a small number of surviving artefacts from the last period of his life. Gauguin died on May 8, 1903. He was buried on a hill near Atuana in a Catholic cemetery.

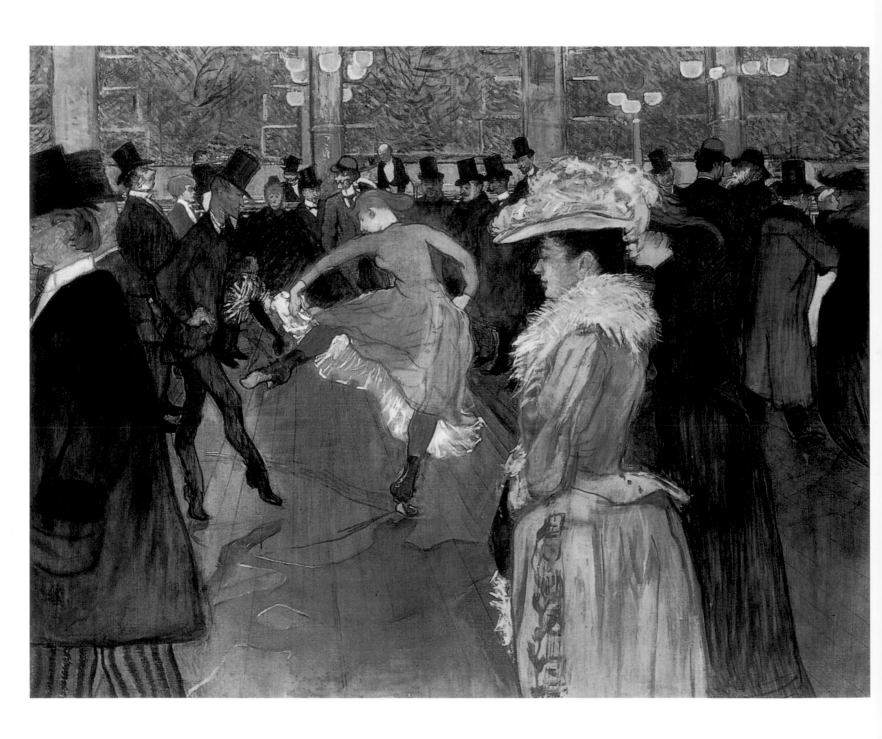

HENRI DE TOULOUSE-LAUTREC (1864-1901)

*H*enri de Toulouse-Lautrec did not just capture life in his paintings, drawings and lithographs, but he also caught the life of a singular and unique Paris that did not exist before him and disappeared after him. During the third Republic, the new Paris imagined by Haussmann was already a reality with its boulevards, its department stores, commercial malls, stations, iron-framed markets and luxurious private hotels owned by the new bourgeois around the Champs-Elysées. The city was expanding further away from its centre invading the last resisting hills. Only the distinctive blocks of the village of Montmartre remained, where vineyards grew and where Auguste Renoir worked outdoors whilst his wife and children gathered snails in the poppy fields. The dens of iniquity where all the rejected and poor people would find a refuge kept moving further up the hill slopes. New restaurants appeared one after the other, brothels, cabarets and concert-cafés. In the 1860s and 1870s Maupassant, the Goncourt brothers, Daudet and Renoir would meet up at the rustic restaurant of the Father Fournaise, on the river banks, near Chatou. The art world would then meet up at the 'Chat noir', a cabaret founded in 1881 by Rodolphe Salis on Rochechouart Boulevard. There one could see Hugo, Zola, Anatole France, Wagner, Gounod, Massenet. In those cabarets there were dancing stars; the first Parisian chansonniers suddenly blossomed before disappearing just as abruptly without a trace. Painters were there but only Forain and Steinlein have acquired a place in art history for representing that little underworld. Many were killing themselves drinking absinth and were hiding in dark corners. In fact, there is only one bright star in the Montmartre figurative art of the end of the nineteenth century: Toulouse-Lautrec.

Henri Marie Raymond de Toulouse-Lautrec-Monfa was born on November 24, 1864 in the south of France, in the family chateau of the Bosc in Albi. He descended from an ancient family: his ancestors had been on crusades and entered Jerusalem in the eleventh century.

His parents, Count Alphonse and Countess Adèle, were cousins; the purpose of their marriage was to consolidate the Toulouse-Lautrec line that was weakening. The birth of their son Henri was a joy for the whole family, especially as he was the only male descendant. As a young boy, Henri already knew horses, dogs and hawks very well. The father, grandfather and uncles of the artist painted well and Henri started drawing horses, dogs and birds at an early age. With some help from his uncle he painted a still life with hunting trophies. He worked very well. The only thing that worried his family was his health. The close links in his parents' blood played a tragic role: Henri grew up and struggled to walk. Aged fourteen he broke his thighbone falling in the sitting room of the chateau, fifteen months later, he fell in a gutter and broke his other leg. He remained a cripple. His legs stopped growing whilst his torso reached a normal size. As he grew up his nose grew big and his lips lost their shape giving him a speech impediment. No more horse riding or hunting. He had to give up the idea of a normal life. He could only expect disgust and pity from young women. The only thing that he had left was his hands, which could do wonders. It was a gift for the painter and he spent his life developing that talent. When he was sixteen, he carried out thirty drawings and fifty paintings in one year.

126. **Henri de Toulouse-Lautrec,**
At the Moulin Rouge: The Dance,
1890.
Oil on canvas, 115.6 x 149.9 cm.
Philadelphia Museum of Art,
Philadelphia.

127. **Henri de Toulouse-Lautrec,**
*The Artist's Mother, Countess
Adèle de Toulouse-Lautrec,
Breakfast at Château Malromé,*
1881-1883.
Oil on canvas, 93.5 x 81 cm.
Musée Toulouse-Lautrec, Albi.

128. **Henri de Toulouse-Lautrec,**
*Mademoiselle Marie Dihau
at the Piano,* 1890.
Oil on cardboard, 69 x 49 cm.
Musée Toulouse-Lautrec, Albi.

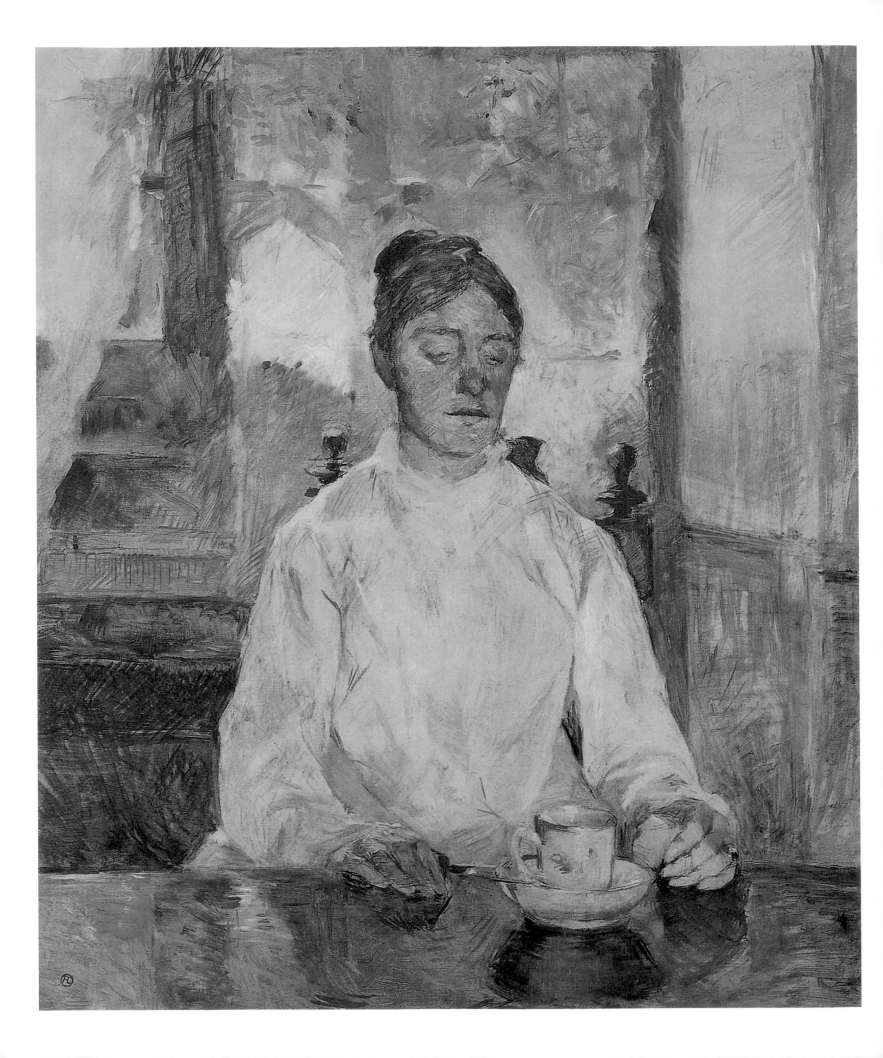

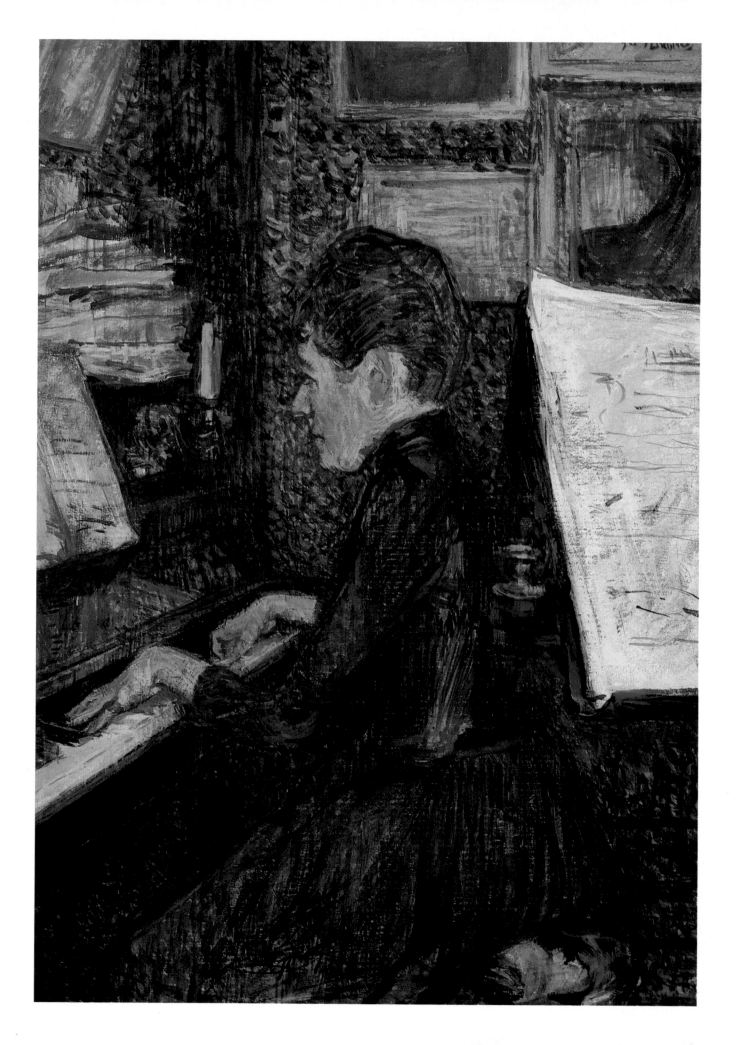

When Henri moved to Paris with his mother, he started to take lessons with the deaf-and-dumb painter Princeteau, a family friend. In Princeteau's studio he became friendly with the witty and caustic Forain who painted the customs of the Parisian Bohemian life. At Fernando's circus in Montmartre he painted horses and clowns, and when his mother took him for a cure at a spa in the south, he kept on painting the horses that he loved. That is where he also carried out his first portrait. His mother finally insisted that he took his baccalaureate in Toulouse.

Back in Paris, Lautrec entered the studio of the academic master Léon Bonnat and later of Professor Carmon. There he met Van Gogh and made friends with Louis Anquetin who was to become a pointillist in the future, and also Émile Bernard, Gauguin's friend.

Lautrec's appearance attracted attention upon him wherever he went. The first sessions in the studio with his mates were very difficult for him. He needed courage to struggle against rejection. He had no pity for himself and always mocked his appearance. Lautrec's self caricatures were remarkable. His piercing eyes noticed not only outstanding details in others but also in himself. He painted himself sitting in front of his easel, drawing in a firm and assured line his profile with a big nose and protruding lips whilst a few light lines recalled the scattered hair on his head and chin. He had, in a way, created a formula of his appearance. He only felt free in the company of other rejected people, like himself – Montmartre was his real home.

Lautrec spent the summer 1887 at the chateau of Malromé that his mother had bought near Bordeaux. He painted a classical and very serious portrait of his mother with harmonious blue tones (*Countess Adèle de Toulouse-Lautrec in the Living Room of the Malromé Château*). He changed the letters of his name and signed 'Treclau'. Perhaps he did not want to disgrace his family again, from whom he was becoming more and more distant. He severed ties with his family when he decided to move definitively to Montmartre.

From then on Lautrec looked more and more often for models amongst old declining prostitutes; in human faces, he was mostly looking for the signs of adversity and despair, vice and debauchery. Yet, his portraits were never caricatures. His own moral tragedy allowed him to dig a lot further into the personal universes than a simply gifted portraitist could have done. The Dihaus, a family of musicians (two brothers and a sister) belonged to his remote family. Lautrec enjoyed visiting them a lot: they knew Edgar Degas and many artists visited their house. Degas had always been his favourite out of all the painters of the time whom he appreciated and had learned something from. Besides, like Degas, Lautrec's first work was a portrait. He even tried the themes of Parisian life that Degas painted: ballet dancing, horses, hatters' workshops, cafés, nudes. But the way he interpreted those subjects was completely different. Degas painted nudes with harmonious lines, catching a fleeting moment or the outline's gracious curve. Lautrec's hard lines underlined dry hands mercilessly, sticking out shoulder blades or a loose knot in thin hair. When Lautrec was twenty-eight, his friend Joyant offered him his gallery on the boulevard de Montmartre for his first personal exhibition. Lautrec sent a special invitation to Degas, who accepted with emotion. Degas went round the room in silence. Finally he stopped to say: "Well, Lautrec, one can say that you know what you're doing!"[48]

Amongst Impressionist subjects there is a famous painting by Renoir called the *Dance at the Moulin de la Galette* (1876), an elegant symphony of colourful glittering lights. Lautrec painted his Moulin de la Galette in 1889 (*At the Moulin de la Galette*, p. 167). Blue tones gave it an atmosphere of hopeless tediousness. Clumsy and confined outlines of people were

129. Henri de Toulouse-Lautrec,
Laundress, 1884.
Oil on canvas, 93 x 75 cm.
Private collection, Paris.

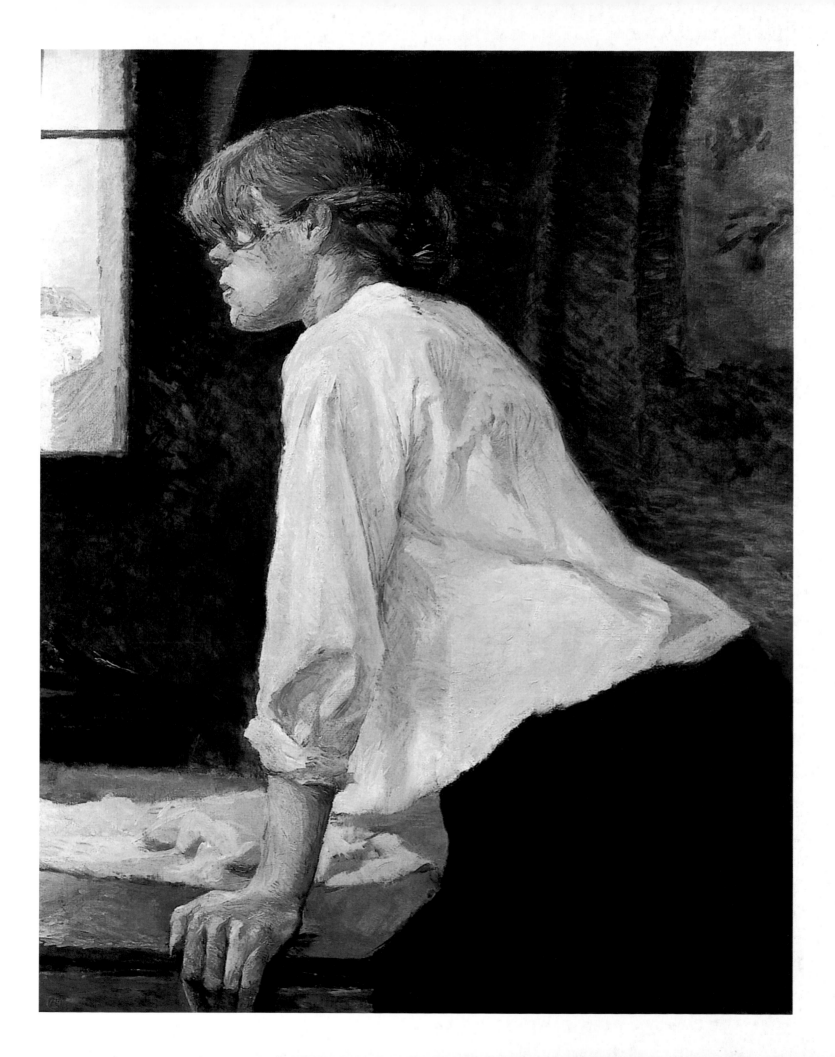

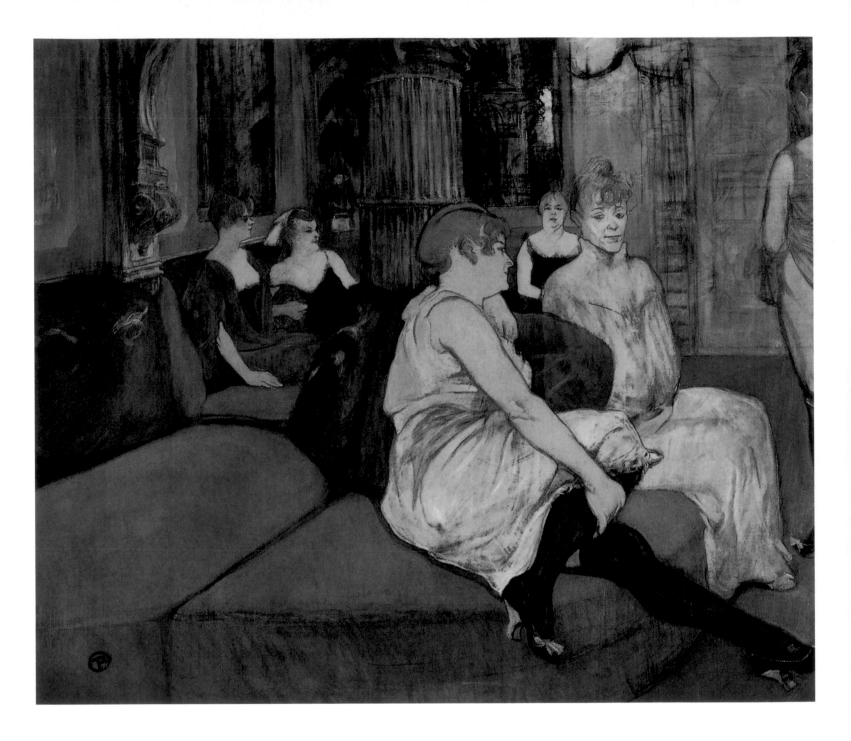

130. **Henri de Toulouse-Lautrec,**
 In the Salon at the Rue des Moulins,
 c. 1894.
 Oil on canvas, 111.5 x 132.5 cm.
 Musée Toulouse-Lautrec, Albi.

131. **Henri de Toulouse-Lautrec,**
 Nude Study, 1883.
 Oil on canvas, 55 x 46 cm.
 Musée Toulouse-Lautrec, Albi.

going round and round in a dark room. Lautrec did not look at the world with rose tinted spectacles, which is something that Maupassant reproached Renoir with. Lautrec's lucid eyes, amplified by the bitterness coming from his own personal drama, dissected the places of 'pleasure' in Montmartre. That painting was the first of a series of compositions that turned out to be a real chronicle of 'joyous' Montmartre.

Near the avenue de Clichy, the wings of a red mill had started to turn, like a signal: it was the beginning of the famous cabaret. There one could see people of the Parisian high society as well as characters from the very bottom. Louise Weber, a young Alsatian, danced quadrilles with her partner, a wine merchant from the Coquillère street. His incredible suppleness was the reason he was nicknamed the boneless Valentin; as for Louise, she received the nickname 'La Goulue' [the Greedy] because of her insatiable appetite.

132. **Henri de Toulouse-Lautrec,**
At the Café La Mie, c. 1891.
Oil on cardboard, 53 x 67.9 cm.
Museum of Fine Arts, Boston.

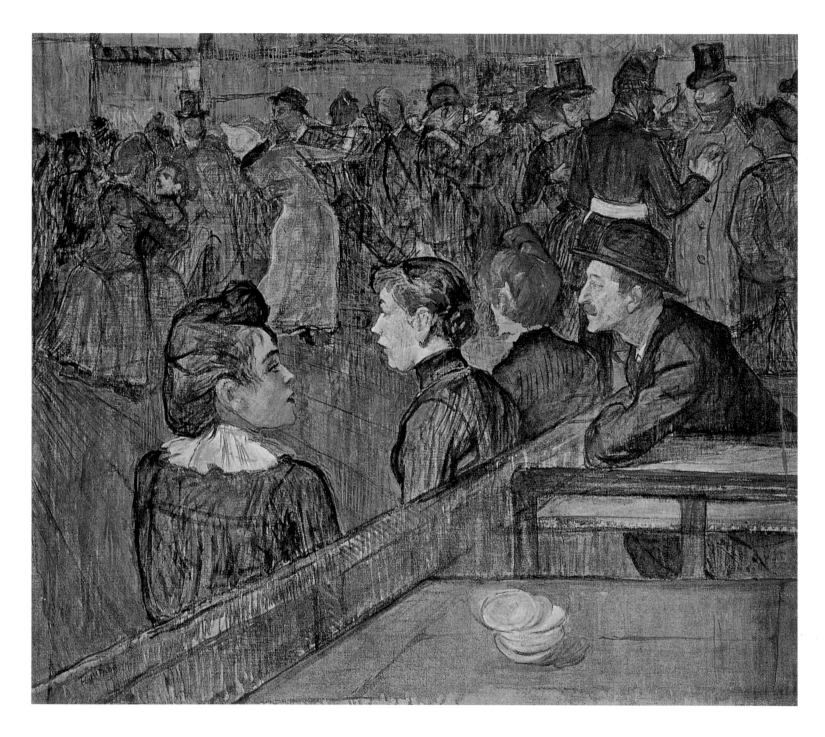

133. **Henri de Toulouse-Lautrec**,
At the Moulin de la Galette, 1889.
Oil on canvas, 88.5 x 101.3 cm.
The Art Institute of Chicago,
Chicago.

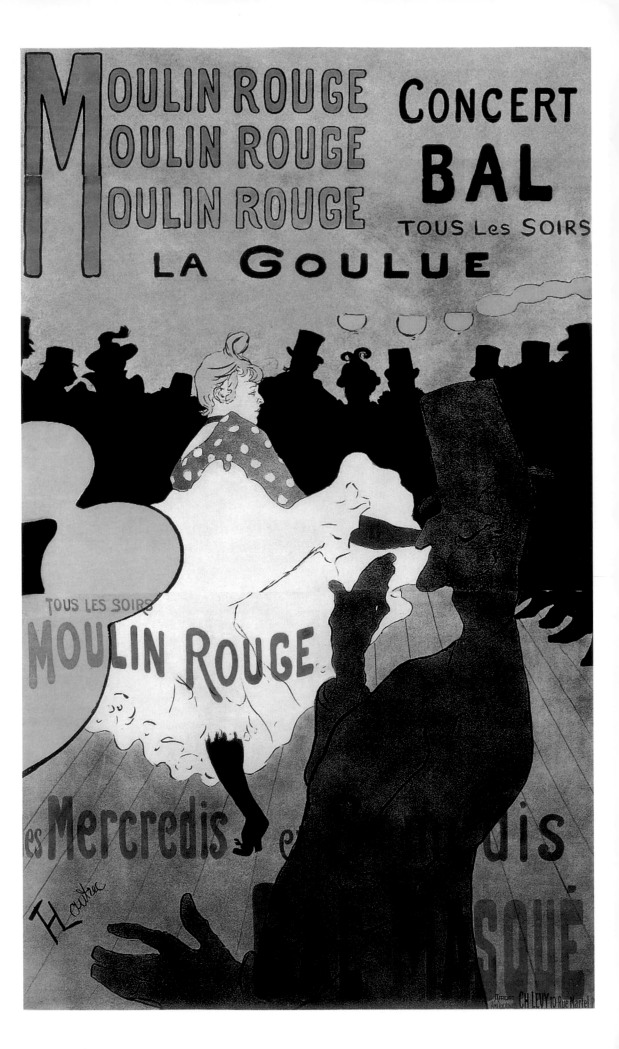

134. **Henri de Toulouse-Lautrec,**
Moulin Rouge: La Goulue, 1891.
Lithograph in colours,
191 x 120 cm.
Private collection.

135. **Henri de Toulouse-Lautrec,**
*Ambassadeurs: Aristide Bruant
in his Cabaret*, 1892.
Lithograph in colours,
138 x 94 cm.
Bibliothèque nationale de France,
Paris.

Lautrec untiringly painted the dancer who was the central character of his composition. They became very good friends. He used an image of La Goulue for a poster that made him immediately famous in Paris.

Drawing was the major part of Lautrec's work. On several occasions he provided newspapers with some drawings, but he did not like it. However, in 1891, he was inspired by an order from the owners of the Moulin Rouge, Oller and Zidler, who asked Lautrec to design the poster for the opening of the cabaret season. He drew La Goulue and the outline of Boneless Valentin over a crowded background as they had both become the symbols of the Moulin Rouge. La Goulue's pink blouse and white skirt seemed to be shining with light. The poster was readable from far away; it was provocative and striking. (*La Goulue au Moulin Rouge*, p. 168). Lautrec was competing with a powerful opponent: before him, the Moulin Rouge poster had been done by Chéret, a very fashionable artist in Paris. Lautrec's victory was quick and unarguable. His poster had become a collector's dream as soon as the day after it was released in the streets of Paris. For the artist himself, it was the revelation of a new form of art, which he immediately favoured.

Lautrec established poster drawing as a graphic art. That first poster was followed by new orders. Aristide Bruant, a striking character who had become one of the symbols of Montmartre, ordered a poster for his cabaret. Lautrec's posters actually played an essential role in French art history. The greatest cabaret stars wanted to be immortalised by him. In that limited genre, Lautrec managed to express his admiration for the dancer Jane Avril. He drew her many times. His broken lines conveyed the sudden movements in her dancing and her fragile outline (*Jane Avril Dancing*, p. 173).

The making of a poster was preceded by a vast amount of drawings. The impression of lightness was deceiving: with Lautrec, everything was the result of dedicated long work. At the Folies-Bergères, he drew the American dancer Loïe Fuller fluttering about the stage with her light, vaporous dresses. Lautrec's drawings and paintings nourished his posters. The opposite was also true, his posters brought laconism and finesse to his painting style.

His understanding of graphics later led Lautrec to join the editorial staff of the *Revue blanche* along with his editor Thadée Nathanson, his seductive wife who was a pianist, Misia, and writers who took part in the journal.

Lautrec would arrive at the *Revue blanche* eternally accompanied by a line of people.

As Lautrec liked contrasts, people around him had striking appearances. He looked minuscule next to the big and massive outlines of Numa Baragnon and Maxime Dethomas; there also was Sescau, a frighteningly slender photographer. Maurice Joyant had been to high school with Lautrec. He was the manager of the Boussod-Valadon gallery since the death of Theo van Gogh, Vincent's brother. His gallery became a natural meeting point for young painters. Lautrec's closest friend, the jovial fellow Guibert, led the little group]. These drinking friends and companions, as well as many others, were part of Lautrec's paintings; they were his Paris.

Despite his handicap, Lautrec was eager for life and joyously curious. He was merciless with himself, careless of danger and would not listen to his friends' warnings. He was tired out by the nocturnal life of Montmartre and contracted disease through his contact with women. Still, he worked tirelessly. His friends became worried when he suddenly disappeared.

136. **Henri de Toulouse-Lautrec**,
Portrait of Monsieur Delaporte in the Gardens of Paris, 1893.
Gouache on cardboard,
76 x 70 cm.
Ny Carlsberg Glyptotek,
Copenhagen.

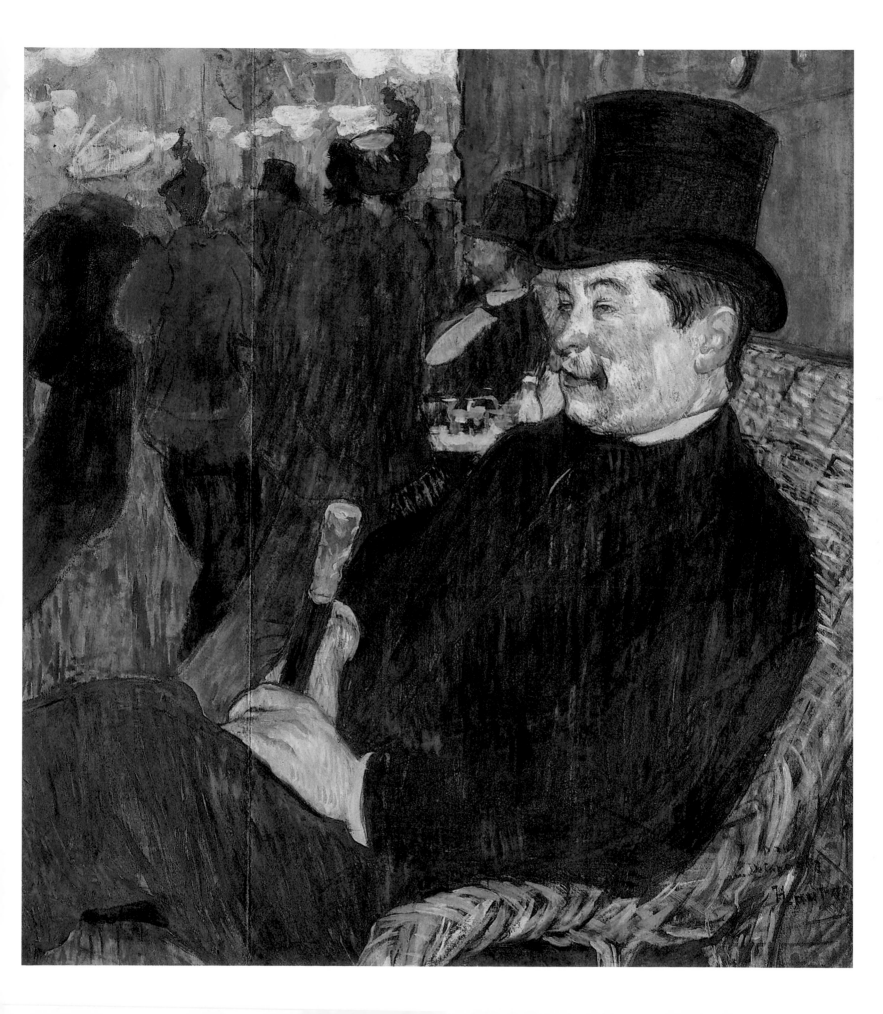

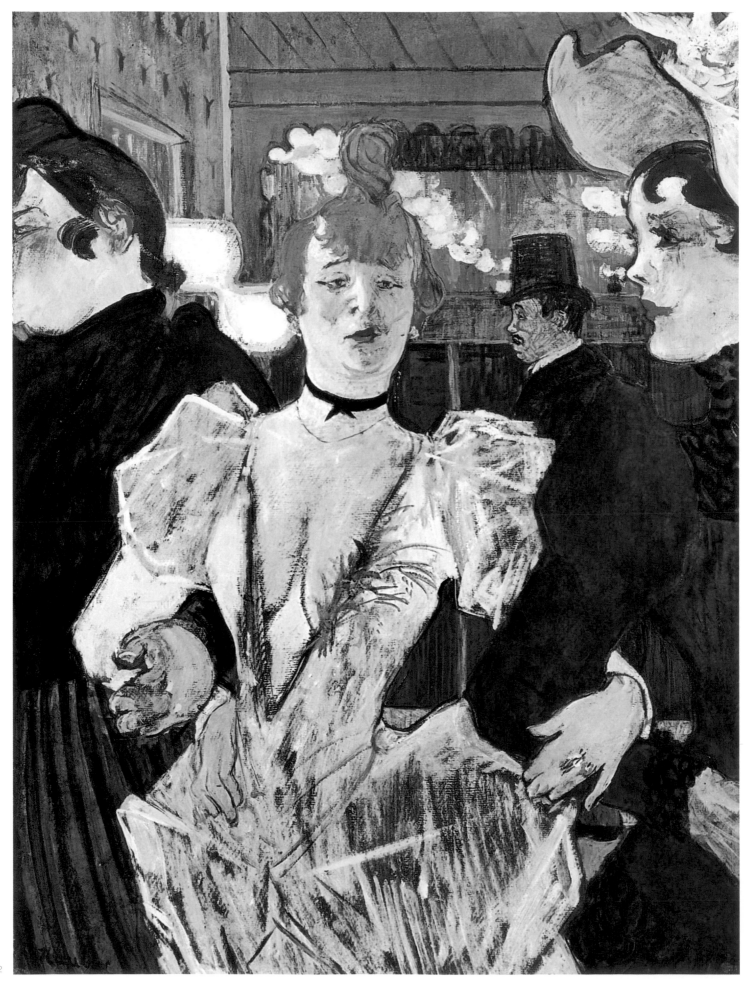

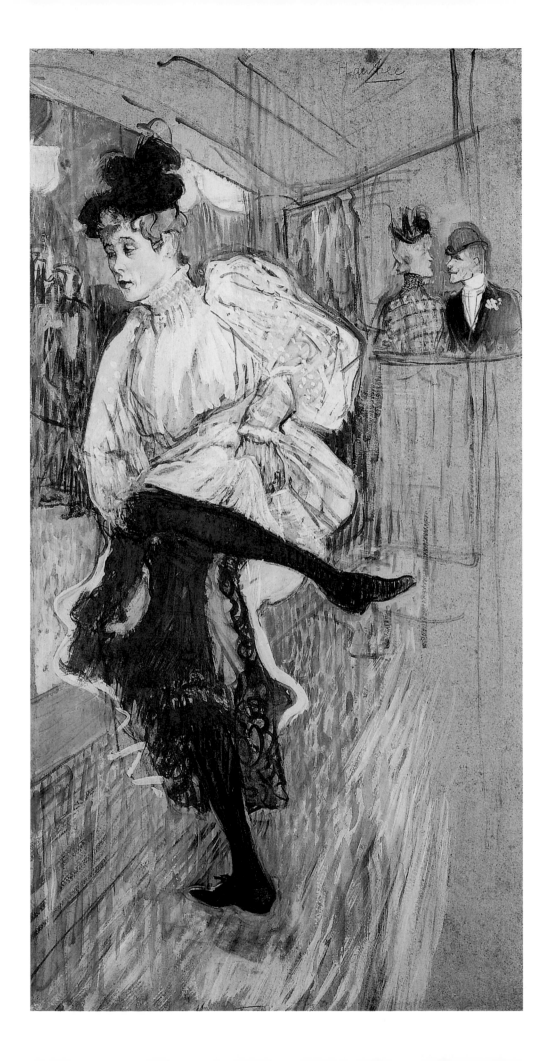

137. **Henri de Toulouse-Lautrec,**
La Goulue Entering the Moulin Rouge with Two Women, 1892.
Oil on panel, 79.4 x 59 cm.
The Museum of Modern Art,
New York.

138. **Henri de Toulouse-Lautrec,**
Jane Avril Dancing, c. 1892.
Oil on cardboard, 85.5 x 45 cm.
Musée d'Orsay, Paris.

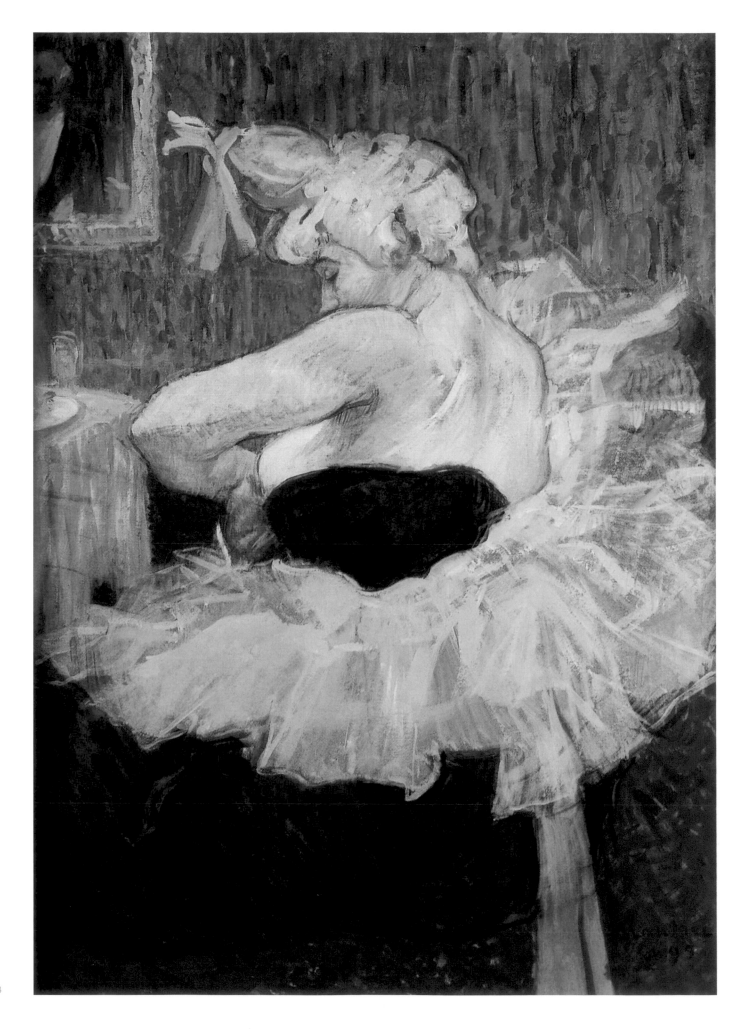

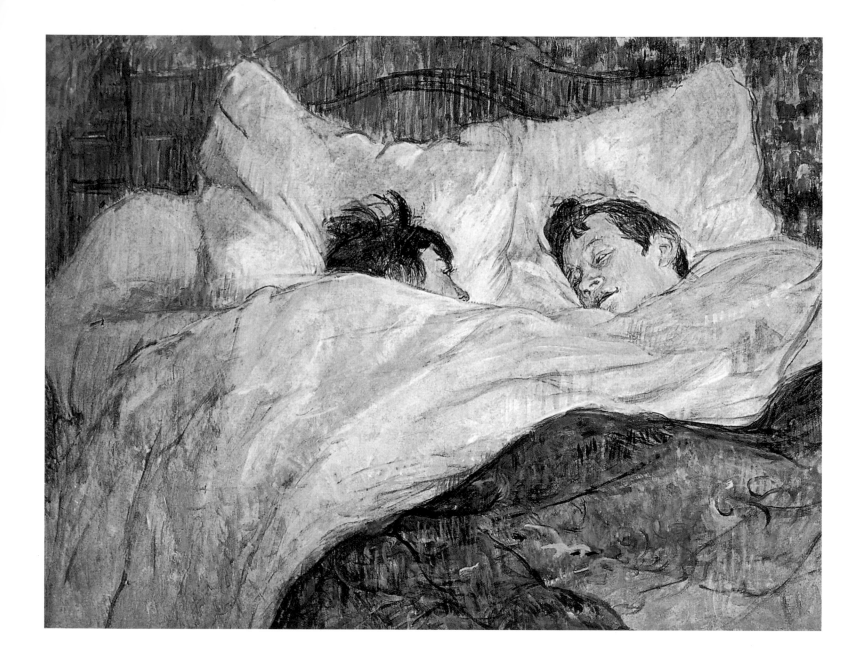

It turned out that he had been taking a break in a brothel. Prostitutes were outcasts like him. Lautrec could understand them and appreciated their friendliness, and he drew them again and again. They were models for his paintings.

However, Lautrec's Montmartre had changed. Its cabarets and concert-cafés were not going to last. They disappeared or turned into something else one after the other. As for La Goulue, she earned a rather good living and launched her own pavilion at a famous fair: the Foire du Trône, in Paris in 1895. She could not dance her crazy quadrilles anymore but her life was like a dance. On her request, Lautrec painted two large panels for the pavilion. In the middle of both one could see La Goulue dancing the quadrille that she had made famous. The last years of the century were very difficult for Lautrec. His feverish eagerness for life took him on travel: he went to Britain, Spain, Portugal, Holland; he rested in Normandy, always moving between his family's properties and his friends' houses. He did lots in painting and graphics, throwing himself passionately into theatre for which he created paintings and posters, but it was getting harder and harder for him to work.

139. **Henri de Toulouse-Lautrec,**
Clowness Cha-U-Kao, 1895.
Oil on cardboard, 64 x 49 cm.
Musée d'Orsay, Paris.

140. **Henri de Toulouse-Lautrec,**
The Bed, c. 1892.
Oil on cardboard, 54 x 70.5 cm.
Musée d'Orsay, Paris.

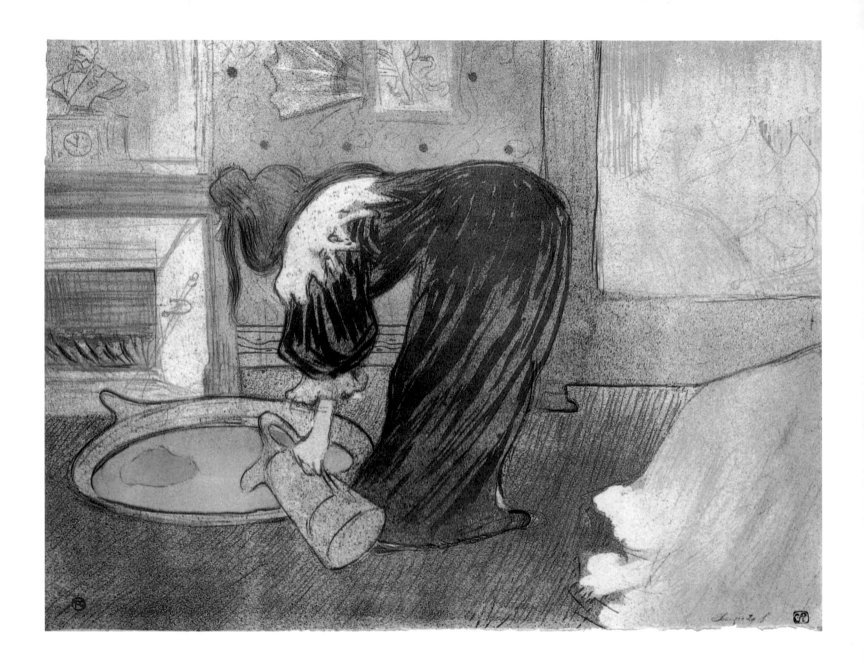

141. **Henri de Toulouse-Lautrec,**
Woman at the Bath Tub,
from the *"Elles"* album, 1896.
Lithograph in colours,
40 x 52.5 cm.
Private collection.

142. **Henri de Toulouse-Lautrec,**
Loïe Fuller, 1892-1893.
Lithograph in colours.
Private collection.

His mother and friends tried to save him from alcoholism but it was beyond his power to give up. In 1899, he had to stay in a clinic for the insane for a while. He tried to get a taste for life back again through work for a little while, when he came out of hospital, but he finally died aged thirty-seven at Chateau Malromé, on September 9, 1901.

Lautrec had started to exhibit his works very early on. By 1888 already, when he was only twenty-four, he had already shown some works in Brussels with the Groupe des Vingt. The following year he had started displaying works at the Exhibition of the Indépendants. His contemporaries did not understand his work well. The public and most critics were choked by its indecency. His paintings entered museums quietly, as if they were on a black list. Several works by Lautrec were thus lost to French museums. Yet, without his paintings and prints, the art of the Post-Impressionist era would not be as rich. Lautrec was responsible for an immense contribution to the formation of the decorative style called Art Nouveau, which became the symbol of the link between the nineteenth and twentieth centuries.

THE NABIS

At the time of the last Impressionist exhibition in 1886, the painters of the group called the Nabis were still very young as all of them were born towards the end of the 1860s and beginning of the 1870s. Raised in the Symbolist atmosphere, in a spirit of mysticism and refinement, they acquired at the same time a sort of suspicion towards proclaimed authority. Admirers of the great new masters (Cézanne, Gauguin, Van Gogh), they cherished their independence above all, a quality that they had inherited from them. With the eagerness of their youth, they gathered the most striking, the most exceptional and at the same time the most typical aspects that art had developed in the second half of the nineteenth century to transpose them delicately in the new century.

We do not know exactly when those young painters got together to create the group of The Nabis. Everything started when five young Parisians started to study painting at the Académie Julian: Maurice Denis, Pierre Bonnard, Paul Ranson, Henri-Gabriel Ibels and Paul Sérusier. In 1888, the eldest of them, Paul Sérusier, was twenty-five and already brilliantly educated. Apart from figurative art he was interested in philosophy and oriental languages (Arabic and Hebrew). He had achieved success quickly: his painting titled *The Breton Weaver*, which showed an academic style, was displayed at the Exhibition and was judged 'honourable'. At the end of the summer 1888, Sérusier went to Brittany in order to renew his subjects.

At the time, Pont-Aven was a pilgrimage place for the most diverse painters, a sort of Mecca for painting. Sérusier discovered there the rowdy group that Gauguin led. Sérusier stayed in the same inn as them, Gloanec's. Gauguin was already working on his 'compartmentalised' manner, which he preferred to call 'Synthetism' and he passionately taught Symbolist theory to his followers. On the last day of Sérusier's stay in Pont-Aven, Gauguin offered him to go and paint with him outdoors. Sérusier oil painted a landscape on the lid of a cigar box under Gauguin's supervision. He took the box back as a precious treasure to show to his friends. They called that study *Talisman* and it became the symbol of their new pictorial religion (*The Talisman, L'Aven in the Bois d'Amour*, p.178).

The youngest of them, Maurice Denis, was eighteen. In addition to his painting lessons he was studying at Condorcet high school. Pierre Bonnard was twenty-one; he had read law though all his interest laid in figurative art. He was a remarkable draughtsman, like Ibels. Paul Ranson was older: he was twenty-four and already married. Two friends soon joined them: Édouard Vuillard and Ker Xavier Roussel, who were at Condorcet high school with Maurice Denis. The group also welcomed Vallotton, a Swiss man from Lausanne who was studying at the Académie Julian too. They all shared in their interest for mysticism and symbolist literature, debating the art of their time with enthusiasm; they wanted to bring something new into it. It was probably Paul Sérusier, the oldest of them, who convinced them to band up.

His knowledge of oriental languages made him suggest the Hebrew word 'Nebiim' meaning 'prophets' to his friends and so they became the Nabis.

143. **Paul Sérusier**, *The Talisman*, 1888.
Oil on wood, 27 x 21.5 cm.
Musée d'Orsay, Paris.

The Nabis took their philosophical debates very seriously. They scheduled monthly dinners that neither the uninitiated nor women were allowed to attend. They had invented a secret language in which they communicated and which uninitiated people could not understand. Each of them had a name. Maurice Denis, who was a convinced Catholic keen on religious painting, was the 'Nabi of beautiful icons'; Paul Sérusier was the 'Nabi with a shining beard'; Pierre Bonnard, who was keen on Japanese art, was the 'Japaniard Nabi'; as for the Swiss Félix Vallotton, he remained the 'foreign Nabi'.

Soon their circle opened up to friends and to friends of friends. Georges Lacombe became the 'sculpting Nabi', Auguste Cazalis, a linguist and historian educated in oriental languages, the 'Nabi ben Calyre'. Aristide Maillol, still a painter at the time before becoming a remarkable sculptor, was also close to the Nabis. The Nabis got close to writers of the Symbolist circle and contacted the journals *Mercure de France*, *La Plume* and above all the *Revue blanche* edited by Thadée Nathanson and for which many of them worked.

The Nabis, who understood the best representatives of the nascent culture of the time, also had another particularity: they were willing to welcome foreigners in their circle. A 'Hungarian Nabi' joined them, the painter Josef Rippl-Ronai who was a friend

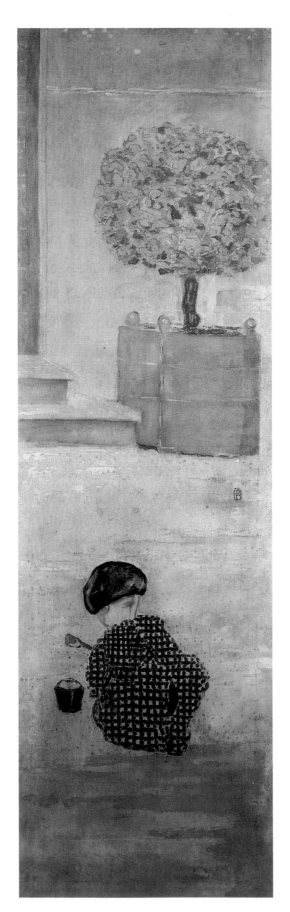

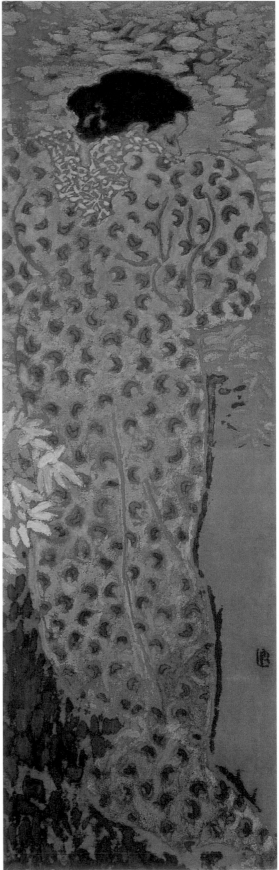

147. **Pierre Bonnard**, *The Child with a Sand Castle*, c. 1894.
Oil on canvas, 167 x 50 cm.
Musée d'Orsay, Paris.

148. **Pierre Bonnard**,
The Dressing Gown, c. 1890.
Cloth, 150 x 50 cm.
Musée d'Orsay, Paris.

149. **Paul Ranson**, *The Tiger*, 1893.
Lithograph in colours.
The State Hermitage Museum,
St. Petersburg.

150. **Édouard Vuillard**,
Public Gardens, 1894.
Glue tempera on canvas,
214.5 x 88 cm; 214.5 x 92 cm;
213.5 x 73 cm; 213.5 x 154 cm;
214 x 81 cm; 214.3 x 97.9 cm;
214 x 98 cm.
Musée d'Orsay, Paris.

La revue b[lanche]

PARAIT CHAQUE MOIS
EN LIVRAISONS DE 100 PAGES
le n° 1 fr. BUREAUX 1 rue Laffitte
en VENTE PARTOUT

La revue blanche

Imp. Edw. Ancourt, PARIS.

of Maillol. Sérusier introduced Meyer de Haan, the 'Dutch Nabi', an artist from Amsterdam whom he had met in Pont-Aven in Gauguin's group. In 1890, another Dutch painter arrived in Paris: Jan Verkade who became the 'Obeliscal Nabi' because of his great height and extreme slenderness. There also was a Jew from Copenhagen, Mogens Ballin. The Nabis were the first sign of an emerging international artistic circle in Paris that a journalist from Montmartre, André Warnod, rightly called in the twentieth century the 'École de Paris'.

In 1896, Sérusier and Bonnard created the scenery of the premiere of Alfred Jarry's play *'Ubu Roi'* at the Théâtre de l'Œuvre, which was immediately successful. The Nabis carried out sketches, models of scenery, costumes and drew programs for the shows of their friends in the world of theatre: Lugné-Poe, Antoine, Paul Fort.

The time when painters only painted and all other creative activities belonged to the realm of artistic occupations was over. From then on, ceramics, tapestry, stained-glass windows, graphic arts were a priority for artists in the highest sense of the word, which is partly to the Nabis' credit. They worked in all graphic areas. Lithography was especially popular amongst them. It allowed passing on the spontaneity of the drawing to the spectator whilst keeping the particular lines of the artist. Denis, Ibels, and Vallotton created posters for journals of the time using that technique. Bonnard's poster for the *Revue blanche* representing Thadée Nathanson's wife, the pianist Misia, went round Paris (Pierre Bonnard, *Poster for the Revue blanche*, p. 186). Maurice Denis illustrated books with wooden engravings. The Nabis were among the first artists to use it as a creative means. Félix Vallotton nearly abandoned painting for eight years and spent the last ten years of the century at xylography. His engravings, full of black and white surfaces, created a new style close to Gauguin's compartmentalisation, which was reflected in Vallotton's painting at the end of the century. Many Nabis tried ceramics and stained-glass windows. On order of the Bing Gallery, Maurice Denis drew some furniture.

In 1900, Maurice Denis painted *Homage to Cézanne* (p. 193). It showed his Nabis friends in the gallery of their usual dealer: Ambroise Vollard. There was one of Cézanne's still lifes on the easel and everyone knew that it belonged to Gauguin. Two of their idols were thus represented. The third one, the old Symbolist Odilon Redon was standing by the easel. The 'Nabi with the shiny beard', Paul Sérusier, was showing the painting to his friends. Around him there were Denis, Vuillard, Ranson, Roussel and Bonnard, the founders of the group. Beside them there was the critic André Mellerio, the owner of the Gallery Ambroise Vollard and Marthe, Denis' wife. This painting was a sort

151. **Pierre Bonnard,**
La Revue blanche, 1894.
Lithograph in colours,
80.1 x 61.6 cm.
National Gallery of Art,
Washington, D. C.

152. **Ker Xavier Roussel,**
In the Snow, 1893.
Lithograph in colours.
The State Hermitage Museum,
St. Petersburg.

153. **Pierre Bonnard**, *Women in the Garden*, 1891. Glue distemper on canvas, 160 x 48 cm (each panel). Musée d'Orsay, Paris.

154. **Maurice Denis**, *Ladder in Foliage* or *Poetic Arabesques for the Decoration of the Ceiling*, 1892. Oil on canvas, 235 x 172 cm. Musée départemental Maurice Denis "Le Prieuré", Saint-Germain-en-Laye.

155. **Édouard Vuillard,**
Place Vintimille, 1911.
Distemper on paper mounted
on canvas, 230 x 60 cm
(each panel).
National Gallery of Art,
Washington, D. C.

156. **Félix Vallotton,** *Interior*,
1903-1904.
Oil on cardboard, 61.5 x 56 cm.
The State Hermitage Museum,
St. Petersburg.

of assertion: Denis represented the Nabis by the painters whose works were, according to them, the source of their art.

In the 1890s all Nabis artists paid a tribute of some sort to decorative painting. Pierre Bonnard created a particular type of panel: folding screens taken from Japanese art but adapted to the Post-Impressionist environment (*Les Femmes au jardin*, p. 188). Édouard Vuillard turned the decorative surface of his panels into glimmering and harmonious patches of painting (*Place Vintimille*, p. 190). Paul Ranson made beautiful arabesque for tapestry (*The Tiger in the Jungle*, p. 183). Vallotton's easel paintings often were as decorative as his friends' large panels (*Interior*, p. 191). Even the short list of xylographs by Vallotton contributed to monumental art.

In 1890, under the fictitious name of Pierre Louis, he published in the journal *Art et critique* an article clearly expressing their theory of painting: "Before being a battle horse, a naked woman or any anecdote, a painting is essentially a flat surface covered

157. **Maurice Denis**, *Portrait de Marthe Denis*, 1893.
Oil on canvas, 45 x 54 cm.
The Pushkin State Museum of Fine Arts, Moscow.

with colours put together according to a certain order."[49] It was not a fancy of his: the recognition of the priority of colours and attention paid to the method of organisation of paint on the surface were essential points that united the diverse ways of the greatest masters of Impressionism and Post-Impressionism. The Nabis based their relationship to painting on it, which offered them the largest choice of options for their own way. They religiously kept their *Talisman* but none of them adopted Gauguin's method of work. They considered themselves as people living in a rational time, that of scientific and technical revolution, and they could look at the world and art around them with lucid and critical eyes. Their efforts to be original in their art and different from the others, two essential qualities for avant-garde art in the twentieth century, were their main step forward.

158. **Maurice Denis,**
Homage to Cézanne, 1900.
Oil on canvas, 180 x 240 cm.
Musée d'Orsay, Paris.

NOTES

[1] "Paris", *Le Guide du Patrimoine*, Paris, Hachette, 1994, p. 194

[2] Françoise Cachin, *Gauguin*, Paris, 1968, p. 146

[3] Émile Verhaeren, "Le Salon des indépendants", *L'Art moderne*, April 5, 1891

[4] *Le Douanier Rousseau*, Paris, 1985, p. 262

[5] *Conversations avec Cézanne*, Paris, 1978, p. 89

[6] Paul Cézanne, *Correspondance*, Paris, 1937, p. 71

[7] Émile Zola, *L'Œuvre*, Paris, 1886, p. 7

[8] *Conversations avec Cézanne, op.cit.*, p. 80

[9] Paul Cézanne, *op.cit.*, p. 98

[10] Jack Lindsay, *Paul Cézanne*, Moscow, 1989, p. 204

[11] *Conversations avec Cézanne, op.cit.*, p. 170

[12] Paul Cézanne, *op.cit.*, p. 127

[13] *Conversations avec Cézanne, op.cit.*, p. 163

[14] Paul Cézanne, *op.cit.*, p. 227

[15] *Conversations avec Cézanne, op.cit.*, p. 47

[16] Paul Cézanne, *op.cit.*, p. 297

[17] Camille Pissarro, *Lettres, critiques, souvenirs de ses contemporains*, Moscow, 1974, p. 79

[18] Paul Signac, *D'Eugène Delacroix au néo-impressionnisme*, Paris, 1964, p. 84

[19] Vincent van Gogh, *Lettres*, St. Petersburg, 2000, p. 328 n° 402

[20] *Ibid.*, p. 384 n°450

[21] *Ibid.*, p. 62 n°130

[22] Vincent van Gogh, *Lettres à Van Rappard*, Paris, 1950, p. 223

[23] *Ibid.*, p. 238

[24] Vincent van Gogh, *Lettres, op. cit.*, p. 331 n°404

[25] J. Rewald, *Post-impressionism*, Leningrad-Moscow, 1962, p. 24

[26] J. Rewald, *op. cit.*, p. 39-40

[27] J. Rewald, *op. cit.*, p. 34

[28] Vincent van Gogh, *Lettres, op. cit.*, p. 516 n°511

[29] *Ibid.*, p. 508 n°503

[30] *Ibid.*, p. 542 n°534

[31] *Ibid.*, p. 565, n°545

[32] *Ibid.*, p. 595 n°564

[33] *Ibid.*, p. 620 n°578

[34] *Ibid.*, p. 622 n°579

[35] *Ibid.*, p. 503 n°499

[36] *Ibid.*, p. 721-722 n°638

[37] *Ibid.*, p. 730, n°646

[38] Gauguin, *Racontars de Rapin*, Paris, 1951, p. 35

[39] *Lettres de Gauguin à sa femme et à ses amis*, Paris, 1946, p. 66

[40] *Ibid.*, p. 140

[41] Françoise Cachin, *op. cit.*, p. 125

[42] *Lettres de Gauguin à sa femme et à ses amis, op.cit*, p. 173-175

[43] *Ibid.*

[44] *Ibid.*

[45] *Ibid.*, p. 184

[46] Paul Gauguin, *Noa Noa*, Paris, 1924, p. 85

[47] *Ibid.*, p. 52

[48] Henri Perruchot, *Toulouse-Lautrec*, Moscow, 2001, p. 213

[49] Agnès Humbert, "Maurice Denis, Nabi aux Belles Icônes", *Les Nabis et leur époque*, Geneva, 1954, p. 137

INDEX

THÉO VAN RYSSELBERGHE

JAN VERKADE

ÉDOUARD VUILLARD